HENRY WALTERS AND
BERNARD BERENSON

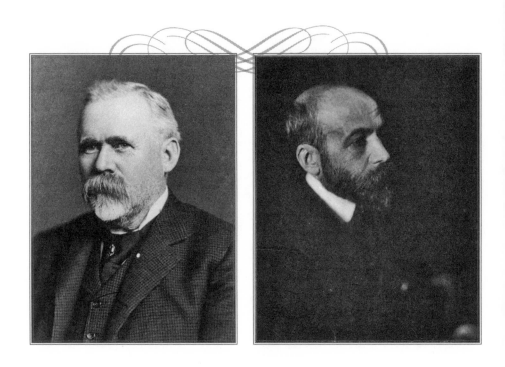

HENRY WALTERS and BERNARD BERENSON

Collector and Connoisseur

STANLEY MAZAROFF

Foreword by William R. Johnston

The Johns Hopkins University Press | *Baltimore*
in association with The Walters Art Museum

© 2010 The Johns Hopkins University Press
All rights reserved. Published 2010
Printed in the United States of America on acid-free paper
2 4 6 8 9 7 5 3 1

The Johns Hopkins University Press
2715 North Charles Street
Baltimore, Maryland 21218-4363
www.press.jhu.edu

Library of Congress Cataloging-in-Publication Data
Mazaroff, Stanley.
Henry Walters and Bernard Berenson : collector and connoisseur /
Stanley Mazaroff.
p. cm.
ISBN-13: 978-0-8018-9512-8 (hardcover : alk. paper)
ISBN-10: 0-8018-9512-X (hardcover : alk. paper)
1. Walters, Henry, 1848–1931. 2. Berenson, Bernard, 1865–1959.
3. Art—Collectors and collecting—United States—Biography. 4. Walters
Art Gallery (Baltimore, Md.) I. Title.
N5220.W43M39 2010
709.2′273—dc22
[B] 2009037378

A catalog record for this book is available from the British Library.

Frontispiece: Henry Walters around 1908 at the age of sixty
(Walters Art Museum, Baltimore, Maryland); Bernard Berenson
around 1909 at the age of forty-four (Villa I Tatti, Firenze)

Special discounts are available for bulk purchases of this book.
For more information, please contact Special Sales at 410-516-6936
or specialsales@press.jhu.edu.

The Johns Hopkins University Press uses environmentally friendly book
materials, including recycled text paper that is composed of at least
30 percent post-consumer waste, whenever possible. All of our book
papers are acid-free, and our jackets and covers are printed on paper
with recycled content.

To Nancy

CONTENTS

Illustrations

PLATES

Color plates appear after page 30.

FIGURES

Foreword

What transpires when a self-described capitalist engages a world-renowned con-
noisseur of Renaissance Italian art to refine and enhance his vast collection?
Stanley Mazaroff explores in depth the complex relationship and the exchanges
between Baltimore collector Henry Walters and scholar Bernard Berenson. The
years covered in his study, principally 1910 through 1916, proved critical for both
of them: Berenson was beginning to venture into the art market, collaborating
with Joseph Duveen in a partnership that would sometimes compromise his
judgment, and Walters, having just completed a Genoese palazzo-style museum
building, was hastening to fill it with additional purchases.

The Johns Hopkins University Press has devoted two publications to the Wal-
ters collection. This writer's *William and Henry Walters, the Reticent Collectors*
(1999) is primarily biographical and deals with two generations of the Walters
family, their lifestyles, and their varied activities in finance and philanthropy,
as well as their art collecting. The current volume, in contrast, examines Henry
Walters's most pivotal, yet most controversial acquisition, the Marcello Mas-
sarenti collection. With this single purchase of more than sixteen hundred works
of art in 1902, Henry Walters created the core collection for a museum that he
would eventually bequeath to his native city in memory of his father.

In particular, Mazaroff focuses on the 520 Italian paintings in the collection,
ranging from the Gothic through the Baroque periods. Although aware of the
rumors then circulating regarding the authenticity of many of these works, Wal-
ters could not have anticipated that so many of their original attributions would
prove untenable. Realizing that neither he nor his immediate advisers could
resolve such issues themselves, he retained Berenson for advice on the elimina-
tion of works, additional purchases, and the cataloguing of the collection.

Berenson faced numerous challenges in his dealings with his client. Though
seemingly profligate when purchasing *objets d'art* in an astonishingly wide range
of fields, Henry Walters was far less cavalier when it came to paying large sums
for individual paintings. Winnowing the collection was equally problematic,

given Walters's extreme reluctance to part with anything; the offending works were usually merely consigned to storage. Most significantly, Berenson was already overextended; he had previous commitments to other clients and, once partnered with Duveen in 1912, he no longer regarded Henry Walters and his collection as a top priority.

Mazaroff examines Berenson's proposals for the many works to be discarded, and he also discusses Berenson's thirty-six additions, observing that, although none of the latter were truly stellar, they contributed to the breadth of the collection. By eliminating the pretentious attributions inherited from Massarenti, Berenson's major contribution was not through additions but through "a refined process of subtraction." In the course of his research, Mazaroff discovered considerable new information both in Baltimore and at I Tatti, Berenson's villa at Settignano. As a result of Mazaroff's perseverance and through the diligence of the archivists in Florence, much of Berenson's research on the Walters collection, previously unlocated, was rediscovered. Mazaroff's realization that Walters's 1915 handbook incorporated many of Berenson's reattributions proves particularly significant for the study of the Italian holdings, especially in view of the fact that the proposed scholarly catalogue was abandoned after Walters severed his ties with the expert in 1917.

Although Mazaroff has ostensibly confined his research to one aspect of the Walters collection, the scope of his research is far more expansive. Not only does he provide rare insights into the personalities of his key subjects, Walters and Berenson, but he also presents an exceptional overview of the art market during their time. His observations should prove fascinating to all readers who are interested in collecting during the Gilded Age.

William R. Johnston
Curator Emeritus, The Walters Art Museum

Acknowledgments

Several years ago, after my retirement from the active practice of law, I enrolled as a special student in the art history department of Johns Hopkins University. During the course of my studies, I was encouraged by Stephen Campbell, the chair of the department, to write an article on Henry Walters's acquisition in 1902 of a massive collection of art owned by Marcello Massarenti, an assistant to the pope in Rome. My research on this project began with Bill Johnston's definitive biography, *William and Henry Walters, the Reticent Collectors,* and it continued with Bill Johnston's generous offer to open for my exploration the historically rich archives of the Walters Art Museum, where I came close to residing for days and weeks on end. I was introduced to Elissa O'Loughlin, a senior conservator at the Walters, who, like a guardian angel, carefully escorted me through a treasure trove of old letters, newspaper clippings, vintage photographs, and notes which, when collaged together, began to reveal both Berenson's substantial influence on Walters's collection of Italian paintings and the episodic events that brought Walters and Berenson together and then drove them apart.

My research led to the Villa I Tatti (now owned by Harvard), Berenson's beautiful villa outside of Florence, which I visited initially in January 2007 and again in January and April of 2008. There I was warmly greeted by Joseph Connors, the director of I Tatti, and by Fiorella Superbi and Michael Rocke, who granted me access to I Tatti's archival records pertaining to Henry Walters. It was there that I found the substantial body of correspondence between Walters and Berenson upon which this book primarily rests. I want to thank Dr. Connors for authorizing me to publish some of these letters, which can be found in appendix A. I am also indebted to Ms. Superbi, the director of the Berenson Fototeca, not only for sharing her knowledge about Berenson but also for discovering and promptly bringing to my attention Bernard and Mary Berenson's handwritten notes recorded while inspecting Walters's collection of Italian paintings in 1914, as well as an unfinished catalogue about these paintings that Berenson had

written. I likewise want to extend my thanks to Mr. Rocke, the director of the Berenson Biblioteca, for placing before me Berenson's copy of the Walters Gallery Catalogue of Paintings that Henry Walters published in 1915 based on Berenson's advice and direction.

From 1910 to 1916, Walters was a client of Berenson and acquired many paintings from him, but for the reasons discussed in this book, Walters retained no coherent record of this. One of my challenges has been to unlock the history of these purchases. In pursuing this task, I was guided by an excellent article — "Bernard Berenson, Villa I Tatti and the Visualization of the Italian Renaissance," by Professor Patricia Rubin — which referred to several paintings that Berenson sold to Walters from his own collection. In response to a letter inquiring about her research for that article, Professor Rubin provided me with her research notes about the paintings that Walters acquired from Berenson. I hope that this acknowledgment adequately conveys my respect for her scholarship and gratitude for her generosity.

I am also grateful to Joseph Rishel for allowing me to review the archival records at the Philadelphia Museum of Art pertaining to the correspondence between Berenson and John G. Johnson, who was a Berenson client around the same time as Walters; Jay Fisher, deputy director of the Baltimore Museum of Art, for allowing me to read the BMA's archival records pertaining to Walters; Barbara File, an archivist at the Metropolitan Museum of Art, for providing me with documents pertaining to Walters's service on the Metropolitan board and his gifts to that museum; Christine Nelson, the Morgan Library's curator of literary and historical manuscripts, for facilitating my examination of archival documents at the Morgan Library pertaining to Bella da Costa Greene, Berenson, and Walters; Beverly Tetterton, the librarian of the New Haven Public Library in Wilmington, North Carolina, who shared with me files of newspaper clippings about Henry Walters and his life in Wilmington; and the many wonderful librarians at the Enoch Pratt Free Library in Baltimore, especially the librarians in the Maryland and Fine Arts Departments, whose courtesy and professionalism set a standard to which all librarians across the country should aspire.

My work on this book took me to Wilmington, North Carolina, where Walters once resided, and to the Cape Fear Club, where eight of the paintings Walters acquired from Massarenti can now be found. I thank Kay Stern and Marilyn Anderson for their gracious hospitality, for arranging for me to see the paintings that Walters gave to the Cape Fear Club, and for serving together as a font of information about Henry Walters's life in Wilmington. I likewise want to thank

my dear friends Laura and Barrett Freedlander for organizing this trip and for their ongoing interest in my project.

Without the support of the Walters Art Museum, the publication of this book would not have been possible. I specifically thank Joaneath Spicer, the curator of Renaissance and Baroque art, for carefully reading my manuscript and offering frank and constructive criticism, sometimes of the no-holds-barred variety, which served to correct some of my missteps and improve the quality of my work. I also want to thank Chris Henry, the Walters' head librarian, for responding with alacrity to my many requests for hard-to-find books, for providing me with shelves and other space for my work, and for permitting me to reside in her library for days and weeks on end while she made me feel at home. I also thank Susan Tobin, head of photography, and Ruth Bowler for their excellent work in creating the photographic illustrations for this book and Joan Elizabeth Reid, the chief registrar, for sharing her knowledge, files, and records relating to the history of the Italian paintings in the Walters collection. Most of all, I am deeply indebted to Gary Vikan, the great director of the Walters Art Museum, for his active encouragement and support, which have been instrumental in bringing this book to publication.

I am also indebted to Sylvia Eggleston Wehr, the associate dean of external affairs of Johns Hopkins University. After reading the first chapter of my manuscript, she encouraged me to submit it to the Johns Hopkins University Press for publication and at the same time encouraged the press to consider it. But for her vital assistance, this book might not have been published. Finally, I express my deep appreciation to the Johns Hopkins University Press, especially to Executive Editor Henry Tom, Assistant Editor Suzanne Flinchbaugh, and Assistant Managing Editor Linda Forlifer, for their thoughtful ideas and suggestions that improved the book and that paved the way to its publication.

Henry Walters and
Bernard Berenson

PROLOGUE

New York has lost the chance of a generation and at one blow
Baltimore has raised herself far above all other American cities
by the purchase of the collection of Don Marcello Massarenti
of Rome . . . a collection that will make our Metropolitan
Museum look silly and place the Walters Museum in Baltimore
on a level with the great public museums of London, Paris and
Berlin. —*The New York Times*, May 11, 1902

Loaded with 275 crates containing seventeen hundred works of art that related
to twenty-five centuries of history, culture, and archaeological treasures, in-
cluding Roman and Greek sculpture and more than nine hundred paintings,
520 of which were purportedly by Leonardo, Raphael, Titian, Caravaggio, and
other Italian masters, the British steamship SS *Minterne*, on the morning of July
12, 1902, sailed into the New York harbor, as if on a mission to refashion the
culture of America in the style of a Renaissance prince. All of the art aboard
the ship had been purchased by Henry Walters, the wealthy, well-cultivated,
and socially prominent president of the Atlantic Coast Line Railroad, from Don
Marcello Massarenti of Rome, who had amassed the collection over the course
of fifty years while serving in the influential position of Assistant Almoner to
the Holy See. Although unloaded in New York City, the massive art collection,
consistent with its Italianate quality and antique character, would ultimately be
housed in a museum designed in the Renaissance Revival style of a fifteenth-
century Florentine palazzo and constructed in Walters's native city of Baltimore,
Maryland.

By the turn of the last century, the Italian Renaissance represented to upper-class society and the new captains of finance and industry in the United States an idealized model of artistic, intellectual, and financial sophistication for translating wealth into culture. Through the acquisition of Italian old masters, the collection of Renaissance-vintage books, and the adoption of Renaissance Revival architecture in the construction of new residences, museums, and libraries, wealthy Americans sought to wrap themselves with the visual symbols and, by implication, the cultural values of the Italian Renaissance.[1] In the context of this cultural phenomenon, Henry Walters's purchase of the encyclopedic Massarenti collection was a significant, groundbreaking event that captured the attention of art connoisseurs on both shores of the Atlantic. It was "an acquisition then unprecedented in the annals of American collecting," as William R. Johnston, the biographer of William and Henry Walters, has observed.[2] And it propelled Henry Walters into the elite circle of America's millionaires whose patronage of the arts would be described in Medicean terms.

The significance of this event was reflected in its extensive coverage by the *New York Times*, whose editors apprehended that Baltimore, by reason of the Massarenti collection, would eclipse New York in the firmament of the world's cultural centers.[3] The newspaper coverage began on May 11, 1902, when the *New York Times* used the following headline in reporting Massarenti's intent to sell his "wonderful" art collection to Henry Walters:

> Titians, Peruginos, Pinturicchios, Paolo Veronese, Tintorettos Among the 1,000 Canvases in the Wonderful Collection

This headline suggests that the names of Italian Renaissance masters resonated in the consciousness of the New York public with a familiarity similar to the names of New York Yankee baseball stars of today. The headline also reflects the fact that the public's interest was focused on the Italian Renaissance paintings, even though the paintings represented only a fraction of the treasured objects in the Massarenti collection. In a separate editorial, on the same date, the *New York Times* claimed that the Massarenti collection contained two hundred masterpieces, chiefly of the Florentine and Venetian schools, and opined that it "will place the Walters Museum in Baltimore on a level with the great public museums of London, Paris and Berlin."

On May 14, 1902, the *Baltimore Sun* reported that Walters had spent over a month in Rome examining the Massarenti collection but that the deal remained unconsummated because the parties had not agreed upon the purchase price.[4] As if buoyed by this news, the *New York Times* tried to rally New Yorkers to pur-

chase the collection for the Metropolitan Museum of Art, whose collection at that time was devoid of any significant Italian Renaissance paintings. In this regard, the *Times*, on May 18, 1902, cautioned that "the time is past when Europe can offer great collections of this kind." And on May 20, 1902, it floated the prospect that New York could still contend for the "great collection which Henry Walters seeks . . . if her rich men are equal to the occasion."

The effort to entice New Yorkers to purchase the collection was unavailing. On July 13, 1902, in a front page story, the *New York Times* reported that Henry Walters had finalized his purchase of the Massarenti collection by promising Massarenti to keep the collection intact and that he would pay Massarenti 5,000,000 lire, which was roughly equivalent to $1,000,000 at that time. This price, in the opinion of the *Times*, was a "great bargain."[5] On the same date, the *Baltimore Sun* proudly reported that the Massarenti collection was headed for Baltimore with "a portrait by Raphael of himself, [and] a painting by Titian, either of which would add distinction to any collection."[6]

As he read these flattering accounts of the Italian masterpieces he supposedly was bringing to America, Henry Walters's momentary pleasure was undoubtedly shaken by his own, private misgivings about the overall quality of the collection and the likelihood that many, if not most, of the attributions given to the paintings by Massarenti were fabricated, intentionally or otherwise.[7] As a result of his education, experience, and cultivation, Walters certainly was aware that the Massarenti collection was infected with a virus of misattributions engendered by the deeply rooted Italian tradition of making endless copies of Renaissance masterpieces. He also undoubtedly was aware that others engaged in the field of Italian old master paintings, like Wilhelm von Bode, the director of the Friedrich Museum in Berlin, and the art dealer Joel Duveen, had previously inspected the Massarenti collection and had summarily dismissed it as a hodgepodge of second-rate imitations.[8] As if to guard against the risk that his family's reputation as art collectors would be soiled by his acquisition of copies and mediocre paintings, Walters, shortly after the collection arrived in the United States, boasted that "there will surely be 25 percent of the collection that I will dispose of because I have better pieces of work of the same kind."[9]

Henry Walters's goal in purchasing the Massarenti collection and placing it in an Italianate gallery in Baltimore was not only to elevate his own stature but also and more importantly to enshrine the memory of his father, William T. Walters, whose fame as a collector of French painting and sculpture and Asian ceramics had already become legendary.[10] Shortly after his father's death in 1894, Henry Walters expressed to friends that one of the most important, remaining

goals of his life was to memorialize the achievements of his father by elevating the family art collection to the status of a great public institution.[11] When the new gallery opened in 1909, Henry Walters prominently installed above its entrance an elaborate cartouche containing the bronze bust of his father stationed triumphantly upon the cornice of an ancient Roman temple and draped with swags of ornamental leaves, like those used to decorate ancient Roman sarcophagi (fig. 1). Conceived of and dedicated at a time when wealthy Americans vied to be surrounded with the symbols of Italy's cultural heritage, the cartouche signified that the image of William Walters as a cultural hero would forever serve as the Walters Art Gallery's coat of arms.

There is within the story of Henry Walters's acquisition and refinement of the Massarenti collection of paintings a paradoxical tale of attention and inattention spurred by Walter's passion for collecting but relative indifference to the joy of beholding a painting and becoming emotionally engaged in its visual pleasures. Surprisingly, Henry Walters rarely saw or demonstrated much interest in seeing the Italian paintings he collected. Unlike other contemporary collectors, such as Isabella Stewart Gardner, John G. Johnson, P. A. B. Widener, Benjamin Altman, and Samuel Kress, who lived with their art, Henry Walters acted like a stranger to the Italian paintings he acquired. He kept for himself none of the paintings he purchased from Massarenti. Not a single painting by an Italian Renaissance artist is known to have graced Walters's elaborately decorated homes in New York City and Wilmington, North Carolina. Rather, they all were destined to be housed in Baltimore in the Italianate museum he built but rarely visited and to be viewed primarily by later generations he would never meet.

When Walters opened his new museum to the public in 1909 and displayed for the first time his collection of Italian paintings, he, like Massarenti before him, pretended that the collection was rich with paintings by Botticelli, Caravaggio, Correggio, Duccio, Ghirlandaio, Giotto, Leonardo da Vinci, Masaccio, Michelangelo, Perugino, Raphael, Guido Reni, Andrea del Sarto, Tintoretto, Titian, Verrocchio, Veronese, and other Italian masters. Among the paintings by these masters, the two that Walters touted most highly were self-portraits allegedly by Raphael and Michelangelo (figs. 2 and 3). If the attributions had been true, these paintings would have crowned the best of collections. Although Walters doubted the accuracy of these attributions, he was willing to sacrifice candor and suspend objectivity in favor of the accolades and fanfare that the names of these famous artists would likely bring to the museum and add to the legacy of the Walters' name.

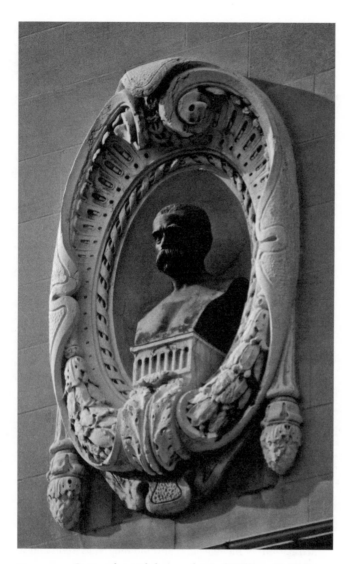

FIGURE 1. Cartouche with bronze bust of William T. Walters. The cartouche was placed over the main entrance of the Walters Art Gallery in 1909 at the time of the museum's grand opening. Photograph by author.

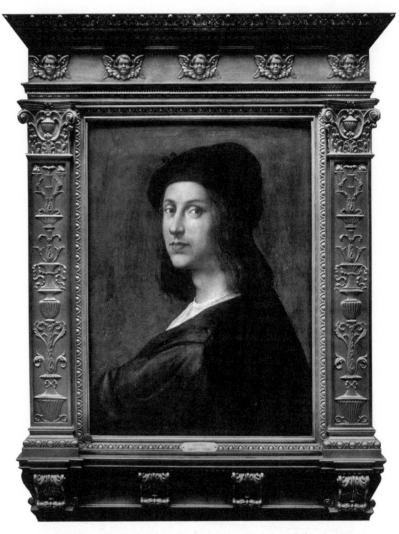

FIGURE 2. *Self-portrait at the Age of 25*, attributed by Massarenti and subsequently by Walters to Raphael, downgraded and reattributed to the Florentine School, sixteenth century, as *Portrait of Raphael*. Oil on panel, 24½ × 18½ in. WAM 37.483. The portrait was considered by Massarenti as the jewel of his collection. Walters adopted Massarenti's attribution, and at the grand opening of the Walters Art Gallery in 1909, Walters proudly claimed that the painting was "Raphael's own portrait from his own studio." Photograph WAM Archives.

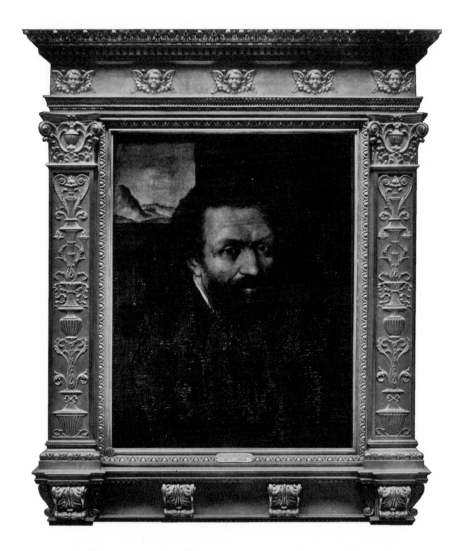

FIGURE 3. *Self-portrait*, attributed by Massarenti and subsequently by Walters to Michelangelo, downgraded and reattributed to the Central Italian School, late sixteenth century, as *Portrait of Michelangelo*. Oil on panel, 25½ × 19½ in. WAM 37.487. Massarenti claimed that this painting was "the only and unique portrait of this master." In the catalogue prepared for the grand opening of the Walters Art Gallery in 1909, Walters called this painting "His Own Portrait" and claimed that it, like Raphael's self-portrait, came "from his own studio." Photograph WAM Archives.

The pretense had its immediate rewards. The *New York Times* called the Walters collection "magnificent."[12] The museum was hailed as "the greatest gallery in America" and described as a "great temple of art."[13] Walters's reputation as America's new Medici soared. His collection attracted the interest of dignitaries across the country, including Bernard Berenson, the world's leading connoisseur of Italian Renaissance painting, who hoped to add Walters to the illustrious list of American millionaires who had become his clients.

To recruit Walters into his fold, Berenson made an irresistible offer. He proposed to analyze Walters's massive collection of Italian paintings, to verify the attributions, and to distinguish the good paintings from the bad. Most importantly, he offered to write a handsome and scholarly catalogue that would illustrate and trumpet the virtues of Walters's important Italian Renaissance paintings and that would be distributed on both sides of the Atlantic for cultured people everywhere to read. Moreover, Berenson offered to provide these invaluable services without demanding any monetary compensation in return.

In essence, what Berenson proposed to lend to Walters's collection of Italian paintings was his name, a name that was synonymous with scholarship. By the beginning of the twentieth century, the *sine qua non* of any serious collection of paintings, public or private, was scholarship. This was the quality that the Walters collection of Italian paintings seriously lacked. Despite its fanfare, it was a collection of Italian paintings that had, at best, a fragile provenance, no documented history, and no imprimatur from any recognized authority. It was a collection that violated the cardinal rule espoused by Berenson that "every painting purchased for a . . . great museum should be of overwhelming and indispensable authority."[14] The imprimatur of scholarship was what was missing from Walters's collection of Italian paintings and what Berenson, more than anyone else in the world, could provide.

Walters, however, was wary of Berenson. Although Berenson's stamp of approval was invaluable, Berenson was also notoriously unpredictable in how he would grade a work of art. He could bury a painting as easily as praise it. In evaluating Berenson's offer, Walters had to weigh the pressing need to attach a credible badge of authenticity to his sizable collection of Italian paintings against the risk that Berenson's assessment, like a boomerang, could do more damage to the collection than good. Walters also understood that the motivation for Berenson's proposal was not purely academic. Berenson was not only a famous connoisseur but also a profit-driven merchant in culture whose dichotomy of worldly, aesthetic interests and personal, business interests had been known to conflict. Walters understood that Berenson expected him to become his client,

to begin purchasing expensive paintings from him, and in this manner to compensate him well, albeit indirectly, for his service. Walters weighed the benefits and potential detriments of Berenson's proposal for two months before accepting it.

As revealed in their extensive correspondence of more than sixty letters, Walters and Berenson developed a warm and personal relationship that appeared to transcend the harsh realities of the commercial art market. For three years, each spring, Berenson wined and dined Walters at I Tatti, Berenson's beautiful villa located in the Tuscan hills overlooking Florence. Even for a person as wealthy, cultivated, and worldly as Walters—who was among the richest men in America, who controlled the country's largest railroad, who was an influential trustee of New York's Metropolitan Museum of Art, who could go anywhere and buy almost anything he wanted, and who circled the earth aboard his luxurious yacht in search of worldly treasures—to be Berenson's guest at I Tatti was an extraordinary experience. The rare pleasure of being courted by Berenson at his beautiful Florentine estate was succinctly expressed by Walters in a letter of appreciation: "I really do not believe that I have enjoyed anything more in my life than I did the month spent in Italy last summer."[15]

Walters was seduced by Berenson's charm, extraordinary intellect, connoisseurship, and savoir-faire. He purchased more than thirty Italian Renaissance and Baroque paintings from Berenson, and he promised Berenson that he would be governed by his advice and directions. By the summer of 1912, he had become Berenson's most active client. But shortly thereafter Berenson's courtship of Walters ended and their relationship dramatically changed. Behind Walters's back, Berenson had entered into a lucrative, secret contract with the controversial art dealer Joseph Duveen which required Berenson to offer all first-rate Italian paintings to Duveen and his clients before offering them to other collectors like Walters. The contract, like an invisible fence, restricted Walters's access to the best paintings in the marketplace. Walters instinctively pushed back. He conveyed to Berenson that he had neither the time nor resources to purchase more Italian paintings from him. He left many of the Italian paintings that had been sold to him by Berenson in the bowels of his gallery uncrated, unseen, and for years unappreciated. He turned his attention to the acquisition of other forms of art from all ages and across all cultures. And his collection of Italian paintings became like a small wave in a vast sea of art that began to inundate his gallery.

In March 1914, when the prospect for continued business with Walters had become secondary to the profits he was obtaining from Duveen, Berenson visited

the Walters Art Gallery to complete the mission, undertaken four years earlier, of assessing the quality of Walters's collection of Italian paintings. It was an evaluation that Walters had asked for but painfully would never forget. It illustrated Berenson's facility to move from the comforting language of flattery expressed when courting a client to the icy criticism of connoisseurship for which Berenson had become notorious when examining the art of a stranger. During the course of one week, Berenson, as if on a mission to exorcise the devil, plowed through the collection of Italian paintings that Walters had purchased from Massarenti, sweeping away countless forgeries of old-master paintings as if they were yesterday's trash, and changing most of the attributions. "Berenson weeded out right and left," read one newspaper report.[16] In light of Walters's prior claim that he had acquired a parade of world-class Renaissance masterpieces, Berenson's contrary assessment was an embarrassing turn of events. It chilled Walters's interest in venturing much further into the risky market for Italian art. Worse yet, as he revealed to Berenson, it stymied his interest in improving and reopening his gallery to the public during his lifetime. The doubt raised about the quality of Walters's collection of Italian paintings was compounded two years later when Berenson, in a book about American collections of Venetian art, sharply criticized some of Walters's paintings. As if indifferent to the harm this would cause to Walters's reputation as a collector and to the collection itself, Berenson ridiculed several of the Venetian paintings Walters had acquired from Massarenti as being by "tenth rate" artists.[17]

Although unappreciated by Walters at that time and overlooked by scholars until now, Berenson's criticism did more than merely cut away at the attributions and the paintings that he believed lacked merit. Berenson transformed the very character of the entire Italian painting collection. What ultimately emerged as a result of his criticism was a collection that had been shorn of pretension and replaced by an array of notable paintings by outstanding although lesser-known artists that effectively conveyed the history of Italian Renaissance and Baroque painting over the course of four hundred years. It was a triumph of scholarship over embellishment, and it established an exacting standard of professionalism that has remained the hallmark of the Walters Art Museum. Today the museum's collection of Italian Renaissance and Baroque paintings stands as one of the finest of its kind in the United States.[18]

The story of Walters, Berenson, and the Massarenti collection evokes the pleasures and perils of collecting Italian Renaissance paintings during America's Gilded Age. It was a time when copies of paintings purportedly by Renaissance masters flooded the market, when the identities of the actual artists were as

clouded as the constellations on a stormy night, and when the ethics of the marketplace were as hard to define as the tenets of the Dead Sea scrolls. It was a time when, due to all of these ambiguities, the acquisition of an Italian Renaissance painting, as Walters painfully learned, was fraught with uncertainty and the ancient warning of caveat emptor was implicit in every sale. What bound Don Massarenti, Henry Walters, and Bernard Berenson together was not simply their passion for art and their respective roles in the sale, acquisition, and improvement of the same massive collection of Italian paintings, but their eagerness to capitalize on the ambiguities and risks that were endemic in this cultural field at that time. Just as Massarenti and Walters in succession shaded the truth about the attributions in the collection, Berenson repeatedly danced around the truth involving his own obligation to improve it. He overstated the quality and condition of many of the paintings that he sold to Walters, he pretended to be making progress on Walters's catalogue when in reality he had placed this project aside, and he concealed from Walters his ethically questionable contract with Joseph Duveen, by which Walters's interests had been rendered secondary to Berenson's personal greed.

All of this dissembling took its toll. After becoming painfully aware of the fragility of Berenson's devotion to his interests, Walters in 1917 formally severed their dealer-client relationship and purchased no more paintings from him. As if to obscure Berenson's important role in transforming his collection, Walters removed from his library the books that Berenson had authored, retained no coherent record of the paintings he purchased from Berenson, discarded most of the letters he received from Berenson, and scrubbed the Berenson name from the annals of the Walters Art Gallery as if it were a four-letter word. As a result of these actions, scholars until now have been left in the dark about the significant influence that Berenson had on Walters's collection of Italian paintings.

Toward the end of their lives, both Berenson and Walters looked back with regret on the events that had interrupted their earlier dreams. Berenson, in a highly publicized book of self-criticism, lamented his decision to sacrifice the demands of independent connoisseurship and the loyalty that he owed to his friends and clients for the wealth he acquired through his uneasy alliance with Duveen. Walters regretted his inattention to the collection of Italian paintings that once had been his source of pride. In a will prepared in 1922, Walters expressed his intent to leave his gallery and art collection to the people of Baltimore. It was a bequest of unprecedented generosity. But thereafter Walters did little to nurture the collection he planned to leave behind. He rarely traveled to Baltimore to visit it. When the gallery's part-time curator died, Walters decided

not to replace him. The gallery's skylights were shrouded in canvas, and, except for a few days each spring, the gallery was left dark, depressing, and ordinarily off limits to the outside world. It began to function more as a depot for the storage of art than as a cultural palace in which to enjoy it. Without the attention of any curator or artistic director, Walters's gallery and his once revered collection of Italian paintings lost its élan and simply vanished for many years from the consciousness of America's cultural elite and of art lovers everywhere. Along with the discarded paintings once attributed to Michelangelo and Raphael, Walters's dream of honoring his father and glorifying the Walters name through the publication of a scholarly catalogue written by Berenson escaped his grasp and, as we shall see, troubled his conscience for years to come.

II

BERENSON'S
MISSION

Forty years before Henry Walters brought the Massarenti collection to America, the cultural channel between Italy and the United States was opened by James Jackson Jarves, an adventurous intellect of the first order who became this country's earliest connoisseur, collector, and promoter of Italian Renaissance paintings. For thirty years during the second half of the nineteenth century, Jarves lived in Italy, serving briefly as America's vice-consul to Florence, writing extensively about Renaissance art, and collecting a significant number of paintings by Italian masters, including Gentile da Fabriano, Antonio del Pollaiuolo, and Domenico Ghirlandaio. As if engaged in a scavenger hunt, Jarves's discovery of Italian masterpieces, according to his own account, involved "miles upon miles of wearisome staircases; dusty explorations of dark retreats; dirt, disappointment, fraud, lies and money often fruitlessly spent" and, on one occasion, the purchase of an entire gallery of two hundred paintings to obtain nine that were worthwhile.[1] This, of course, was what Henry Walters, in purchasing the Massarenti collection, hoped to avoid.

Jarves's collection of Italian paintings was exhibited from 1860 to 1863 in New York, initially at the Institute of Fine Arts and then at the New-York Historical Society. (The Metropolitan Museum of Art did not open until 1870.) Although initially greeted by the American public with skepticism, Jarves's collection ultimately was acquired by the Yale School of Fine Arts in 1873, where it remains today. Thereafter, Jarves returned to Italy and purchased fifty-four additional Italian paintings, including paintings by Guido Reni and Filippo Lippi, which were sold in 1884 to Liberty Holden of Cleveland and today reside at the Cleveland Museum of Art.[2]

Jarves's influence on America's nascent interest in collecting Italian paintings in the 1870s and 1880s was primarily marked not through the exhibition of his own collection of art but through his writings. In 1883, Jarves wrote "A Lesson for Merchant Princes," an essay expressly addressed to the wealthy, upper-class businessmen of America, whom he flatteringly characterized as "princes" and compared, in their "social distinctions . . . and riches" to fifteenth-century Florentines.[3] In his essay, Jarves proposed that America's merchant princes should seek to emulate the life of Giovanni Rucellai, a wealthy Florentine merchant who, following the scholarly advice of Marsilio Ficino and with the political blessings of Cosimo de' Medici, personified the best ideals and values of the Italian Renaissance. According to Jarves, Rucellai was a sagacious, cosmopolitan, and socially engaging patron of the arts. He resided in a palace that was a veritable museum, containing pictures by Filippo Lippi, Verrochio, Uccello, and Veneziano. But most importantly, according to Jarves, Rucellai used his wealth, his influence, and his love of art for the public good, employing the famous architect Leon Battista Alberti to construct beautiful structures throughout the city of Florence, including the façade of Santa Maria Novella. In concluding his essay, Jarves offered to the new "Merchant Princes" of America the following advice:

> If we are to build up on American soil cities like Florence, world-renowned for art and science even more so than for commerce, we must breed merchant princes cultured like Rucellai, and [become] deeply imbued with his maxim, that it is pleasanter and more honorable to spend money for wise purposes than to make it.[4]

It is not known whether Henry Walters actually read "A Lesson for Merchant Princes" or was familiar with the life of Rucellai, but the pattern of Walters's interests and activities aligned so closely to the idealized life of that Florentine prince that Walters likely was influenced, albeit indirectly, by him.

America's fascination at the turn of the century with the Italian Renaissance was also kindled by the poetic writing of Walter Pater. In his essays on Botticelli, Leonardo, Michelangelo, and Winckelmann, which appeared in his book, *The Renaissance*, Pater wrote that the importance of the Renaissance was not as a static event in cultural history marked by time and place but as a moveable spirit that could resurface again and again wherever curiosity combined with a love of beauty.[5] Although written for a literary audience in England, Pater's book was embraced in the United States by connoisseurs, collectors, and other lovers of Italian art. In 1888, Bernard Berenson recommended the book to his client Isabella Stewart Gardner, writing to her that "many a midnight, in coming home,

I took up *The Renaissance* and read it from cover to cover."[6] Under the spell of Pater's ideas, Berenson left Harvard to study under Pater at Oxford and to become one of Pater's most prominent disciples.[7]

While Jarves was the pioneer and Pater the laureate of the Gilded Age phenomenon of wealthy Americans collecting Italian art, Bernard Berenson, more than anyone, became its principal evangelist. Using his extraordinary intellect, impeccable scholarship, and entrepreneurial skills, Berenson convinced wealthy Americans to embark on a shopping spree for Italian Renaissance paintings that would last for a generation.[8] By the 1890s, the center of the commercial world had shifted from London to New York, and European art dealers, like Duveen and Wildenstein, opportunistically opened New York offices to capitalize on the potential for new business. The burgeoning wealth in America during this period coincided with an economic depression in Italy, resulting in an increased availability of Italian Renaissance art that was placed on the market by financially strapped Italian families. Bernard Berenson, who was by then the preeminent connoisseur of Italian Renaissance paintings, shrewdly took advantage of this situation. While writing four volumes on the Italian painters of the Renaissance (*The Venetian Painters of the Renaissance, The Florentine Painters of the Renaissance, The Northern Italian Painters of the Renaissance,* and *The Central Italian Painters of the Renaissance*), which deferentially have been referred to as his "Four Gospels," Berenson adopted the goal of converting America's cultural landscape into a vast repository for Italian Renaissance painting.[9] More specifically, he wrote that his "mission was to send [to the United States] as many Italian works of art (and incidentally others too) as I could persuade collectors to acquire."[10]

Berenson developed three sources for finding and then facilitating the transfer of hundreds of Italian Renaissance paintings into the collections of his wealthy American clients. The first source comprised untold numbers of Italian runners, middlemen, and dealers who scoured the churches and estates in the Italian countryside in search of old paintings and who brought their findings to the Villa I Tatti on virtually a daily basis.[11] Second were Berenson's acquaintances in the English and other European aristocracy who owned desirable Italian Renaissance paintings and, in light of the active American market and escalating prices for these paintings, were quite willing to part with them for the right price. The third source comprised international dealers in Italian Renaissance art, principally the London dealer Colnaghi and Company, with whom Berenson was associated from approximately 1896 to 1906, and Joseph Duveen, with whom Berenson was closely tied from approximately 1912 to 1936.

By the turn of the century, Berenson's reputation as the foremost scholar of Italian Renaissance art was well known by wealthy Americans who were attracted to the prospect of owning Italian old-master paintings. His essays on Italian painting reportedly were in the libraries of Henry Walters, Isabella Stewart Gardner, and Peter Widener, who all eventually numbered among Berenson's elite clientele.[12] To capitalize on his reputation and to attract American millionaires to purchase Italian paintings through him or to seek his valuable imprimatur regarding the paintings' authenticity, Berenson offered not only his knowledge and sophistication but also a variety of social and intellectual enticements. Berenson would invite clients to visit him and be wined and dined at I Tatti, his elegant, thirty-acre estate outside of Florence. To American millionaires like Walters, this amounted to a very special occasion—an opportunity to hobnob with members of European royalty and other luminaries, like the writers Edith Wharton and Marcel Proust, the art historians Roger Fry and Kenneth Clark, the economist John Maynard Keynes, and the American jurist Learned Hand; to participate with a small group (usually eight) of such intellectually gifted dinner guests in discussions that ranged from art to literature, philosophy, ethics, history, and politics; to linger in Berenson's beautifully manicured garden or stroll with him along the pathways lined with cypress and pine in the hills of Settignano overlooking Florence; to pause in his library and browse through the volumes Berenson had read or written and to gaze at his remarkable collection of photographs of Italian Renaissance paintings; and, with Berenson's personal guidance, to examine the paintings he collected and made available for sale.[13] As described by one visitor, "To be with him was to realize, once for all, what was meant by the art of looking."[14] Berenson was well aware of the exhilarating, spiritual effect that the atmosphere of I Tatti had on his guests. He once stated that "this house has a peculiar effect on people . . . It makes them behave as if they were in church."[15]

Berenson also would visit the collections of his clients in America, differentiating the great from the mediocre paintings and identifying the rank copies that should be discarded. Like a magician with a magic wand, Berenson would approach a painting, stare intently at it, tap its surface, and, after a pause pregnant with anticipation, disclose the name of the artist.[16] Despite such displays of legerdemain, Berenson's colleagues and patrons knew that the real basis for his attributions was, as Roger Fry once observed, "a summing up of innumerable aesthetic judgments on the work in question . . . [and] all the aesthetic experience that has led up to it."[17] Invariably, Berenson's visits concluded with his suggestion that the overall quality of the collection could be improved by ac-

quiring paintings from him. To reinforce this promise, Berenson would refer favorably in his essays and books to the paintings purchased by collectors from him.[18] Finally, he would offer to help his potential clients compile and publish catalogues illustrating the paintings in their own collections, which would include his description and, by implication, his valuable endorsement of them.[19]

To augment this marketing campaign, the dealers favored by Berenson would return the favor by publicly praising Berenson's extraordinary visual knowledge and the value of obtaining his imprimatur when purchasing a painting. For example, Joseph Duveen purportedly counseled his clients to "never buy an Italian picture without a Berenson approval! Never!" Thus, by combining his knowledge as a connoisseur of Italian art with his sophisticated, entrepreneurial talent, Berenson became, as David Alan Brown has observed, the greatest "connoisseur-dealer" of all time.[20]

Berenson's first American patron was Isabella Stewart Gardner. "If you permit me to advise you on art matters," Berenson proposed, "it will not be many years before you possess a collection of almost unrivalled—of masterpieces, and masterpieces only."[21] Between 1894 and 1903, Gardner, based on Berenson advice, spent over one million dollars and acquired from either the London dealer P. & D. Colnaghi & Co. or directly from the owners of the paintings a succession of Italian masterpieces, highlighted by Titian's *Rape of Europa*, a painting that originally was commissioned by Philip II of Spain and that was famously copied years later by Rubens. Gardner's acquisition of Titian's painting is credited with generating a groundswell of interest among America's new millionaires in purchasing Italian Renaissance art.[22]

Berenson, like other art connoisseur-dealers at that time, had a legitimate right to be well compensated by his clients for the use of his knowledge and service in obtaining and/or authenticating old-master paintings. Despite the absence, at that time, of any codified standards governing the relationship between the purchasers and the connoisseur-dealers of cultural property,[23] Berenson's clients had a correlative right implicitly derived from common law to expect Berenson to act in good faith and to deal fairly with them. Early in his career as a connoisseur-dealer, Berenson began to breach this fundamental obligation. Without informing his clients, Berenson clandestinely began accepting and later requesting compensation from the dealers to whom he referred his clients. This practice began in the 1890s when Berenson began accepting from the art dealer Colnaghi a share of the profits obtained from the sale of paintings that Berenson had recommended to Gardner.[24] Although Berenson was indebted to Gardner for helping to launch his career, he was not candid with her about this

conflicting arrangement. Troubled by rumors of Berenson's double-dealing and concerned that Berenson was overcharging her, Gardner placed these issues squarely before Berenson in a letter: "*They* say (there seem to be many) that you have been dishonest in your money dealings with people who have bought pictures."[25] Berenson was able to dodge this attack and retain Gardner's patronage by disingenuously blaming any discrepancies related to pricing on Colnaghi.[26] The conflicts that threatened Berenson's relationship with Gardner foreshadowed the ethical conflicts that arose in his later dealings with Walters.

When in the early 1900s Gardner's patronage of Berenson began to decline, Berenson and his wife Mary embarked on a six-month tour of the United States with the aim of enticing America's new millionaires to purchase Italian Renaissance art and to rely upon Bernard Berenson as the quintessential guide for doing so.[27] From October 7, 1903, to March 15, 1904, the Berensons visited New York, Boston, Chicago, Detroit, Cleveland, Pittsburg, Philadelphia, Baltimore, and Washington, D.C., meeting with cultural leaders, including the trustees of the Metropolitan Museum of Art; dining with bankers, industrialists, and the ranking members of America's moneyed aristocracy; and examining the art they had collected. The Berensons were aghast at the Dutch landscapes and French Barbizon school paintings that populated private and public collections in the United States at that time.[28] They privately felt that the paintings at the Metropolitan Museum of Art represented a "vast collection of horrors." They visited the Walters collection of French paintings in Baltimore (the recently purchased Massarenti collection was in a warehouse in New York at the time) and similarly concluded that there were "horrors everywhere." And after viewing the paintings in the collection of Peter Widener in Philadelphia, Mary Berenson wrote that they were the "rottenest we have yet seen."[29] To avoid alienating these potentially important clients, Bernard Berenson at that time diplomatically refrained from expressing his critical opinions about the art they collected.

The Berenson's venture into the potentially lucrative art market of the United States was for them an unqualified financial success. Midway through their tour, Mary Berenson predicted that, "with so many fish biting at our hooks, it will be odd if we don't haul some to shore."[30] Her prediction was on target. In Philadelphia, Bernard Berenson successfully courted John G. Johnson, who shortly thereafter became a major client. While in Philadelphia, he met Peter Widener, who, along with his son Joseph, joined the ranks of Berenson's clients in 1914 and whose great collection was later given to the National Gallery of Art. While in New York, Berenson cultivated William Laffan, who was a highly influential advisor to J. Pierpont Morgan and other powerful members of New

York's cultural elite and who, in 1910, was instrumental in obtaining for Beren-son the patronage of Henry Walters. As if to punctuate the success of Berenson's mission to America, in March 1904, the Ehrlich Galleries of New York mounted the first commercial exhibition of Italian Renaissance paintings in this country. This "novel" exhibit, as described in the *New York Times*, reflected the influ-ence of Berenson and indicated that "the pendulum seems to be swinging again towards the old Italians."[31] Looking back on Berenson's mission to America, Ernest Samuels, Berenson's principal biographer, has observed that "the Ameri-can tour made [Berenson] the most widely known expert in Italian Renaissance art that the world had seen."[32]

Unlike other wealthy art collectors who were eager to gain the acquaintance of Bernard Berenson during his trip to the United States in 1903 and 1904, Henry Walters initially kept his distance. Walters did not seek Berenson's advice when purchasing the Massarenti collection of Italian paintings in 1902. And when Berenson visited the United States in 1904, Walters did not invite him to inspect this collection, which, at the time, was warehoused in New York. Nor did he personally greet Berenson and his wife, Mary, when they visited the Walters Gallery in Baltimore in February 1904. Perhaps he had heard rumors, already circulating in the art market, about the unethical, dark side of Berenson and the growing list of people who disliked him.[33] Or, as has been speculated, Walters might have heard that Berenson had already seen the Massarenti col-lection in Rome and had expressed his disapproval of it.[34] As we shall see, it was not until 1909, after Walters opened his Italianate art gallery in Baltimore and publicly displayed for the first time his Massarenti collection, that Walters and Berenson became personally acquainted.

WALTERS'S CULTIVATION

Among the American millionaires who began collecting Italian art in the late 1890s, Henry Walters was perhaps the most cultivated. He was raised in a sophisticated environment of wealth and privilege where art collecting was a way of life. His father, William T. Walters, initially earned his fortune as a dealer in domestic and imported wines and spirits but expanded his business interests into transportation, becoming a controlling director of the Northern Central Railway Company which, after various mergers, ultimately became the powerful Atlantic Coast Line Railroad. William Walters's business interests also expanded into banking, and he became a founder and director of the Safe Deposit Company of Baltimore, the predecessor of the Mercantile Bank.

William Walters's passion for collecting art began in 1841, at the very beginning of his business career, leading to the legendary claim that "the first five dollars he earned was spent on a picture."[1] His interest in art, however, was not just for art's sake. The art he collected was also utilized by him to promote the interests of the public. According to William Walters, the source of his combined interests in art and public service was his mother, who cautioned him at a very young age not to concentrate all of his attention on business. Instead, she urged him to channel his intellectual energy toward the creation of a public art collection. This, she advised him, "will keep your mind flexible and your soul alive."[2]

In the 1850s, William Walters began collecting contemporary American paintings by such artists of the Hudson River school as Asher B. Durand, Frederick Church, and John Kensett, evidencing a discerning taste for the most prominent artists in the United States at that time, of whom Kensett was his favorite. William Walters's praise of this artist as well as his own refined appreciation of

his art is reflected in a sentimental letter to Kensett: "There is poetry of art, as well as letters—and there is no art without it—and that poetry of yours has gone most deeply in my heart where you have spoken in the plainest and most clearly defined words—for certainty—trees-mountains-Rocks-air . . . are the artists' poetic words."[3]

In 1861, with the advent of the Civil War, William Walters, who sympathized with the interests of the South, left the United States for France and, with his wife, Ellen, his thirteen-year-old son, Henry, and his daughter, Jennie, resided in Paris. Walters felt culturally at home in France, having developed a passionate taste for French art. Two years earlier, in 1859, he had purchased ten paintings from French and Belgian artists, including a version of Gérôme's *The Duel after the Masquerade*, which became one of his favorite paintings and a gem in his collection. After arriving in Paris, William Walters, who was often accompanied by his son, Henry, became immersed in French art, frequenting the studios of artists and studying the masters at the Louvre. Following the sudden death of his wife in 1862, Walters delved further into the French art market, purchasing paintings by Theodore Rousseau, François Daubigny, and Jean-Baptiste Corot, as well as sculpture and watercolors from Antoine-Louis Barye.[4]

By the time Walters had returned to the United States after the Civil War, he had become a devoted patron of contemporary European paintings, especially Barbizon school and French academic paintings. The importance of his collection was reflected in Walters's purchase of *1814*, a classic depiction of Napoleon on horseback directing his troops in battle, by Ernest Meissonier, whose meticulously prepared paintings were then considered to be the best, most sought-after, and expensive in France.[5] In the 1880s, Walters also added to his collection Delacroix's *The Collision of the Arab Horsemen* and *Christ on the Sea of Galilee*, two important paintings belonging to the French romantic school. Although his collection was devoid of paintings by Michelangelo, Raphael, Rubens, Rembrandt, and other old masters, the quality of his nineteenth-century contemporary paintings was extraordinary for an American collector, leading one critic to observe that Walters "has gathered impartially the finest works of the French, English, Belgian and German artists now living or recently deceased, and has with perhaps few exceptions the best representations of each school and individual."[6] In the 1870s, Walters also became an enthusiastic buyer of Asian art, especially Chinese and Japanese porcelains. His goal was not simply to expand the collection, which included more than three thousand objects, but to improve it by judiciously pruning work of questionable merit in favor of better examples.[7]

To display his burgeoning collection, Walters converted his home at 65 Mount Vernon Place in Baltimore into a private museum, with a picture gallery stacked with paintings in the style of a French salon of the Second Empire. Walters was not shy about publicizing the collection and showing it off. He invited artists and art critics to visit his collection and to write about it. He hosted extravagant parties for foreign dignitaries and members of America's upper crust to see the collection and, through the catalogues he prepared, to be reminded of its overall quality. Beginning in 1878, William Walters also permitted the public to visit his private museum each spring. He charged an entry fee of fifty cents, which he collected for the benefit of the Baltimore Association for the Improvement of the Conditions of the Poor; over the years, these fees amounted to more than $125,000.[8]

As a result of Walters's efforts to promote his collection and his generosity in making the collection accessible to the general public, it became widely known and highly praised. It was, at that time, considered one of the most important private art collections in the United States. In *The Art Treasures of America*, published in 1879, Walters's collection was referred to as "an educator of taste not to be excelled in the New World."[9] In 1889, the *Magazine of Western History* described the Walters painting collection as "the finest collection of paintings— the most informing—in this country."[10] In 1892, the *Magazine of American History* described in the following superlative terms the importance of the Walters collection:

> There is no art collection, public or private, accessible to the people of this country where so many real treasures may be enjoyed, and no private art collection in any quarter of the world of such munificent proportions and genuine value. It is veritably a connoisseur's collection, or rather, as we have seen, it is a connoisseur's collection of collections—a masterly triumph in the art of collecting.[11]

In 1894, *Harper's Weekly* called Walters's collection "one of the finest private art collections in the world."[12] Although the quality of William Walters's collection has been obscured by time and superseded by the more ambitious and far more extensive collection of his son, Henry, William Walters's collection, in its time, had an incomparable reputation in the United States and, in terms of quality, remained as a model for his son to emulate.

In evaluating the factors that ultimately led to Henry Walters's acquisition of the Massarenti collection, it would be impossible to overestimate the lasting influence of his father. Henry Walters stepped into a life of considerable wealth,

economic power, and cultural sophistication. Yet the path he chose to follow as a patron of the arts was not in the familiar footsteps of his father but instead in a different, more adventurous cultural direction where the stakes were higher and where he could establish an identity and reputation of his own while at the same time memorializing his father's prior accomplishments.

Although his father's cultural legacy was grounded in Baltimore, Henry Walters aspired to use his wealth and culture to enter the elite circle of the Medicean princes of New York, his adopted city, where he would spend the last forty years of his life and serve as an influential member of the Board of Trustees and vice president of the Metropolitan Museum of Art. Walters thus became an enigmatic man of two cities, living primarily in New York, where his home, family, social circle, and business office were centered, while becoming, *in absentia*, the cultural prince of Baltimore, where his growing art collection was shipped but rarely examined by him. Unlike a proverbial Renaissance prince, who in the privacy of a small *studiolo* would lovingly surround himself with precious books, sculpture, and paintings for his own study and contemplation, Henry Walters's relationship with his cultural treasures was attenuated by time and space, and consequently, as one critic has observed, "One cannot judge how well Henry Walters—who resided in New York—knew his fine collection, or had the opportunity to enjoy it."[13]

Born on September 26, 1848, Henry Walters was initially educated in Baltimore but at the age of thirteen moved with his family to Paris, where he completed his high school education and acquired a proficiency in French that was matched by his early appreciation of the visual arts. William Walters, it is reported, not only took his son hand-in-hand to the galleries and museums of Paris but also required his son to write thoughtful essays on the subject.[14] After returning to the United States, Henry Walters enrolled at Georgetown College in Washington, D.C., where he obtained a Jesuit education, rich in the humanities, philosophy, and classical literature. After graduating from Georgetown in 1869, he attended graduate school in Cambridge, Massachusetts, at Lawrence Scientific School, a division of Harvard, where he studied engineering for three years and later received a Bachelor of Science degree.[15]

After completing his formal education, Henry Walters joined his father's banking and transportation business in Baltimore, and their relationship changed, in the words of biographer William R. Johnston, "from a paternal-filial relationship to one of companionship and friendship." It was not just business, however, that tied them together. In 1873, William and Henry traveled together to Europe,

spending five months in France and taking side trips to Italy, London, Belgium, and Switzerland.[16] Eventually, Henry Walters became a junior partner in the family's business and cultural ventures.

The new, mature relationship between father and son was evidenced by the wording on a formal invitation sent to 125 prominent guests from New York, Washington, and Baltimore inviting them to the grand opening on March 6, 1879, of the Walterses' expanded collection. The invitation for this event was not from William T. Walters alone but instead from "Mr. W. T. Walters and his Son." The oblique reference in the invitation to Henry reflected his emergence, at the age of thirty-one, from his father's shadow and into an identity of his own.

In the spring of 1879, shortly after the grand reopening of his father's gallery, Henry Walters embarked by himself on a cultural odyssey to the great centers of art in Italy, France, and England. From May 9 to May 23, Walters for the first time immersed himself in Italian Renaissance painting, sculpture, and architecture. Using Baedeker's scholarly *Italy: Handbook for Travellers* as his guide, Walters spent a week in Florence, five days in Venice, and two days in Milan.[17] As evidenced by a thirty-six page notebook in which he thoughtfully recorded his observations, Walters was no mere dilettante going through the motions of the Grand Tour but a serious and inquisitive student of Italian Renaissance art. What caught his eye in Florence was a panel in Ghiberti's *Gates of Paradise* in which a female figure balanced a "vase on her head from which grows scrolls, flowers, birds and at top angels"; in Giotto's Campanile, "the light and airy construction"; at San Miniato al Monte, the "beautiful marble choir screen encrusted with marbles and scrolls, flowers and rosettes in relief"; and at Santa Maria Novella, "the length of the nave enhanced by gradually diminishing distances between the pillars from 49 to 37 feet." In Venice, Walters's interest in architecture was reflected in his comments about the interior of Saint Mark's Cathedral, which "carries out its [oriental] conception," and the colonnaded interior of Saint Maria del Salute, "with its two systems of columns, one for the Dome and the other for the arches."[18]

Among all of the artistic wonders of Florence and Venice, Walters's favorite place was the Tribuna in the Uffizi Gallery. It was, according to his notes, the place he returned to in order to see "the things I wanted to see" and to enjoy the pure pleasure of its cultural treasures. The unusual, octagonal Tribuna was constructed in 1583 at the direction of Grand Duke Francesco I for the purpose of exhibiting his collection of rare and marvelous objects of art, science, and nature. Like other *Wunderkammer* designed by princes during the late sixteenth and early seventeenth centuries, it was intended to evoke a sense of wonder and

to demonstrate the breadth of Francesco's intellectual curiosity and far-reaching knowledge. The Tribuna subsequently was converted into an art gallery for showcasing the gems of the Medici collection, and it became one of Italy's earliest and most remarkable private museums and a key destination for privileged tourists on the Grand Tour. In the late nineteenth century, at the time of Walters's visit, the Baedeker guidebook described the Tribuna as "a magnificent and almost unparalleled collection of masterpieces of ancient sculpture and modern painting." Among the masterpieces which were probably on display at the time of Walters's visit were the famous, classical sculpture of Venus then known as the *Medici Venus*; Titian's *Venus of Urbino*; Raphael's *The Madonna of the Bullfinch*; Michelangelo's *Tondo Doni*; and Andrea del Sarto's *Madonna and Child with Saint Francis and Saint John the Evangelist.*[19] It seems as though the seeds of Henry Walters's interest in acquiring a collection of Italian Renaissance masters, constructing an Italianate palace to house them, and displaying side by side remarkable paintings by Raphael, Michelangelo, and Andrea del Sarto were planted in Walters's mind at that time and place. Many years later, Bernard Berenson, perhaps at Walters's suggestion, referred to the "Tribuna" as the place in the Walters Italianate museum where his best paintings should hang.[20]

The value of Walters's notes made during his trip to Italy is that they tell us more about him than merely what he saw. They provide us with a rare glimpse of the qualities inside him that made him tick. Walters, throughout his life, was a secretive man. He wrote very little about himself. Rarely did he speak to the press. To our knowledge, he kept no personal diary in which he expressed any of the inner passions of his life. Other than his letters to Berenson and his usually curt letters of direction to the superintendent of his gallery in Baltimore, no correspondence, not even a note expressing his affection for his wife, exists to reveal his personal side. We know the details of his life primarily from the history of the grand monuments to art and business that he successfully built. But his notes written in Italy at the age of thirty-one reveal the unspoken romantic side of his personality and the things both prosaic and cultural that personally moved him. The notes express not only his interest in painting, sculpture, and architecture but also his interest in opera, which he eagerly attended, as well as his pleasure in the metaphors and similes of poetry. The notes also reveal that he was a man of letters who knew not only how to write but how to write well. Comparing the gloom of a dark and rainy afternoon in Venice with the beautifully clear and cool weather of the following day, Walters wrote: "I have never seen such a metamorphosis. The sun seems to have renovated the city. The dilapidation has entirely disappeared. The holes are filled with light and sunshine, and what in

the rain seemed blackness of age now assumes all shades of colors."[21] What emerges from these notes is the portrait of a sensitive young man whose powers of observation and passion for all manifestations of culture would in combination lead him to the pinnacle of art collecting by the turn of the twentieth century.

During the next several years, Henry Walters assumed more responsibility in shaping the Walters collection, traveling to London and Paris in the spring of 1879 to purchase Oriental art and returning to Europe in the winter of 1880–81 to purchase crystal in Vienna and watercolors and more Oriental art in Paris. In February of 1884, William Walters, having completed the conversion of his home into a museum, hosted another large gala, inviting diplomats from France, Great Britain, Italy, Germany, Japan, and China; prominent figures in Walters's ever-expanding business and cultural communities; and members of the New York, Philadelphia, and Baltimore press. In publicizing this event, William T. Walters not only recognized Henry's contribution to the collection but suggested that it belonged to him as well. The *Baltimore Sun* reported that "Mr. W. T. Walters and his son, Mr. Harry Walters, gave a reception yesterday on the occasion of opening *their* picture and Oriental galleries" (emphasis added).[22] The idea of joint ownership by father and son suggested in this article must have kindled within Henry a lifelong commitment to treat the collection not simply as his father's or later as his own but as "their" collection, a collection that would remain indistinguishable from his father's legacy and the Walters family name.

In the summer of 1884, Henry Walters left Baltimore, never to reside in the city again, and moved to Wilmington, North Carolina. The reason for Walters's move to Wilmington was to assume the post of general manager of his father's railroad, which was headquartered there. His success in managing this business was well recognized, leading one contemporary writer to observe that, "although young in years, he [Henry Walters] has had a large experience and has already acquired the reputation of being one of the best educated, most intelligent and practical railroad men in the country."[23]

Walters's move to Wilmington was a dramatic change in course that would essentially sever his social ties to Baltimore and lead to an unusual relationship with Pembroke and Sadie Jones, a wealthy, socially prominent couple whose marriage that same year was billed as the South's equivalent to a royal wedding.[24] Pembroke Jones was known for his unrestrained appetite for high living and his ambition to get "the utmost flavor out of life." Sadie Jones, the daughter of a wealthy U.S. congressman, surpassed even her husband in seizing all of the pleasures of life and enjoying the benefits of high society. Some even considered her as the second coming of Scarlet O'Hara.[25] With an annual budget of $300,000

to spend each year for entertainment, she captivated society in both the nation's capital and Wilmington with her lavish hospitality. With the assistance of an internationally renowned horticulturist, she developed at her Wilmington estate (known as Airlie-on-the Sound) a magnificent garden containing more than 600,000 multicolored azalea bushes, which she opened to the public each spring. She expanded the family mansion, adding thirty-eight guest suites to its existing twelve bedrooms and placing a covered tennis court in the middle of the house. It was in this mansion that Walters maintained a private office. Later, with Walters's encouragement, Sadie and her husband constructed on an adjacent property an Italianate lodge, which the Italian ambassador to the United States characterized as "the most perfect note of Italy in America."[26] The extravagance of the Joneses became legendary; and the adage "keeping up with the Joneses" was reportedly coined after them.

Shortly after arriving in Wilmington, Walters became acquainted with the Joneses, and then, through the magnetism of their wealth and fame, Walters moved into the Joneses' residence, and his personal and social life in Wilmington quickly became bound to theirs. Little is known about Henry Walters's interest, if any, in the opposite sex. During the many years that he resided in Maryland, there were no reports of any relationship, courtship, or interest in any young woman. The notes from his trip to Italy indicate that he spent his evenings with male friends. Simply stated, Henry Walters was not known to have had any close female friends during the first thirty-five years of his life. As a result, questions remain as to the focus of Walters's attraction to Pembroke and Sadie Jones.[27] In any event, the three became inseparable—traveling around the world together and later electing to live together as a *ménage a trois*, an unusual relationship that led some to refer to Sadie Jones as "the woman with two husbands."[28] With the Joneses by his side, Walters ascended to the top of the social and cultural worlds of both Wilmington and New York and to positions of prominence and cultural influence that would far exceed his father's earlier accomplishments.

In the 1890s, Walters's railroad opened an office in New York, and Henry Walters, in the company of Sadie and Pembroke Jones, began to reside there, living lavishly while ascending the social ladder to gain the acquaintance of similarly well-bred members of the upper class. He joined almost thirty exclusive social clubs in New York and elsewhere, which included the Metropolitan Club, the Manhattan Club, the Players Club, the Racquet and Tennis Club, the Atlantic Yacht Club, the New York Yacht Club, the Westminster Kennel Club, and the Zodiac Dining Club. He became a clubman, a yachtsman, a world traveler, and gourmand and made the acquaintance of other leading members

of New York society, like J. P. Morgan, who were privileged to live similarly self-indulgent lives. For close to ten years, from 1884 to 1894, while his social life expanded, his interest in collecting art remained quiescent, but that would soon change.[29]

In November 1894, William Walters died, leaving Henry an estate valued at $4.5 million (roughly equivalent to $110 million today), a valuable art collection, and the presidency of the Atlantic Coast Line Railroad. William Walters's death, however, did more than enrich his son monetarily. It was for Henry Walters a transformative event that seemed to reawaken his cosmopolitan spirit and to redirect his energies from the narrow pleasures of his self-indulgent flirtation with high society to more noble objectives. Henry Walters's renewed interest in world culture was demonstrated by his influential role in helping to establish the American Academy in Rome. In 1897, Henry Walters joined the academy's small board of trustees and launched a campaign to raise an endowment of $750,000. Besides contributing $50,000 to the campaign, Walters convinced J. P. Morgan to join him in issuing a public appeal for financial support. The central idea expressed in the appeal was reminiscent of Jarvis's earlier effort to promote the Italian Renaissance as a cultural model for America. The appeal from Walters and Morgan stated: "We, the undersigned, believe the time has come when this country is ready for its [the American Academy in Rome] permanent establishment and endowment, and that such an institution would prove of incalculable value in building up the national [American] standards of taste."[30] As suggested in this appeal, it was the standards of taste developed during the Italian Renaissance that Walters would turn to with passion in launching his own collection of art.

The collection that Henry Walters inherited from his father was rich in nineteenth-century European art but limited in paintings and sculpture created before then. At the time of William Walters's death, there were approximately 175 paintings in his collection, 113 of which were by contemporary French artists, 23 by English artists, and 8 by Americans.[31] William Walters's collection, although rich in Chinese and Japanese porcelains, contained few objects from classical Greece, Rome, or other ancient civilizations. The collection was also devoid of any French impressionists or other art that might have been characterized as avant-garde. William Walters's taste in paintings was not parochial (he was not attached to American art) but was characterized by a risk-free, conventional preference for beautiful art by well-known nineteenth-century artists, art that comforted the eye and that would hang fashionably in his Baltimore home or in the French salons of that time.

In 1899, at the age of fifty-one, Henry Walters broke from this tradition and launched his own career as a collector by initially focusing on Italian art. Perhaps because he had waited so long, he had developed a voracious but discriminating appetite for acquiring art that reflected his interest in world history and culture. Although he initially gave priority to the collection and display of Renaissance paintings, Henry Walters's collection ultimately would include more than twenty-two thousand works of art, including Egyptian reliefs; ancient Greek, Etruscan, and Roman sculpture; Medieval arms and armor; Renaissance bronzes; ceramics from Persia; early Christian antiquities; medieval ivories and enamels; and one of the largest collections of Medieval, Renaissance, and Islamic illuminated manuscripts in America. Among all the great collectors during the Gilded Age of America, Walters's collection was the most encyclopedic in scope. His view of culture was, in a word, cosmopolitan. Walters harbored for his collection an ambitious goal that he expressed simply but eloquently: "My hope for the collection has been to make it a thoroughly rounded collection which would give to the observer an understanding of the whole history of the world's artistic development."[32] Walters became, as one colleague from the Metropolitan Museum of Art observed, a collector whose intellectual spirit not only was comparable to the mighty Humanists of the Renaissance but also, in relationship to the other cultural leaders of America at the beginning of the twentieth century, "great among his peers."[33]

Walters's early interest in Italian Renaissance art had been nurtured by his own cosmopolitan upbringing, his periodic visits to Europe's great museums, his activities on behalf of the American Academy in Rome, and his memorable trip to Florence and Venice in 1879. With the exception of Isabella Stewart Gardner, he was one of the earliest American collectors to have a firm appreciation for "primitive" Italian art that led to the Renaissance.[34] Along with J. Pierpont Morgan, he was also one of the earliest collectors of Etruscan and Renaissance bronzes.[35] One of Walters's earliest purchases of art from Italy was an exquisite, small bronze statue of an Etruscan priest, cast around 200 B.C., which he acquired from Sotheby's in New York.[36] The half-draped priest bearing a radiant crown stands in contrapposto, with the upper part of his body twisting slightly to face the viewer while he confidently extends his right hand, which holds an offering dish. Walters would have recognized in this balanced pose the influence of the famous *Apollo Belvedere*, which he probably saw during his earlier visit to Rome. Perhaps mindful of the significance of that statue in cultural history, Walters might have hoped that this purchase would signify his own ascendancy to the upper ranks of America's art collectors.

Henry Walters's next purchase, however, was considerably more adventure-some and heralded a willingness to trust his own judgment in art against the tide of contrary assessments. In 1882, Raphael's *Madonna of the Candelabra* (see plate 1), the first Raphael ever to be shown in the United States, was exhibited with considerable fanfare at the Metropolitan Museum of Art, with the hope and expectation that the Metropolitan would purchase it. The circular painting had a noble provenance tracing its ownership back to the Borghese family in Rome. However, at some time it had been reduced in size, resulting in the elimination of the figure of Saint John the Baptist and the truncation of the Virgin's halo, and, upon its arrival in the United States, it had been touched up by the re-nowned landscape painter Frederick Church. Critics in the United States greeted the painting with widespread skepticism regarding its authenticity, and it was shipped back with a tarnished reputation to its owner in England. Among the doubters was Bernard Berenson, who, in August 1897, discouraged his client Isabella Stewart Gardner from pursuing its purchase, opining that there was "nothing" of Raphael in the painting except for the idea of the composition, that "all" of the painting's execution was by Raphael's students, and that in his esti-mation it was of little value.[37] Other authorities similarly opined that the paint-ing, in particular the two angels, was done mostly by Raphael's students.[38]

Henry Walters undoubtedly knew about the painting's controversial history; Nevertheless, in June 1901, he quietly purchased it from its Scottish owner.[39] The price was rumored to have been between $100,000 and $200,000.[40] As sug-gested by its steep price, a painting of the Madonna by Raphael was one of works of art most sought after by America's new millionaires. As a result of this pur-chase, Walters became the first American to have a "Raphael Madonna" in a collection in the United States, and the purchase placed him in the vanguard of America's foremost collectors of Italian Renaissance paintings. As later expressed to Bernard Berenson, Walters recognized that parts of the painting were done by Raphael's students, but he purchased it because of its rarity. He wrote, "Like others, I doubt that Raphael painted the two angels, but there are few obtainable pictures by him that I would have in preference to the *Madonna of the Cande-labra.*"[41] Walters's purchase of the *Madonna of the Candelabra* also demon-strated his recognition that paintings by Italian Renaissance masters were seldom completed without the help of their assistants and that to acquire great works of Italian art required a willingness to accept a calculated risk that attributions could be mistaken. These considerations were again in play when, less than one year later, Walters was faced with a more monumental decision involving his acquisition of the Massarenti collection.

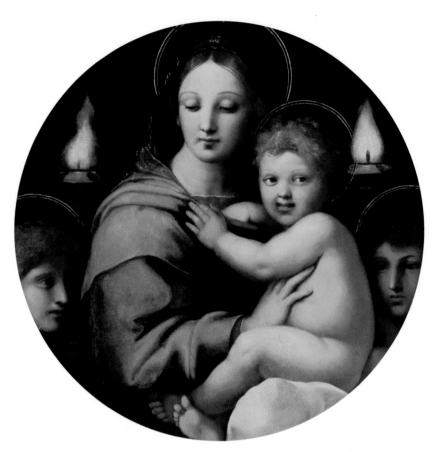

PLATE 1. Raphael and his workshop, *Madonna of the Candelabra*, ca. 1513, oil on panel, 25⅞ × 25¼ in. WAM 37.484. Berenson dissuaded his client Isabella Stewart Gardner from acquiring this painting on the ground that there was "nothing" of Raphael in the painting other than the idea of the composition. Walters likewise recognized that the two angels in the painting were painted by Raphael's workshop and that the painting had been reduced in size but nevertheless acquired it in 1901. It was the first Raphael Madonna to be acquired for a collection in the United States, and it remained one of Walters's favorite paintings. Photograph Walters Art Museum.

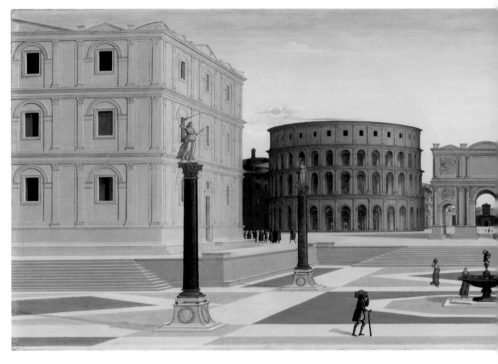

PLATE 2. *The Ideal City*, ca. 1480–84, oil on panel, 31⅝ × 86⅝ in. WAM 37.677. This painting was acquired by Walters in 1902 as part of the Massarenti collection. Although the identity of its painter has remained uncertain—it has been attributed to more than twelve different artists—the painting long has been considered to be one of the icons of Italian Renaissance painting. The painting's perfectly designed linear space, central fountain, columns, and Renaissance architecture might have reminded Walters of Mount Vernon Square in Baltimore, where he planned to construct his Renaissance-revival museum to house the artwork purchased from Massarenti. Photograph Walters Art Museum.

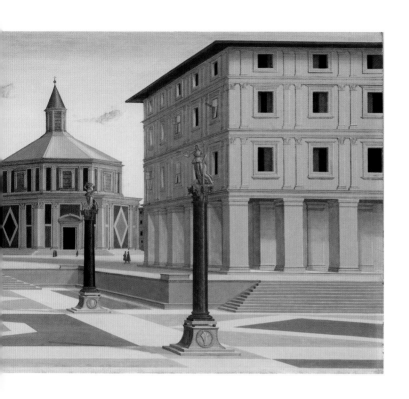

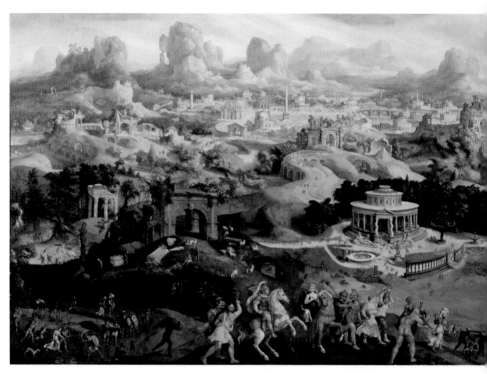

PLATE 3. Maerten van Heemskerck, *Panorama Fantasy with the Abduction of Helen*, ca. 1532–36, oil on canvas, 58 × 151 in. WAM 37.656. When Walters visited the Massarenti Gallery in 1902, he could not have missed this large painting, which is more than twelve feet long. With the wonders of the ancient world in the background, the painting's foreground depicts the Trojan prince Paris abducting Helen and carting away great works of art to ships waiting offshore for transit to Troy. Walters might have interpreted this painting as a history lesson linking his own plan to ship the massive Massarenti collection of art to America to the legendary tradition of treasure hunting of the past. Photograph Walters Art Museum.

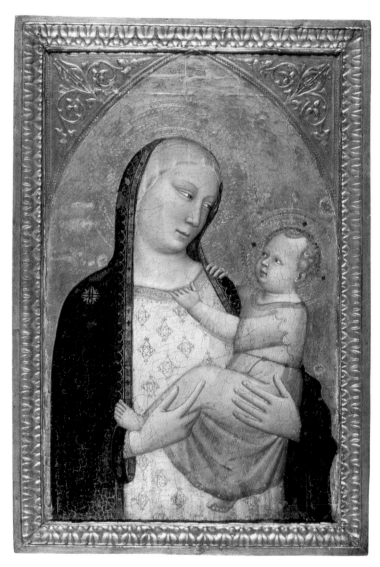

PLATE 4. Workshop of Bernardo Daddi, *Madonna and Child*, ca. 1327–1348, tempera and gold on panel, 27⅛ × 18⁷⁄₁₆ in. WAM 37.553. This painting was in Berenson's personal collection. In 1911, after Berenson acquired another *Madonna and Child* by Daddi, he sold this "Daddi" to Walters. Subsequent scholars have determined that the painting probably was designed by Daddi but painted by artists in his workshop. Photograph Walters Art Museum.

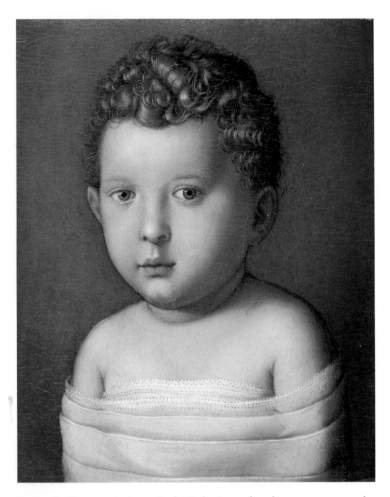

PLATE 5. Bronzino's *Portrait of a Baby Boy*, oil and tempera on panel, 13³⁄₁₆ × 10¼ in. WAM 37.451. This painting was also in Berenson's personal collection before he sold it to Walters in 1911. In Walters's 1915 catalogue, it was entitled *Infant Medici in Swaddling Clothes*. The identity of the child in this painting, however, is uncertain, but he probably was a son of Cosimo I. Photograph Walters Art Museum.

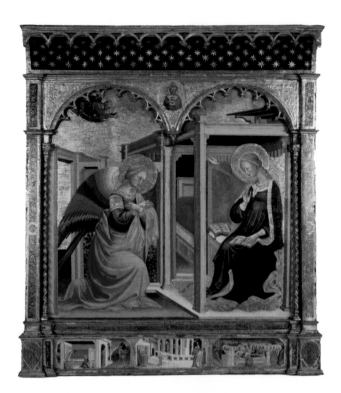

PLATE 6. Bicci de Lorenzo, *The Annunciation*, ca. 1430, tempera and gold leaf on panel, 64¾ × 57 in. WAM 37. 488. Walters acquired this altarpiece from Berenson in 1913. Berenson described it to Walters as "one of the most delightful works painted soon after 1400, & is the masterpiece of one of the most interesting figures of that time." Photograph Walters Art Museum.

PLATE 7. Bartolomeo Di Giovanni, *The Myth of Io*, ca. 1490, tempera and oil on panel, 25⅝ × 67½ in. WAM 37.421. When offering this painting to Walters in 1911, Berenson described it as "a large cassone front representing the telescoped myths of Io & Europa [from Ovid's *Metamorphoses*]. It is in brisk, youthfully joyous narrative style, & is delightfully golden in colour, & truly poetical in landscape." Photograph Walters Art Museum.

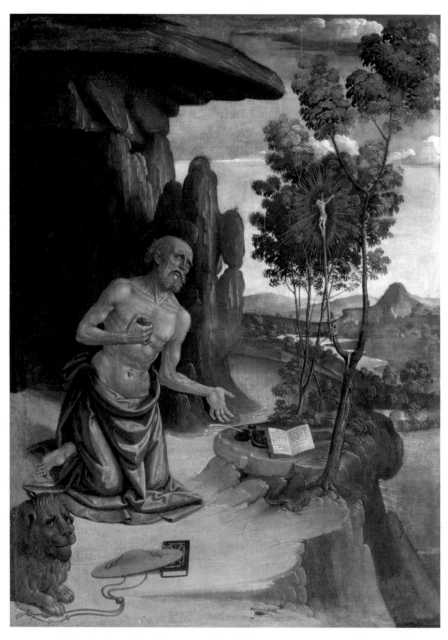

PLATE 8. Pintoricchio, *Saint Jerome in the Wilderness*, ca. 1475–80, oil on canvas,
59 × 41¾ in. WAM 37.1089. When Berenson sold this painting to Walters in 1916,
he attributed it to Fiorenzo di Lorenzo. It was the last painting that Walters purchased
from Berenson. In 1976, the painting was reattributed to Pintoricchio. Photograph
Walters Art Museum.

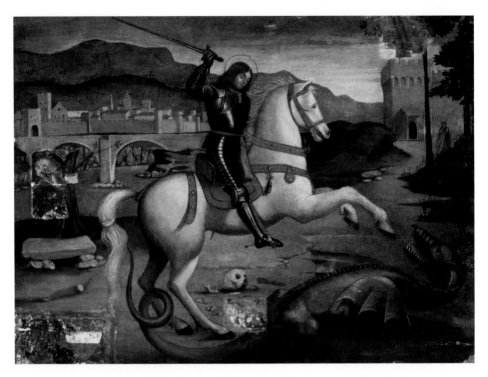

PLATE 9. *Saint George and the Dragon*. WAM 37.466. Berenson attributed this painting to Pietro Carpaccio when he sold it to Walters in 1911 and stood behind this attribution when Walters, with his advice, revised his catalogue in 1915. However, in *Venetian Paintings in America*, published in 1916, Berenson criticized the painting, stating that "it is a mediocre performance, and has been restored not too well." Many years after the deaths of Walters and Berenson, the staff at the Walters Art Museum discovered that the painting was a forgery. Photograph Walters Art Museum.

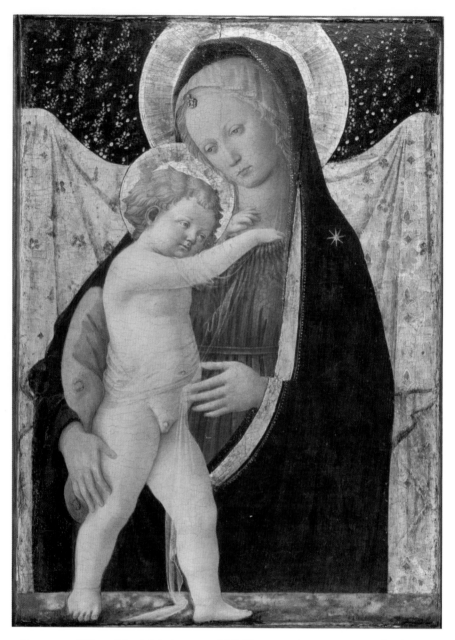

PLATE 10. Filippo Lippi, *Madonna and Child*, ca. 1446–47, tempera and gold on panel, 29¾ × 20⅝ in. WAM 37.429. This painting was acquired by Walters in 1902 as part of the Massarenti collection. Along with Raphael's *Madonna of the Candelabra* and Carlo Crivelli's *Madonna*, Walters identified this painting as one of his favorites. While visiting Walters's gallery and examining his Italian paintings in 1914, Berenson noted that this painting was "one of the loveliest in existence." Photograph Walters Art Museum.

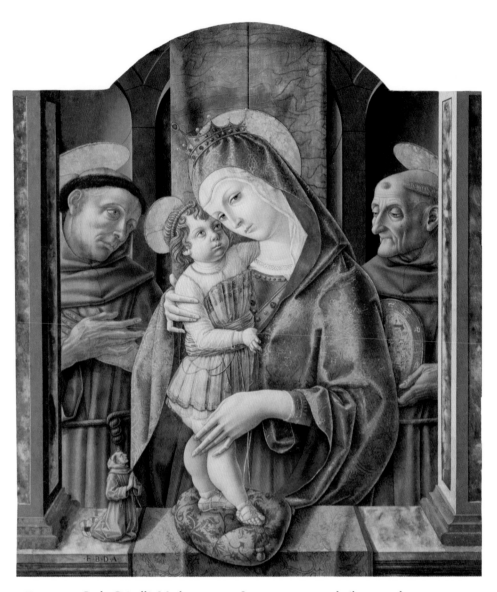

PLATE 11. Carlo Crivelli, *Madonna*, ca. 1485–90, tempera and oil on panel, 38⁹⁄₁₆ × 32⁵⁄₁₆ in. WAM 37.593. Walters acquired this painting in 1902 as part of the Massarenti collection. It was one of Walters's favorite paintings, and Berenson, in his *Venetian Paintings in America*, opined that "it is a delightful work of soft but rich color and lacquer-like effect." Photograph Walters Art Museum.

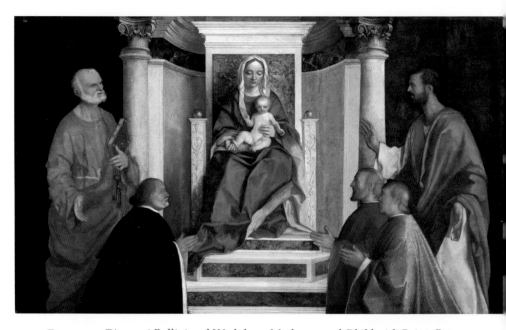

PLATE 12. Giovanni Bellini and Workshop, *Madonna and Child with Saints Peter and Mark and Three Venetian Procurators*, 1510, oil on canvas mounted on wood, 36 × 58 in. WAM 37.466. Walters acquired this painting from a dealer other than Berenson in 1915. The question of what part Bellini played in creating this painting has been the subject of debate. Berenson's own views about the authorship of the painting evolved. In 1916, he questioned whether Bellini painted it, writing "that it was by Bellini himself I find hard to believe." By 1957, however, he concluded that the painting was in "great part" by Bellini. It has now been determined that the saints in the picture were added by Bellini's assistants. Photograph Walters Art Museum.

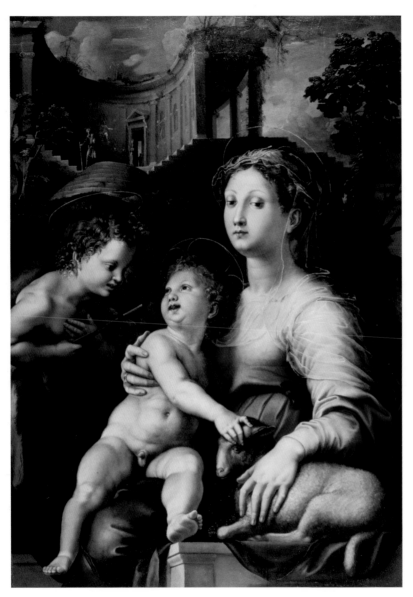

PLATE 13. Giulio Romano, *Madonna and Child with Saint John the Baptist*, 1522–24, oil on panel, 49½ × 33⅝ in. WAM 37.548. When Walters acquired this painting from Massarenti in 1902, it was attributed to Giulio Romano. Thereafter, Berenson attributed it to Raffaello dal Colle. Recently, the painting was reattributed to Giulio Romano. Photograph Walters Art Museum.

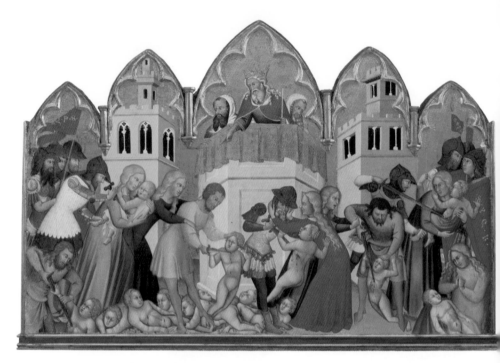

PLATE 14. Bartolo di Fredi, *Massacre of the Innocents*, 1388, tempera and gold leaf on panel, 35⅛ × 51⅛ in. WAM 37.1018. Walters acquired this painting in 1917 from the Demotte gallery in Paris. He informed Berenson that, "though painful in subject," he was "greatly blessed" to own it. Berenson likewise thought very highly of the painting. In an unfinished catalogue about the Walters collection of Italian paintings, Berenson wrote that this was one of Bartolo's "most important" paintings and, from the standpoint of color alone, "ranks with the best" that the Middle Ages left behind. Photograph Walters Art Museum.

ONE COPY ON TOP
OF ANOTHER

The cultural intersection where Henry Walters, Bernard Berenson, and Marcello Massarenti met at the beginning of the 1900s was paved with endless copies of Italian old-master paintings. From one generation of artists to another extending from the fifteenth to the nineteenth centuries, the imitation of old-master paintings became an inseparable part of the fabric of Italy's cultural life. Painters at all levels participated in the practice. Italian masters often made signature copies of their own paintings. Devoted apprentices employed by a master in his workshop and other followers dutifully copied his paintings. Other painters unassociated with a master made additional copies both to pay homage to him and to identify themselves with established standards of greatness. Students, as a means of learning their trade, endlessly made copy after copy. And to all of the copies made for legitimate reasons were added the work of the forgers whose motivation was purely to deceive a never-ending flow of eager purchasers. Over centuries the copies, like a house of cards, were layered one upon the other to the point of their inevitable collapse. It was this phenomenon that led inexorably to the hundreds of copies attributed to Italian old masters that were scattered throughout the Massarenti collection, and it was the challenge presented by these copies that brought Walters and Berenson together.

In the tradition of the ancient Roman practice of repetitively copying the statuary of earlier Greek masters such as Praxiteles and Polyclitus, the idea of copying venerated works of art had become both widespread and ethically acceptable during the Renaissance and continued for hundreds of years thereafter. A faithful copy of a masterpiece was nothing to frown upon. To the contrary,

sometimes a skillfully made copy not only was considered to be as valuable as the original but also, paradoxically, was viewed as having attained a higher level of perfection than the original itself. This point is illustrated by a legendary story recorded in 1568 in the second edition of Vasari's *The Lives of Artists*. According to Vasari, the Duke of Mantua, while visiting Florence early in the sixteenth century, saw a painting of Pope Leo X by Raphael in the Medici palace. He asked Pope Clement to obtain the painting for him, a request that was conveyed to Ottaviano de' Medici, a member of the family who served as the painting's custodian. Unwilling to part with the Raphael, Ottaviano summoned Andrea del Sarto, a painter whose prodigious skills almost equaled Raphael's, and commissioned him to copy Raphael's painting. This copy was sent to the Duke of Mantua, who, unaware of the deception, was fully satisfied with his "Raphael." After learning about this, Vasari confidentially informed the painter Giulio Romano, one of Raphael's most gifted disciples, that the painting in Mantua was by Andrea del Sarto, not Raphael. Although surprised, Romano replied that it made no difference to him because "I value it [the Andrea del Sarto painting] even more than if it was by Raphael, for it is extraordinary that one great master should so exactly imitate the style of another."[1]

Another instructive story about the Renaissance art of imitation involves Baccio Bandinelli, a sixteenth-century sculptor whose prominence rested on his skill at replicating classical sculpture. As retold by Leonard Barkan, in his *Unearthing the Past*, certain ambassadors of the French King Francis I, while visiting two cardinals at the Vatican, saw the *Laocoön*, probably the most venerated ancient sculpture in Rome, and suggested that it would make a wonderful gift for their king. One of the cardinals, Giulio de' Medici, replied, "There shall be sent to his majesty either this one [the Roman original] or one so like it that there shall be no difference." Bandinelli was then summoned and asked whether he could carve a statue that was equal to the original. He replied memorably that "he could make one not merely equal to it, but even surpassing it in perfection."[2] After Bandinelli completed his replica, Guilio adored it so much that he sent it to his home in Florence instead of delivering it to France. While the ancient Roman version of the *Laocoön* has remained firmly ensconced in the Vatican, Bandinelli's marvelous copy has for generations been on display at the Uffizi, where its adoration has not been diminished by the absence of originality.

The idea that a copy could be as desirable as the original work of art was at the heart of negotiations in 1664 between a member of the Medici royal family and a notable dealer, Annibale Ranuzzi, for a painting purportedly by Michelangelo. As negotiations between Leopoldo de' Medici and Ranuzzi progressed,

Ranuzzi admitted that Michelangelo was not the author of the painting, but this did not end the prospect of making the sale. Ranuzzi argued that the painting he sought to sell was so exquisite that it not only could pass for a Michelangelo but was "more beautiful than if it were by Michelangelo, in a style that will not be difficult to baptize as by the hand of Michelangelo, especially if it were in your Highness's room."[3]

These stories demonstrate that, as works of art by Renaissance and Baroque masters became increasingly rare, members of Italy's aristocracy permitted copies of their best paintings to be made and given to friends or allies as special gifts or, conversely, requested that copies be made for their collection if the originals were unavailable. Often, the master himself would participate in creating a second or duplicate signature copy of a significant painting at the request of an important donor or donors. As a result, the question of what constituted an "original" or "signature" painting by a master and what constituted a "copy" became increasingly difficult to define. The problem is illustrated by Guido Reni's practice of repeatedly copying his most illustrious paintings. To a casual viewer, there was often no perceptible difference between Reni's initial composition, which served as a prototype, and his subsequent copies. Reni's goal, however, was not simply to "stamp out" pictures but instead to achieve a more perfect image of an earlier composition by making subtle changes in color, texture, and brushwork.[4] While Reni became known for the quantity of replicas that came from his studio, practically every notable Renaissance and Baroque artist engaged to some extent in the practice of making more than one "signature" painting of the same picture. Perhaps the three most illustrious examples of this practice are Leonardo's *Virgin of the Rocks*, copies of which are at the Louvre and the National Gallery in London;[5] Giorgione's *Adoration of the Shepherds*, versions of which are at the National Gallery of Art in Washington, D.C. (the *Allendale Nativity*) and the Gemäldegalerie in Vienna; and Titian's *Portrait of Filippo Archinto*, copies of which are in the Johnson Collection at the Philadelphia Museum of Art and the Altman Collection at the Metropolitan Museum of Art.

Many Renaissance and Baroque masters, seeking to capitalize on the market for their work, employed dozens of assistants to copy an earlier painting or complete a painting based on only a concept or sketch by the master, further complicating the identity of the actual artist and leading ultimately to the common "school of" attributions used in museums today.[6] Vasari reported that Raphael "kept a great number of artisans at work . . . and was never seen leaving home . . . without fifty painters, all worthy and good men, accompanying him."[7] Titian's

large workshop of over thirty artists included his son, his nephews, and several other artists who resided with Titian in his home for many years and who became consequently so intimately familiar with Titian's manner of painting that their versions and Titian's own paintings became hardly distinguishable. In the later years of Titian's long life, members of his workshop began to sell copies painted solely by them while pretending that Titian was also involved.[8] The production of workshops became so widespread and prodigious that John Walker, former director of the National Gallery of Art, has suggested that "virtually all Italian Renaissance paintings were the product of a shop with assistants almost invariably at work on some part of the picture."[9]

By reason of the express terms of most commissions, those who contracted with a master to paint a picture were well aware that that the artists employed in the master's studio would have a significant role in its production. Most commissions called for the painting to be done "by his [the master's] hand" (*di sua mano*). While this phrase might connote to modern readers a contractual obligation imposed on the master to complete the painting solely with his own hand, it meant something significantly different to the contracting parties in the fifteenth and sixteenth centuries. The phrase *di sua mano* meant only that the master was obligated to design the work, retouch the work of his subordinates where necessary, paint the most important or difficult aspects of the painting, and approve of the final product. The master was free to delegate most of the painting to other artists employed within his workshop.[10] Some master painters permitted a painting to be considered an "original" by them if they simply retouched the painting with a few brush strokes. Titian, for example, was legendary for completing the paintings of his workshop with only a few strokes of his brush.[11] Guido Reni, to cite another example, was reported to have responded to a request from a cardinal for a copy of one of his paintings by stating, "I not only entreat Your Eminence to have a copy made of it, but I promise you, that, without any profit, I will retouch and finish it all in such a way that it will not have to envy the original."[12] Some contracts even allowed the master to subcontract a painting or part of a painting to an independent artist so long as he approved and signed the final product.

Paintings authored by Italian masters were endlessly copied not only by their students and followers but also by other distinguished masters. These copies were not intended to deceive a purchaser or to devalue the original painting. Instead, the painters making the copies sought to demonstrate their own skill in being able to replicate the work of another great artist while at the same time paying homage to him. As reflected in Vasari's tribute to Raphael, the practice

of imitation was highly encouraged throughout the Renaissance. Referring to Raphael, Vasari wrote that his successors should imitate him, "for anyone who imitated him [Raphael] discovered that he had taken refuge in a secure port, and likewise, those painters, who in the future will imitate his efforts in the art of painting will be honored in the world."[13] In keeping with Vasari's advice, copies of Raphael's famous portrait of Pope Julius II were made not only by artists in his studio but also by Titian, another great master. Today, Raphael's portrait of Julius II is in London's National Gallery; the copy by his studio, in the Uffizi Gallery; and the copy by Titian, in the Pitti Palace in Florence.[14] In the same spirit that prompted Titian to copy Raphael, Rubens made numerous copies of paintings by Titian, and the cycle of one outstanding painter copying another continued for generations.[15] Because countless copies of Titian paintings were made over the centuries, it is not surprising that seven paintings erroneously attributed to Titian found a home in Massarenti's collection in the late nineteenth century and were later purchased by Walters.

In the sixteenth and seventeenth centuries, copies of old-master paintings also proliferated in teaching academies throughout Italy. Milan's Ambrosiana Art Academy, founded around 1620 by Archbishop Federico Borromeo, commissioned artists to paint copies of exemplary paintings having sacred themes, such as Leonardo's *Last Supper*, Correggio's *Coronation of the Virgin*, and Raphael's *Adoration of the Magi*. The copies were used both as models for students, who were admitted and graded on the basis of their ability to replicate them, and for devotional purposes, as called for by the Council of Trent. According to Borromeo, "It was a praiseworthy thing to procure copies provided that they are worked with extreme diligence and taken from the most excellent models."[16] By integrating his copies into his splendid collection, Borromeo created one of the earliest and greatest full-scale teaching museums in Europe.[17] It was a model that Henry Walters might have had in mind when acquiring many copies of Italian masterpieces in the early 1900s to augment the paintings he purchased from Massarenti and to satisfy the educational goals of his own collection.

As the making and acquisition of copies became an increasing phenomenon in the burgeoning market for Italian paintings between the fifteenth and eighteenth centuries, many talented painters achieved their fame not through creativity or originality but as artist-entrepreneurs who satisfied the taste for Renaissance and Baroque art by beautifully replicating and imitating the art of others. Vincenzo Camuccini was among the most gifted of these Italian copyists. Beginning at the age of thirteen, he supplemented his income by painting replicas of Italian old masters and selling these copies as originals to primarily

unsuspecting English aristocrats who had traveled to Rome as part of their grand tour. He focused his talents on copying paintings by famous Baroque artists, such as Annibale Carracci, Caravaggio, Guido Reni, and Guercino.[18]

By the middle of the nineteenth century, after centuries of copying, it had become exceedingly difficult to distinguish between an Italian painting authored by a master, a painting made by subordinate artists in the master's workshop, a close version of a masterful painting made by another notable artist as a tribute to the master, an imitation made by a very good student or follower of the master, and a forgery or fake made by a copyist for the purpose of deceiving a purchaser into believing that it was painted by the master.[19] The passage of time had simply obliterated, for the most part, both the identities and the motivations of the artists who made the copies. Churches, museums, and private collections throughout Italy were full of paintings that lacked any provenance and had uncertain authorship. Although it is impossible to quantify the number of such anonymous paintings, one art historian has estimated that half of the notable paintings in Italy were without a reliable attribution.[20] As a result, Italy's rich cultural heritage epitomized by its Renaissance and Baroque paintings was in danger of becoming as fragmented and anonymous as the pieces of classical Roman sculpture that had been recovered from its soil.

Following Italy's unification in 1861, Giovanni Morelli, a member of the Italian Parliament and Italy's foremost connoisseur, undertook the monumental task of changing this. His mission was to establish a national inventory of Italy's art treasures by identifying the authors of the massive number of misattributed Italian Renaissance and Baroque paintings, to promote their cultural and economic value, to place these paintings in newly established museums, and to prevent the most precious of these works of art from being gobbled up by hungry collectors and newly established museums in Germany and England. In pursuing these goals, he became a giant in his field.

Morelli's fame is derived primarily from the scientific methodology he devised for identifying the authors of Renaissance paintings. Trained in medicine and the natural sciences, Morelli's understanding of human anatomy led him to examine works of art for unnoticed, anatomical details of the painter's subject, such as his or her ears and hands. These details, Morelli insisted, were spontaneously repeated by artists in their paintings and served like fingerprints to link painters to their works of art. Morelli contended that the evidence imbedded in the painting itself, which could be detected by close visual analysis, provided a more confident basis for determining the painter's author than did

collateral documentary evidence, which was often misleading.[21] Morelli, how-
ever, did not believe that accurate attributions were essential for their own sake.
Instead, he thought they were a means for understanding that the art of Italy
had evolved "organically" based on the distinct natural and cultural qualities of
the different regions of Italy and the different schools of art they produced.[22] To
Morelli, connoisseurship was an inseparable component of art history.

Morelli's approach to connoisseurship and his willingness to challenge the
conventional attributions given to Italian paintings by earlier art historians and
museum curators had a dramatic effect on Berenson.[23] After studying Morelli's
explanation of his scientific approach in 1889 and briefly meeting with him in
1890, Berenson became his most dedicated disciple. Berenson referred to Morelli
as his "revered master." He expressed the belief that the brilliance of Morelli's
scientific approach to art was comparable to if not greater "than Winckelmann's
to antique sculpture or Darwin's to biology."[24] In two books written around the
turn of the century, Berenson explained to a broader audience the importance
of the Morellian method of connoisseurship and his plan to develop a similar
approach to the study of art history.[25]

Morelli, however, had one failing which, like a virus, seemed difficult to re-
sist. It was caused by allowing his independent judgment to be compromised by
his pursuit of financial gain. Despite Morelli's public opposition to the export of
Italian Renaissance paintings, from the 1850s to the time of his death in 1891, he
engaged actively as a dealer in the marketing of Italian paintings to wealthy
patrons abroad, especially in England. In return for commissions, he authenti-
cated, estimated the value, and sold paintings not only from outside sources but
also from his own collection. Sometimes he exaggerated the importance of the
paintings in his collection, leading scholars to question in hindsight the objec-
tivity of many of his attributions.[26] His willingness to compromise his intellec-
tual judgment for economic gain soiled his otherwise splendid reputation.[27] Part
brilliant connoisseur, part self-serving commercial raconteur, Morelli became a
twisted model of the conflicts and contradictions that subsequently confronted
many of his followers, especially Bernard Berenson.

Beginning in the sixteenth century, successive generations of wealthy En-
glish art collectors became the principal victims of the Italian copyists.[28] The
copies that they unwittingly purchased were proudly displayed in their country
homes as if they were original Renaissance and Baroque masterpieces. In No-
vember 1894, an extensive exhibition of Venetian old masters owned by members
of the English aristocracy opened at the New Gallery in London. The paintings

purportedly included thirty-three paintings by Titian, seventeen by Giorgione, fourteen by Giovanni Bellini, and thirteen by Paolo Veronese. Berenson, who was relatively unknown at the time, attended the London exhibition. Applying the scientific theory of connoisseurship that he had learned from Morelli, Berenson wrote, in March 1895, a devastating critique challenging most of the attributions in the exhibition. With regard to the thirty-three paintings attributed to Titian, Berenson wrote that "no other name, it is true, is so recklessly abused as Titian's," and he concluded that only one of the thirty-three was painted by Titian. Turning to the seventeen paintings allegedly by Giorgione, Berenson focused on one, *Portrait of a Lady Professor of Bologna*, and caustically stated that it was "neither of a Lady, nor of a Professor, nor of Bologna." He claimed that neither this painting nor any others in the exhibition were by Giorgione. With regard to the paintings by Giovanni Bellini, Berenson expressed the opinion that throughout Europe only one in six paintings attributed to Giovanni was actually by him and, consistent with this ratio, only three of the eighteen paintings in the exhibition were painted by him. And with regard to the paintings by Veronese, none, according to Berenson, were by him.[29] Much to the chagrin of the owners of the paintings on display, Berenson's analysis of the exhibition at London's New Gallery helped launch his career and quickly made him the most well-known, albeit controversial, connoisseur of Italian art.[30]

Berenson's critique of the exhibition of Venetian artists in London was republished in 1901 in volume 1 of *The Study and Criticism of Italian Art*. In this volume, Berenson observed that, due to the haphazard practices of what he characterized as the "old connoisseurship," attributions to famous Italian masters were often abused and not worthy of trust.[31] This warning was followed in 1902 by Berenson's republication of his "Rudiments of Connoisseurship," in which he cautioned that many Italian masters delegated the execution of their conceptions to members of their workshops, that the names of the masters placed on these paintings should be treated with suspicion, and that the attribution given to any picture purportedly by an Italian master should be subjected to "severe criticism before it is accepted." Berenson then proceeded to describe in detail the morphological standards he used in assigning a name to a painting, suggesting that he was among the very few who were able not only to reliably identify the artist but also to rate the quality of the painting. Blending his extraordinary knowledge about art with his interest in self-promotion, Berenson concluded that connoisseurship to him was not just a science but an art as well.[32]

Berenson was not the first or only connoisseur to warn prospective buyers against the peril of copies and false attributions in the Italian art market. In 1860,

James Jackson Jarves, in an article in the *Atlantic Monthly*, "Italian Experience in Collecting Old Masters," observed that, due to the pervasive practice among Florentine artists and dealers of forging copies of old-master paintings and documents designed to deceive unwary buyers about the paintings' provenance, there was in Florence an unending quarry of copied paintings that had no value. Jarves warned that "no purchaser . . . should give heed to any statement about the history or authenticity of the works offered to him through such channels [Florentine art dealers], but rely both for value and facts upon his own resources."[33] Ironically, although Jarves recognized that Florence had turned into a "vast picture shop," Jarves himself fell prey to purchasing many works of art by purported masters whose attributions proved to be untrustworthy, including a painting allegedly by Raphael that turned out to be a forgery.[34]

As a result of the Italian culture of reproduction that continued for four hundred years, American millionaires who ventured into the market for Italian master paintings at the turn of the last century had to tiptoe through a veritable minefield of copies and fake paintings as well as contrived documents seeking to prove the contrary. Risk was an inherent component of collecting Italian old masters. Benjamin Ives Gilman, the influential director of the Boston Museum of Fine Arts, warned that "the flood of reproductions threatens to drown out the seeds of artistic culture" and that it was hard to distinguish great Italian masterpieces from "the chaos of reproductions."[35] An article in the *New York Times Magazine* similarly cautioned that a virtual flood of fictitious "old master" paintings had been arriving in the United States, causing America's art lovers to "meet with copies everywhere."[36]

At the beginning of the twentieth century, wealth provided American millionaires with no shield from the perils of collecting Italian paintings. While Isabella Stewart Gardner, with the assistance of Berenson, was able to assemble a significant collection of Italian old masters before the turn of the century, other titans struggled. Andrew Mellon, for example, allegedly spent over $400,000 (the equivalent of $10 million today) between 1899 and 1905 without purchasing a single painting that he later found worthy of hanging in the National Gallery of Art.[37] In 1903, John G. Johnson, a wealthy and renowned Philadelphia attorney and one of America's earliest collectors of Italian Renaissance paintings, was fooled by an Italian dealer who purported to sell him twenty-three paintings by Renaissance masters.[38] After reviewing Johnson's collection, Berenson sent him a letter that brutally challenged the attributions of some of Johnson's most precious paintings. With regard to Johnson's painting attributed to Botticelli, Berenson sarcastically noted, "Never in the world"; with regard to his Carpaccio,

Berenson wrote, "most certainly not"; with regard to his Perugino, Berenson noted, "Not Perugino"; and with regard to his Lorenzo di Credi, Berenson caustically observed, "No and not even Florentine."[39] When, in 1904, Berenson visited the collection of Joseph Widener, he found "mostly horrors masquerading under great names," and when he returned in 1908, he similarly found "nothing of importance among the Italians."[40] A Titian purchased by Widener for $40,000 was discovered to be a copy, and a painting attributed to Botticelli was downgraded to a workshop piece.[41] In 1909, J. P Morgan paid $200,000 for a *Madonna and Child*, purportedly by Raphael, only to have its authenticity questioned by Berenson and others. This resulted in the painting being reattributed to "School of Raphael" and subsequently sold by Morgan's heirs for only $2,500, a small fraction of its original price.[42] In light of the publicity about the perils of collecting Italian Renaissance paintings and the misadventures of some of his fellow millionaires, Walters should have been keenly aware of the risk he was taking when venturing into this field.

THE
MASSARENTI
COLLECTION

Don Marcello Massarenti was a Roman priest and member of the papal court. For many years, he had served as a pontifical under-almoner. But beneath this veneer of respectability, Massarenti was a shadowy figure with an unsavory reputation. It was said that he was enamored more with the material than with the spiritual side of life. His position empowered him to dispense financial benefits, or alms, to churches and monasteries throughout Italy, likely providing him with the influence and connections to amass an enormous collection of approximately sixteen hundred works of art. Massarenti retained no records documenting the provenance of his artwork, and their origins have to this day remained mostly unknown. The dark side of his reputation stemmed from stories about his sexual predilections and his willingness to pander to the salacious practices of higher officials in the church.[1] Whether by reason of Massarenti's reputation or Walters's personal dealings with him, Walters disliked Massarenti. He disparagingly referred to him as "the old man on the hill," perhaps referring to the fact that he isolated himself in a small apartment in the Vatican that overlooked Saint Peter's Dome. Massarenti's collection of art was housed nearby on two floors of the Palazzo Accoramboni, which had been constructed in the seventeenth century and was prominently located at the eastern end of Bernini's colonnaded extension of Saint Peter's Piazza.[2]

In 1881, Massarenti published a catalogue of his collection, which at that time included 309 paintings, most of which were allegedly by Italian masters.[3] Thereafter, the collection grew tremendously. By 1897, it numbered 848 paintings, and Massarenti, who was approaching his ninetieth birthday and was almost

blind, decided to sell the entire collection.[4] He retained the Dutch artist, Edouard Van Esbroeck, to organize the collection and to write a new catalogue describing it. That catalogue, entitled *Catalogue du Musée*, was published in 1897 and followed in 1900 by a supplemental catalogue that described an additional 62 paintings that had been added to the collection.[5] Thus, in 1902, at the time of Henry Walters's visit, the Massarenti collection had approximately 930 paintings. Of these, 520 paintings were by Italian artists.

The catalogue published in 1897 expressly informed the public that the art was available for purchase. Written in French, the catalogue was addressed primarily to potential purchasers on the mainland of Europe. The catalogue's introductory remarks were tantamount to an infomercial—transparently disingenuous and full of fluff. It claimed that it was a collection "of the highest order" and that it "would add to the renown of any foreign city." It claimed that the paintings were assembled during the previous thirty years from "illustrious old families," but it failed to provide specific information about the provenance of any of the paintings. It represented that the collection had been praised by many authorities in the field of Italian art, but it cavalierly dismissed any need to identify them. It stated: "As for its high value, we could draw support from numerous testimonies of competent persons who have visited it, but we consider these citations superfluous." What Massarenti characterized as "superfluous," most prudent collectors would have considered as essential. Devoid of any endorsement by a specialist in Italian painting and crammed with transparently fictitious attributions, the Massarenti catalogue was like a red flag that warned potential buyers to proceed with caution.

The catalogue attributed many of the paintings to the greatest Italian artists. According to the catalogue, there were two paintings by Botticelli, one by Giovanni Bellini, four by Bronzino, six by Caravaggio, one by Annibale Caracci, six by Correggio, a pair painted jointly by Domenichino and Reni, one by Dossi Dosso, three by Giotto, three by Giorgione, three by Ghirlandaio, one by Leonardo de Vinci, two by Filippo Lippi, two by Mantegna, one by Masaccio, one by Antonello da Messina, two by Michelangelo, two by Pollaiuolo, two by Raphael, seven by Titian, four by Tiepolo, one by Tintoretto, five by Veronese, and four by Verrocchio. As suggested by the remarkable array of Renaissance and Baroque masters whose names filled the catalogue, the Massarenti collection of paintings, in a very real sense, was the quintessential product of Italy's culture of copying—a collection perhaps more than any other ever acquired that serves as a laboratory to study the innumerable misattributions of Italian paintings that had been made during the course of the previous four centuries. Anyone vaguely

familiar with the traditional practice of imitation and reproduction in Italian cultural history and the consequent confusion about who painted what would have approached Massarenti's attributions with a mixture of two-thirds skepticism and one-third hope that below the surface of the misrepresentations were some authentic treasures of Renaissance art.

Massarenti crammed his paintings into approximately ten dimly lit rooms. As evidenced by vintage photographs of the Massarenti collection, the paintings were hung from floor to ceiling so closely together that their individuality merged into a collage of pictures and frames, leaving the identity of each painting largely dependent on a number which appeared at the bottom of its frame.[6] Some of the paintings were hidden behind others and could not be seen at all. The purported gems of the collection, such as the paintings attributed to Raphael and Michelangelo, were displayed on easels in front of the other paintings (fig. 4).

In several of the rooms, the paintings also competed for space with display cases full of small statues, vases, and other objects of decorative art that impeded any opportunity to closely examine the paintings. The difficulty in seeing many of the paintings was further compounded by layers of discolored varnish that darkened the surface and obscured important details.[7] A reporter for the *New York Times* aptly captured the problem by writing that "the pictures hung on two floors of the gloomy palazzo . . . where it was difficult to see them and where it was impossible to see them without a special introduction from Msr. Massarenti."[8]

Although the floor-to-ceiling manner in which the paintings were displayed was consistent with museum practice at that time, the lack of light and congested surroundings created a claustrophobic atmosphere that was not conducive to the leisurely enjoyment or close examination of fine art. This problem is reflected in the photographs and also revealed in the anecdotal account of a visit to the Massarenti collection in 1898 by the famous London and New York art dealer Joel Duveen and his nephew James Henry Duveen. Upon entering the collection, Joel Duveen's first request was for "better light," but his guide responded that better light was unavailable. Duveen reiterated his displeasure, directing the guide to "take me to something I can see." When the guide again indicated with a negative shrug that the problem was not remediable, Joel Duveen responded, "I don't like the atmosphere of this place." After quickly looking at several paintings that he characterized as *ghadish*, a derisive Yiddish word meaning imitations, Duveen and his nephew promptly walked out.[9]

While the manner in which Massarenti displayed his paintings lacked aesthetic appeal, there was an effort to rationally organize and divide the Italian

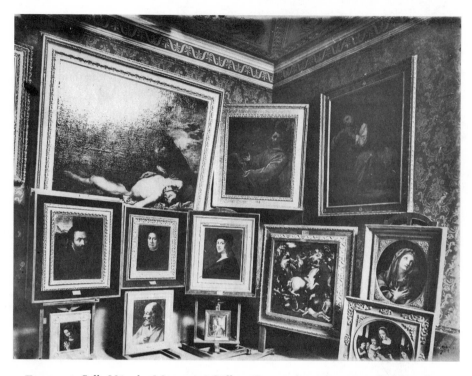

FIGURE 4. Salle V in the Massarenti Gallery, Rome, about 1900, crowded from floor
to ceiling with paintings attributed to great masters. The paintings on display
purportedly included *Saint Francis of Assisi* attributed to Annibale Carracci (now
his workshop, WAM 37.1920); *Saint Mary Magdalen* attributed to Caravaggio
(now Sparadino, WAM 37.651); *The Mourning Virgin* attributed to Guido Reni
(now his workshop, WAM 37.492); *Battle Scene* attributed to Paolo Uccello (now
School of Ferrara, WAM 37.499) and featuring self-portraits purportedly by Raphael
and Michelangelo mounted on easels in front of the other paintings. Photograph
WAM Archives.

paintings into eleven schools of art in a manner that had been advocated by Mo-
relli. The schools, designated primarily by their location, were Tuscany, Tuscany/
Florence, Bologna, Lombardy, Ferrara, Parma, Umbria, Turin, Venice, Naples,
and Byzantine. According to the catalogue, the paintings in each school were
displayed together in one of the ten salons. The paintings and their artists, the
catalogues claimed, could be identified by the numbers on the paintings, which
corresponded with the numerically organized descriptions of the paintings in
the catalogues.

The execution of the plan set forth in the catalogue stumbled badly for several
reasons. First, scattered throughout the collection were blatant copies of famous

paintings by Italian old masters, such as Titian's *The Worship of Venus*, and Correggio's *Allegory of Vice* and *Allegory of Virtue*. The second, more pervasive problem involved the sheer number of paintings that carried erroneous attributions. Although Massarenti might not have recognized the extent of this problem, more than two-thirds of his paintings were probably attributed to the wrong artist. Because the attributions were in general problematic, Massarenti's effort to organize his paintings by the locations where the artists resided and the schools of art to which they belonged was futile. The Massarenti catalogue simply failed to satisfy the basic Morellian principle demanding that any analysis of Italian art begin with the accurate identities of the artists who painted the individual works of art.

Among myriads of apparent misattributions in the Massarenti collection, six paintings exemplify the pervasive nature of the problem: an easel-sized portrait that, according to Massarenti, was a rare self-portrait by Michelangelo; a pair of paintings purportedly co-authored by two of the masters of Italian Baroque art, Domenichino and Guido Reni; a painting attributed to Caravaggio and described as a small version of *The Entombment*, one of his best-known masterpieces; a painting purportedly by Titian of *Christ and the Tribute Money*; and a painting that appeared to be of a woman dressed in black and apparently in mourning by a relatively unknown artist by the name of Sabastiano del Piombo.

With regard to the self-portrait purportedly by Michelangelo (see fig. 3), Massarenti was not content in simply claiming to possess this painting. He also asserted that it was the only painting of its kind. Moreover, he wanted prospective buyers to believe that Michelangelo remained virtually alive in the painting and that, by acquiring the painting, the purchaser would hold the key to nothing less than Michelangelo's soul. According to the catalogue, Michelangelo's self-portrait was "the only and unique portrait of this master . . . His features are sculpted, the design is tight and powerful, the unity is perfect, and the forms are of an unparalleled grandeur and simplicity." All of these qualities, Massarenti contended, combined to capture "the soul of this giant."[10] If this were so, of course, it would have been one of the most treasured paintings in art history.

There is no need to rehearse the singular fame and standing of Michelangelo. It is sufficient to recognize that Michelangelo's life and art were the subjects of extraordinary documentation both through the meticulous records and drawings he maintained and in the biographies written by Vasari in the first and second editions of his *Lives* and by Ascanio Condivi, Michelangelo's studio assistant, whose biography of Michelangelo is widely acknowledged to have been directed by Michelangelo himself.[11] In 1892, shortly before Massarenti published his

catalogue and placed his collection on the market, an extensively researched, two-volume biography written by John Addington Symonds updated Vasari's and Condivi's earlier biographies.[12] If Michelangelo had painted a self-portrait, surely the rarity and importance of this painting would have been mentioned by Vasari, Condivi, or Symonds. However, no mention of a self-portrait appeared in any of these biographies, and it was understood then as now that Michelangelo rarely painted any easel-sized paintings and never painted any easel-sized portrait of himself of the kind purported to be in the Massarenti collection.[13] In light of the absence of any historical evidence that Michelangelo painted a self-portrait, Massarenti's claim that he was offering to sell such an extraordinary painting was astounding. It reflected at best a cavalier attitude in the assignment of attributions to the paintings in his collection as well as a hope to attract a buyer who was gullible enough to accept such a remarkable claim at face value.

In claiming that he owned Michelangelo's self-portrait, Massarenti seized upon a resemblance of the man in his painting to two well-known portraits of Michelangelo. The first was a painting by Jacopino del Conte completed in 1540, when Michelangelo was sixty-five years old (now on display at the Metropolitan Museum of Art). This image of Michelangelo obtained widespread currency in 1568 when it appeared in the opening pages of the second edition of Vasari's *Lives*. The other portrait of Michelangelo was in the form of a bronze bust sculpted by Daniele Da Volterra in 1564, shortly after Michelangelo's death (now on display at the Bargello in Florence).[14] Probably modeled after Conte's painting or Volterra's bronze bust, the painting in the Massarenti collection captured Michelangelo's distinctive features—a broken nose that was flattened at its bridge, deep-set eyes, high cheek bones, and a mustache and long sideburns that together were combed into a beard about two inches in length. By the end of the nineteenth century, easel-sized paintings of Michelangelo's portrait, which were based on Volterra's model, abounded in the marketplace. It is likely that one of these copies by an anonymous artist is what landed in Massarenti's collection and what he effusively mischaracterized as Michelangelo's unparalleled self-portrait.

A second example of the misattributions in the Massarenti collection involves two pictures that Massarenti claimed were jointly painted by two of the masters of Baroque art, Domenichino and Guido Reni (figs. 5 and 6). According to the Massarenti Catalogue, the paintings were completed by Domenichino and Reni around 1620 when they were working in Rome on frescoes in the oratory of Saint Gregory in the church of San Gregorio Magno al Celio. ("Ces deux peintures furent faites pour concourir a l'execution des deux fresques si vantees

de l'Oratorie de St. Gregorie, aumont Celius.")[15] By referring to the oratory of
Saint Gregory, the catalogue misleadingly suggested that the painting depicted
the martyrdom of Saint Gregory. That was certainly the understanding of Henry
Walters, who, after acquiring the Massarenti collection, entitled both paintings
as the *Martyrdom of Saint Gregory* and attributed both to "Domenichino and
Guido," as if they were joined at the hip.[16]

There was little more than a grain of truth in Massarenti's description of
these two paintings. Domenichino and Reni were both born in Bologna, be-
came friends and fellow students in the Carracci Academy, and early in their
careers followed similar paths to Rome, where they became celebrated masters
of Baroque painting and collaborated in the painting of two magnificent fres-
coes in the same oratory. Practically everything else in Massarenti's description
of these two paintings was inaccurate. The subject of the paintings, the location
of the paintings, the date of their completion, and the notion that these two
paintings were jointly painted by Domenichino and Reni all represent depar-
tures from the two paintings' well-documented history known at that time.[17] In
1608, Guido Reni received an important commission from Cardinal Borghese
to decorate two oratories near the church of S. Gregorio Magno on the Caelian
hill in Rome. One of these oratories was dedicated to Saint Andrew. The plan
to decorate the Saint Andrew Oratory called for two frescoes depicting the
martyrdom of Saint Andrew to be painted as fictive tapestries on two long side
walls facing each other in the oratory. Although Reni was in charge of the en-
tire project and painted one of the frescoes, known as *Saint Andrew Led to his
Martyrdom*, Domenichino managed to obtain the commission to paint the
other fresco, known as the *Flagellation of Saint Andrew*.[18] Both were completed
around 1609. These are the paintings that served as the models for the small
copies in the Massarenti collection, which were mischaracterized as the *Martyr-
dom of Saint Gregory*.

The notion that Reni and Domenichino painted these two pictures together
collides with the fact that, by 1609, the two painters had developed sharply con-
trasting styles that would have made any collaboration on the same painting
extremely awkward and highly unlikely.[19] Domenichino's composition, which
focuses on Saint Anthony on the rack at the moment of his martyrdom, appears
stiff and disjointed, with different participants in the event grouped unnaturally
together. In contrast, Reni's composition flows from figure to figure almost po-
etically. Reni's painting depicts the moment when Saint Andrew, while being
led to his death, stopped and knelt in prayer upon receiving a vision of the
crucifixion.[20] In the late nineteenth century, when Massarenti was marketing

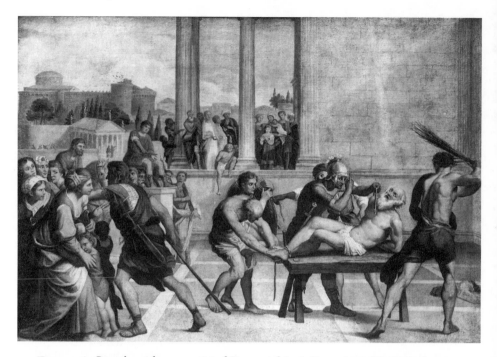

FIGURE 5. Copy by unknown artist of Domenichino's *Scourging of Saint Andrew*. Massarenti and Walters mislabeled the painting *Martyrdom of Saint Gregory* and characterized it as a "Study by Domenichino and Guido." In 1922, after Berenson's examination of the painting, Walters disposed of it, and its present owner is unknown. Photograph WAM Archives.

these paintings as being created jointly by Domenichino and Reni, the two paintings were understood by both art historians and the general public as having been produced by different hands. For instance, two of the most respected guides to Italian art, Burckhardt's *The Cicerone* and Baedeker's *Handbook for Travellers*, clearly drew a distinction between Reni's picture of Saint Andrew on the way to execution and Domenichino's picture of the execution.[21] Thus, contrary to the assertion by Massarenti, the paintings did not represent an amalgamation of the styles produced jointly by the hands of these two painters but, as the art historian Stephen Pepper has observed, two distinctly different paintings in which "each artist . . . executed the work assigned to him in his own style."[22] The misrepresentations in the Massarenti catalogue regarding these two paintings well illustrate its unreliability and its primary goal of attracting potential buyers rather than providing scholarly information about the works of art.

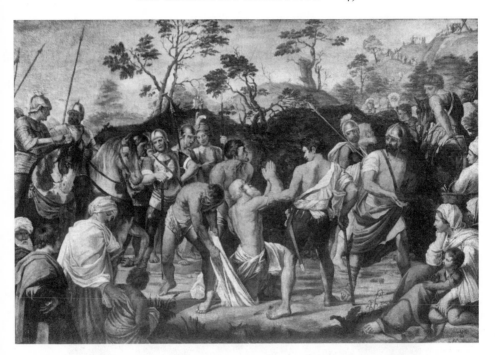

FIGURE 6. Copy by unknown artist of Reni's *Saint Andrew Adoring the Cross*. Massarenti and Walters also mislabeled the painting *Martyrdom of Saint Gregory* and likewise attributed it to both Domenichino and Reni. Along with its companion, Walters disposed of this painting in 1922, and its present owner is unknown. Photograph WAM Archives.

According to the Massarenti catalogue, *The Descent from the Cross* (fig. 7), purportedly by Caravaggio, was a small replica of the larger, well-known painting that was in the Vatican ("Replique en petit de la Deposition de la Croix existante dans la Galeria Vaticane").[23] This would have been remarkable because Caravaggio, unlike Guido Reni, rarely made any replicas of his own paintings. This was due in large measure to his practice of employing live models whom he individually posed and carefully illuminated to create the realistic scenes that he painted.[24] On the other hand, following his death in 1610 and for the next thirty years during which Caravaggio's fame ascended, his paintings served as models for young artists who converged on Rome to study painting and to compete for commissions. As a result, copies of Caravaggio's paintings became legion in Italy and beyond.[25] The popularity of Caravaggio's paintings as models for other artists was reflected in the Massarenti collection, which claimed to have six paintings by him. Except for the paintings attributed to Titian, there

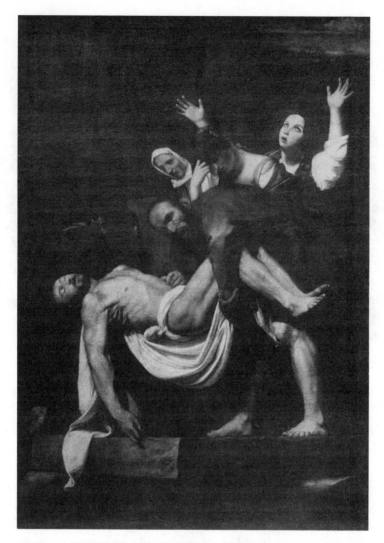

FIGURE 7. *The Descent from the Cross* attributed to Caravaggio.
Massarenti and Walters attributed this painting to Caravaggio. It
was described in Walters's 1909 catalogue as a "Replica, in small,
of the painting in the Vatican." Based on Berenson's advice, Walters
disposed of this painting in 1922, and its present owner is unknown.
Photograph WAM Archives.

were more paintings in the Massarenti collection purportedly by Caravaggio than by any other artist.[26]

Among the most admired and copied paintings by Caravaggio was his *Entombment* (which Massarenti named *The Descent from the Cross*), in which Caravaggio depicted the athletic, nude body of Christ being dramatically lowered toward an open tomb by Nicodemus and John the Evangelist, whose hand simultaneously touches the open wound on Christ's side, while Mary lowers her head in mourning and the Magdalene raises her arms in grief.[27] The painting was created in 1604 and strategically placed above the sacramental altar in the Vittrici Chapel in the Church of Chiesa Nuova in Rome. For the faithful looking up in awe at this painting, it was as if the body of Christ was being handed down to them literally in a manner that merged the symbolism of the Eucharist with the realism of Caravaggio's brush. This dramatic painting was praised from its inception. Bellori, the highly regarded seventeenth-century critic of Baroque art, characterized it as "among the best works ever made by Michale [Caravaggio] and is therefore justly held in highest esteem."[28] It was so highly venerated that Rubens, while in Rome in 1609, created his own version of Caravaggio's painting. Although Berenson initially frowned upon Caravaggio, toward the end of his life he converted into a champion of his art, characterizing him as the most serious and interesting Italian painter of the seventeenth century and acknowledging that his *Entombment* was "considered one of the greatest masterpieces of art."[29]

The *Entombment* remained in the Vittrici Chapel until 1797, when, as a result of Napoleon's defeat of the Papal States, it, along with over a thousand other Italian old-master paintings and other treasured works of art (such as the *Laocoön* and the *Apollo Belvedere*) were shipped as spoils of war to Paris and placed in the Louvre. Anticipating the transfer of Caravaggio's *Entombment* to France, the Church of Chiesa Nuova commissioned Vicenzo Camuccini, the renowned copyist, to paint a replica of it. The Camuccini *Entombment* replaced the Caravaggio painting above the altar of the church. When Caravaggio's painting was repatriated to Rome in 1817, it was not returned to the church but instead entered the collection of the Pope in the Vatican, where it has remained to this day. As a result, after 1817, there were in Rome two prominently displayed paintings of the *Entombment*, one being a mirror image of the other.[30]

Over the centuries, one copy of the *Entombment* seems to have spawned another, resulting in more than one hundred renditions of Caravaggio's famous painting finding places in prominent collections and galleries across Europe.[31] Although Caravaggio's fame had lessened in the nineteenth century, the

Entombment, more than any other painting in his *oeuvre,* retained its fame, and for that reason, it was prominently displayed by Massarenti in his collection. There should have been little doubt, however, that the painting was by an unknown albeit highly skilled copyist.

Around 1518, Titian painted *Christ and the Tribute Money,* a copy of which was in the Massarenti collection (fig. 8). The painting depicted the moment described by Matthew in the Gospels when Christ was approached by a Pharisee, who, intent on entrapping him into committing treason, asked whether the Pharisees were permitted to pay taxes to the Roman emperor. Christ requested the Pharisee to show him the coin used for the tax, and upon recognizing the face of Caesar on the coin, replied philosophically, "Then pay to Caesar what belongs to Caesar, and to God what belongs to God."[32] Titian's memorable painting emphasized the difference between good and evil, as embodied in Christ and the Pharisee. He contrasted the beautifully luminous face of Christ, his perfectly straight nose, and elegant fingers with the rugged, beastlike countenance of the Pharisee, whose hooked nose, boxed ear, gnarled hand, and darker skin, all of which were punctuated by a garish ring that hung from his ear, suggested that he had recently emerged from an inner circle of hell. It was a study of Christ's divine confidence and self-control when faced with the perils of those who would maliciously harm him. From the time of its execution to the end of the nineteenth century, the painting was extolled as one of Titian's masterpieces. By the end of the nineteenth century, the painting had found a permanent home in Dresden's Gemäldegalerie.

Massarenti acknowledged that one version of this famous painting was in Dresden but claimed that Titian had made two more replicas of the same painting, one of which was in his own collection. Massarenti's catalogue characterized his version as "a masterpiece by a great master" ("C'est un chef d'oeuvre du grand maitre"). To prove that his version was painted by Titian, his catalogue noted that the painting was signed by the master, "Ticianus, F." Massarenti strategically placed the painting on a picture stand near a large window in a manner that emphasized its importance and provided viewers with additional light with which to inspect it (fig. 9).

The painting, however, was not by Titian. It was a copy of Titian's painting made in the seventeenth century, approximately one hundred years later, by Domenico Fetti. Fetti was born in Rome in 1588 and at the age of twenty-five became the official court painter to Duke Ferdinando Gonzaga of Mantua and the superintendent of his significant art collection. Fetti's fame was based primarily on his paintings of New Testament parables, in which the spiritual

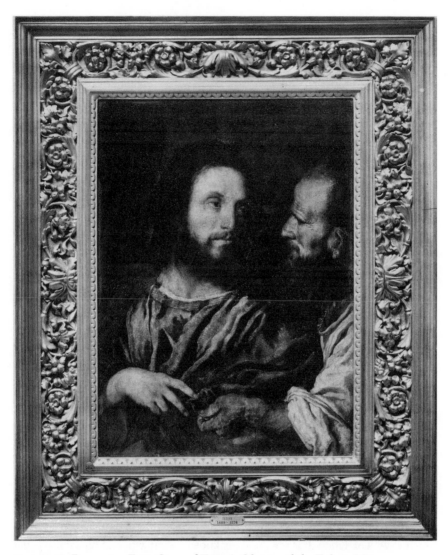

FIGURE 8. Domenico Fetti, Copy of Titian's *Christ and the Tribute Money*,
ca. 1618–20, oil on panel, 31¼ × 22⅛ in. WAM 37.582. Massarenti attributed this
painting to Titian and claimed that it was signed by him. Echoing this assertion,
Walters claimed that this painting as well as the self-portraits by Michelangelo and
Raphael "have the names of the artists upon them." Photograph WAM Archives.

FIGURE 9. Salle I in the Massarenti Gallery, Rome, about 1900. In the upper right-hand corner of the room is a portrait purportedly of Catherine de' Medici attributed to Bronzino (now workshop of Allesandro Allori, WAM 37.1112), but the main attraction in the room was the painting of *Christ and the Tribute Money* attributed to Titian, which was prominently placed on an easel in front of the other paintings. Photograph WAM Archives.

teachings of Christ about the difference between good and evil were imparted to his followers.[33] In 1621, Fetti traveled to Venice for the purpose of purchasing art for the duke and was subjected to the influence of Venetian painting, including the work of Titian. It is not precisely known when, where, or what motivated Fetti to copy Titian's painting of *Christ and the Tribute Money*, but it is likely that the Duke of Mantua, aware of Fetti's skill in painting scenes depicting Christ's teachings as well as his ability to emulate the colors of Titian, requested that he copy Titian's painting for his collection. The painting illustrates the practice of prominent artists, at the request of their patrons, of painting copies of famous paintings by earlier Renaissance masters.[34]

Perhaps the most remarkable misattribution was attached to an easel painting, which had been darkened with veneer, of a woman solemnly dressed in black

FIGURE 10. Salle in Massarenti Gallery, Rome, about 1900, with a portrait of Maria Salviati de' Medici by Pontormo, mistakenly identified as a portrait of the poet Victoria Colonna and misattributed to Sebastiano del Piambo. The painting was relegated to a dark corner of the room near the floor, where it was unlikely to be noticed. Photograph WAM Archives.

as if in mourning. Practically hidden from view, it hung just above the floor in the dark corner of a room full of paintings in a manner that suggested that it was unworthy of attention (fig. 10). The painting, according to Massarenti's catalogue, was by Sabastiano del Piombo, a relatively unknown artist, and depicted the sixteenth-century poet Victoria Colonna.

Walters initially adopted this attribution when he opened his museum in 1909. Five years later in 1915, however, following Berenson's inspection of Walters's collection, the Colonna painting happily was reattributed to Jacopo Pontormo, the most prominent painter in Florence toward the middle of the sixteenth century and a favorite artist of the Medici.[35] Because the identity of the woman painted by Pontormo was unknown, the painting was simply entitled "Portrait of a Lady." The importance of the painting was further elevated in 1937 when the "lady" was identified as Maria Salviati de' Medici, the granddaughter

FIGURE 11. Pontormo's *Portrait of Maria Salviati de' Medici* before its restoration. Walters adopted Massarenti's attribution, and in his 1909 catalogue, Walters referred to Sebastiano del Piambo as the artist. After Berenson's examination of Walters's collection in 1914 and based on Berenson's advice, Walters upgraded the attribution to Pontormo in a new catalogue that was published in 1915. Photograph WAM Archives.

of Lorenzo de' Medici and mother of Cosimo de' Medici, who became Duke of Florence in 1537 (fig. 11). Furthermore, a careful cleaning of the painting that year revealed that it was actually a double portrait of Maria Salviati and a child, whose image had been painted over (fig. 12). The child in the Pontormo painting was subsequently identified as Giulia, the illegitimate African European

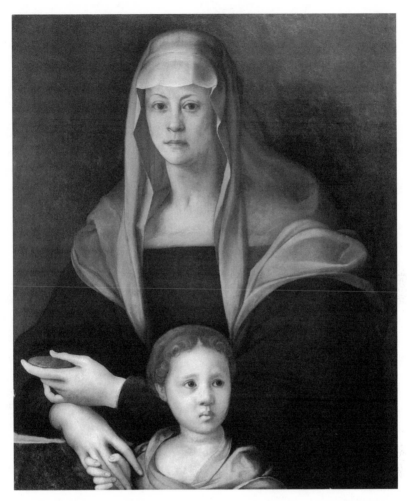

Figure 12. Pontormo's *Portrait of Maria de' Salviati with Giulia de' Medici*, ca. 1539, oil on panel, 34⅝ × 28¹⁄₁₆ in. WAM 37.596. When Walters acquired this painting from Massarenti in 1902, the young girl was painted over. In 1937, six years after Walters's death, the painting was restored and the young girl discovered. The young girl has been identified as Giulia, the daughter of Duke Alessandro de' Medici, heir to the leadership of the Florentine Republic, who was assassinated in 1537. Following Alessandro's death, Giulia was cared for by Maria de' Salviati, the mother of Cosimo de' Medici. Pontormo pictured Giulia holding onto the long elegant fingers of Maria while both appear to be in mourning. Photograph WAM Archives.

daughter of Duke Alessandro de' Medici, whose assassination in 1537 led to
the selection of Cosimo as duke. Following Alessandro's death, Maria Salviati
looked after Giulia with the care and tenderness reflected in Pontormo's double
portrait. The importance of the painting of Maria Salviati and Giulia in mourn-
ing lies not only in the fact that it was painted by Pontormo but also in its visu-
alization of a significant page of Renaissance history.[36]

As illustrated by the unrecognized painting by Pontormo, scattered in Mas-
sarenti's field of misattributed copies were genuinely important paintings of
quality that helped to frame the history of Italian art from the thirteenth to the
eighteenth centuries. Some were truly by well-known artists, such as Pietro
Lorenzetti, Giovanni di Paolo, Fra Filippo Lippi, Carlo Crivelli, Giulio Ro-
mano, Rosso Fiorentino, Jusepe De Ribera, Bernardo Strozzi, and Giambattista
Tiepolo. Other paintings, such as *The Ideal City*, evoked a time and place in
Renaissance history in a manner so astounding to the eye and mind that the
identity of its author was unnecessary. From the time that *The Ideal City* (see
plate 2) was displayed in the Massarenti collection to the present, twelve differ-
ent artists or anonymous members of different schools of art have been identi-
fied by various scholars as its likely painter.[37] The inability to reach any agree-
ment as to its authorship has not kept the painting from being universally
admired as one of the Renaissance's great masterpieces. Thus, below the surface
of Massarenti's collection of bogus masterpieces was an array of paintings that
were of the kind and quality which, Walters believed, would tell the history of
Italian painting.[38]

Massarenti's goal was to keep his collection intact and to sell it to someone
who was willing to purchase the whole thing and who would allow the collec-
tion to carry his family name. He could not find any European collector who
would accept these terms. Like Joel Duveen, most Europeans doubted the at-
tributions given to the paintings and considered the collection as a whole to
have little value. Unable to entice any European collector to buy it, Massarenti
turned to the United States for prospects. He retained the services of J. H.
Senner, an American attorney and journalist, who had served as U.S. commis-
sioner for immigration in New York. There was nothing in Senner's background
to indicate any expertise in the field of art. By reason of his legal training and
governmental experience at Ellis Island, however, he was familiar with the regu-
latory nuts and bolts of bringing Italian works of art into the New York harbor
and was able to bring this special knowledge to the bargaining table. Moreover,
he was familiar with New York's upper-crust collectors and brought the avail-
ability of the Massarenti collection to their attention. Senner's initial objective

was to sell the collection to the Metropolitan Museum of Art, but when this failed to materialize, he offered the collection to Walters. His instrumental role in selling the Massarenti collection to Walters was recognized by the New York press: "To him [Senner] is due the credit of having called the attention of Mr. Walters to it, in order to secure it for America."[39]

5

A REMARKABLE
ACQUISITION

In 1902, as America entered the twentieth century, there was among the country's wealthy industrialists a soaring confidence in the destiny of the country to become an economic and military superpower. The United States had emerged victorious in the Spanish-American War, occupied Puerto Rico, and secured the Philippines as its own territory halfway around the world. As exemplified by President Theodore Roosevelt's hubristic claim in 1901, "I took the [Panama] Canal Zone,"[1] the nineteenth-century concept of manifest destiny had grown in the United States from a national to an international mandate. The key to America's economic expansion was the dramatic growth in America's rail and shipping industries, and business tycoons like Henry Walters and his friend J. P. Morgan, who were perched at the top of these commercial empires, foresaw tremendous gains in the profitability of their companies as well as their own net worth. In 1901, Morgan engineered the consolidation of several international shipping and railroad companies whose combined capacity to control Atlantic shipping caused England, in 1902, to reluctantly relinquish its traditional hegemony over cross-Atlantic shipping and to agree to become an international partner, not a competitor, in Morgan's American-based shipping trust. In the same year, Morgan orchestrated the creation of United States Steel Corporation, the largest corporation in the world, and several years later he invited Walters to join its Board of Directors. By the end of 1902, U.S. Steel had generated over $150 million in net profits for its investors.[2]

Like Morgan's financial and industrial empire, the profitability of Henry Walters's railroad interests surged at the turn of the century through mergers and acquisitions. In April 1900, Walters was instrumental in convincing several in-

dependent railroads operating in Virginia, North Carolina, and South Carolina to merge and become the Atlantic Coast Line Railroad Company of Virginia (ACLRR), whose stock was in large measure controlled by Walters's Atlantic Coast Line Company. Approximately two years later, in March 1902, the ACLRR acquired and then merged with the extensive Savannah, Florida & Western Railway Company, providing ACLRR with an additional 2,235 miles of track. This acquisition and merger not only resulted in the creation of one of the country's largest railroads, with more than four thousand miles of rail lines, but also in a dramatic increase in the railroad's profitability and the value of its common stock. Walters, who was elevated to chairman of the board of the combined railroads, was its largest stockholder,[3] and he became, at least by reputation, "the wealthiest man in the South."[4]

On March 24, 1902, four days after the Atlantic Coast Line Railroad's Board of Directors approved of the merger, Walters left for Europe, leaving business behind temporarily to pursue an acquisition of culture that would overshadow his successful business ventures. Joined by his good friend and advisor, William Laffan, Walters moved rapidly from his acquisition of railroads at home to the acquisition of culture abroad as if they were on the same track. The travelers stopped briefly in Paris to consider the purchase of an ornamental gate from a cathedral's choir screen before hastening to Rome to inspect and probably purchase the Massarenti collection.[5]

As he headed for Rome, Walters likely was in an upbeat mood about his prospects for purchasing the Massarenti collection. He had been informed that Massarenti not only was anxious to sell his collection but also had already obtained the permission of Italian authorities for the collection to be exported to the United States. The asking price and the basic terms of the deal also had been conveyed by Senner to Laffan and Walters in advance. Massarenti offered to sell the collection for $1 million. This price included Massarenti's payment of the Italian export duty of 20 percent, the expenses entailed in crating and transporting the collection to a steamer in the nearby port of Civita Vecchia, and the payment of a potentially "enormous" amount of "*bakseech*" (a euphemism for bribes) to Italian governmental officials.[6]

None of the terms proposed by Massarenti deterred Walters. To the contrary, Walters viewed the offer as a propitious opportunity to purchase a potentially magnificent collection of art. As a result of the remarkable success of his recent business ventures in the railroad industry, Walters had the financial confidence and wealth to purchase it. The nationalistic mentality favoring the acquisition of foreign treasures, whether territorial, commercial, or cultural, encouraged it.

He was also aware that the collection had been on the market for many years, and Massarenti, as he grew older, was very anxious to sell it. In contrast to the cultural patrimony laws of today, there were no firm laws in the young Italian nation that effectively protected it. Nor were there any laws in the United States or standards of conduct for museums, such as exist today, which prevented voracious collectors like Walters from hauling away to American shores another nation's cultural treasures. Having recently purchased three adjacent houses on Baltimore's Charles Street (around the corner from where his father resided on Mount Vernon Place) for the purpose of constructing a new museum, Walters already had in mind a place to house it. And he was guided by one of the most sophisticated cultural impresarios in American, William Laffan, who was in favor of buying it. All of these factors coalesced to generate in Walters a strong disposition to purchase the Massarenti collection even before he ever saw it.

Yet the catalyst for Walters's purchase of the Massarenti collection was not primarily the surrounding, external circumstances that weighed in its favor, but instead his own insatiable thirst for adventure in the challenging field of international culture. At the age of fifty-four when he purchased the Massarenti collection, Walters was not in appearance a dashing, heroic-looking figure. To the contrary, he was short and portly, with a waistline that approached his age and a full mustache that covered his lips. He had the outward appearance of a wealthy man who had led a sedentary life of overindulgence and who had too much of a good thing. Walters was known and admired for his quiet, retiring nature and his avoidance of personal publicity. His demeanor was more characteristic of a true gentleman than a successful businessman. However, behind this soft and gentle appearance was a hard-nosed, risk-taking, cultural entrepreneur who purchased art without hesitation but with his fingers crossed. The quality that propelled Walters to success as an art collector was not his shyness but his decisiveness. He had neither the time nor the inclination to hem and haw over each acquisition. He made his decisions quickly but intelligently. Beginning with his acquisition of the Massarenti collection, Walters would continuously acquire art in quantities so large as to eliminate any possibility that he carefully examined firsthand each work of art before committing to its purchase.

The fusion of cultivation with the globe-trotting spirit of adventure, which motivated Walters, was also embodied in the personality of his good friend and advisor William Laffan. Bernard Berenson's wife Mary had an apt description for Laffan. She characterized Laffan as the "deus ex machine, a wicked old boy."[7] Born in Dublin, Ireland, Laffan moved to the United States to pursue a career

in journalism, becoming editor of Baltimore's *Daily Bulletin* and thereafter the editor and owner of New York's *Evening Sun*. Regularly dressed in formal attire, sporting a Van Dyke goatee and having a glass eye, Laffan was a well-recognized, singularly influential character in the New York cultural world. He was, as Mary Berenson suggested, the one figure in New York to whom every wealthy collector turned as the arbiter of cultural taste. Laffan was a close friend of J. P. Morgan and an influential member of the board of directors of the Metropolitan Museum of Art. According to one account, he was "responsible for the purchase of millions of dollars worth of treasures that were sent from Europe to American collections."[8] In the 1870s, Laffan became a devoted friend and influential advisor of both William and Henry Walters. He guided William Walters in his acquisition of Oriental ceramics, and he was instrumental in engineering Walters's purchase of the Massarenti collection. Aware of Laffan's reputation and influence, Bernard Berenson courted Laffan in 1904 while visiting New York, and a few months later, Berenson arranged to dine with him again while both were in Paris. Berenson sought to enlist Laffan's good will, hoping that Laffan would encourage his elite circle of wealthy and sophisticated New York friends to buy their Italian Renaissance art from him.[9]

Henry Walters cherished Laffan's advice on cultural matters and openly acknowledged his indebtedness to him. In a letter to Bernard Berenson, written in 1909 shortly after Laffan's death, Walters wrote:

> His loss to me is irreparable. Our friendship covered a period of time of over thirty years. Our sympathies and interests were alike, and at my time in life, his friendship cannot be replaced. His loss to our country is much greater than people believe. His connection with the real people in Europe . . . made it possible for him to do things as no one else in our country can do them.[10]

Although Walters did not document the advice he received from Laffan regarding the purchase of the Massarenti collection, his praise of Laffan's connections and wherewithal to get things done "as no one else in our country can do them" probably alluded to Laffan's pivotal role in facilitating Walters's acquisition of the Massarenti collection.

Given that Walters and Laffan did not arrive in Rome until April 7, 1902, at the earliest and signed the contract of sale on April 16, there was obviously little time or inclination to carefully look at each of the nine hundred paintings or to even glimpse the additional eight hundred objects in the collection. At best, Walters, with the aid of the catalogues prepared by Massarenti, obtained only a generalized impression of the overall nature and quality of the collection.

Although Walters and Laffan shared a general knowledge about Italian Renaissance art, neither was a connoisseur in this field, and neither had the expertise to challenge Massarenti's attributions or to distinguish with any sense of confidence rank copies from original works by Italian masters. In any event, arguing over the attributions of the individual paintings would have tied the parties in knots and served no useful purpose in light of the understanding that the sale was an all-or-nothing deal. Rather than occupy his time discussing attributions, Walters planned to address this problem and, with the assistance of his own curatorial staff, "sort out those I do not desire to keep" after the collection arrived in the United States.[11]

As he surveyed the Massarenti collection, Walters saw very few paintings that in his judgment were bona fide masterpieces. This did not disturb him. Walters's overarching interest in the Massarenti collection was not in the pedigree of each individual painting but in the capacity of the collection as a whole to tell the overall story of Italian art from school to school and from century to century. Years later, in a letter to Bernard Berenson, Walters described his reason for purchasing the Massarenti collection:

> In buying the Massarenti collection, I understood quite well there were few pictures therein which could be considered masterpieces. I did, however, believe I could retain a sufficient number of pictures to present fairly a history of Italian art, it being my intent to add, from time to time, a few important Italian pictures to improve the collection.[12]

Walters undoubtedly recognized that many of the paintings in the Massarenti collection were copies of famous paintings, such as Caravaggio's *Descent from the Cross* and Titian's *Adoration of Venus*. He did not, however, summarily dismiss these paintings. Walters was well aware that throughout history great masters occasionally made one or more duplicates or versions of earlier paintings and that duplicates could be as valuable as their earlier prototypes. He learned this lesson from his father, who in 1859 purchased an autograph version of Gérôme's *The Duel after the Masquerade*, which was viewed by him and art critics in general as among the most important works of art in the Walters's collection. In 1871, his father purchased at considerable expense another replica of a famous work of art: Delaroche's *The Hémicycle des Beaux-Arts*, which, as its name implied, was at the Academy of Fine Arts in Paris. Years later, in 1908, Henry Walters, like his father, elected to purchase a later version of another celebrated painting—Ingres's *Oedipus and the Sphinx*, the earlier version of which was in the Louvre.[13] Moreover, even if Henry Walters believed that the copies in the

Massarenti collection were not by the hand of the master, he would not have shied away from their acquisition. Like the great seventeenth-century collector Cardinal Borromeo, Walters saw value in excellent copies of old-master paintings. There is no better evidence of Henry Walters's interest in acquiring excellent copies of Italian masterpieces than his purchase of a copy of Leonardo's *Mona Lisa*, which he displayed at the opening of his gallery in 1909 and referred to in his catalogue as "Copy of L. Da Vinci—*Lisa, Gioconda*—Original in the Louvre."[14]

Walters was impressed with the manner in which the schools and periods of Italian art were organized and conveyed in the Massarenti catalogue. He subsequently instructed Faris C. Pitt, whom he retained as his curator, to arrange the paintings purchased from Massarenti in a similar manner. Walters wrote:

> It is my intent to arrange these [pictures] upon the walls in a certain sense according to schools, and to this end as a starter, I will take "The old man in the tower's" [Massarenti's] catalogue and divide the galleries into sections and allot to each one of these sections, by the numbers of the catalogue, which are also on the pictures, so that, as the pictures are delivered in Baltimore at the galleries, they can at once be placed on the floor in front of the proper division.[15]

Walters left behind no notes or diary from which can be discerned any special interest in any particular painting in the vast Massarenti collection. However, among the hundreds of paintings that Walters surveyed, two prominently displayed, remarkable landscapes probably registered in his mind and spirit more personally than the others. The subject matter of both paintings served to bridge the gap in time and place between the Renaissance era paintings and Walters's own contemporaneous plan to collect and display them in a new museum to be constructed in Baltimore's Mount Vernon Place. Baltimore's Mount Vernon Place was, from the standpoint of landscape architecture, one of the most beautiful public squares in America. The cross-shaped plaza with axes running north and south as far as the eye can see was designed in 1830; it features a symmetrical park with a fountain and punctuated at its center by the Washington Monument, whose shape is reminiscent of a Roman celebratory column, like the Column of Trajan in Rome. At the top of the column, of course, is not any Roman hero or virtue but the father of our country, who was thought to embody all virtues. Along the axes of Mount Vernon are stately, neoclassical homes, one of which was where Walters had been born and raised.

Following the Civil War, wealthy Americans turned to architecture as the primary means for translating their new interest in the Italian Renaissance into

the language of American culture.[16] Led by the architectural firm of McKim, Mead and White, important public buildings, such as the Boston Public Library, and stately private residences, such as the Villard Houses in New York City, adopted the style of fifteenth- and sixteenth-century Italian palazzos, with prominent, overhanging cornices, deep friezes, decorative pilasters, rusticated facades, and arches seemingly everywhere. In Baltimore, the interest in Renaissance Revival architecture initially was expressed in the design of the Peabody Institute on Mount Vernon Place. Completed in 1861, the Peabody was designed to house a magnificent library, a large lecture hall, and an art gallery. To capture the spirit of culture and learning, the building featured architectural motifs borrowed from the Italian Renaissance, such as a stone balustrade, arched doors framed by pilasters, and Palladian windows.[17] In 1884, Robert Garrett, one of Walters's wealthy neighbors in Mount Vernon Place, retained Stanford White to redesign his home in the new Renaissance Revival style that had captured much favor. Many other homeowners along Mount Vernon Place joined suit, and the spirit of the Italian Renaissance became imbedded in the fabric of the Mount Vernon neighborhood where Henry Walters once lived and where he planned to build his new museum.

As Walters wandered from room to room looking at the Massarenti collection of Italian paintings and thinking about the space he had purchased on Mount Vernon Place to house them, his attention was probably arrested by a long, rectangular painting then entitled *Architecture with Figures* (now called *The Ideal City*) displayed high on the center of the wall in one of the rooms (see plate 2).[18] The painting, which is now acclaimed as one of the masterpieces of the Italian Renaissance, depicts a vast public square perfectly designed in accordance with the tenets of linear perspective in which versions of the Roman Colosseum, the Arch of Constantine, and the Baptistery in Florence are harmoniously arranged in a manner that appears both rational and pristine. While the surrounding buildings help to define the space, they do not confine it. Entrance to the public square is open to all. In the center of this idealized square is a public fountain adorned with a figure of Cupid; from the fountain two unusually tall, elegant women freely draw water in a manner that illustrates the benevolence of the ruler and his devotion to the public good. Placed around the fountain are four Corinthian columns holding marble statues of Roman goddesses who likely embodied the virtues of justice, moderation, fortitude, and liberality.[19] Like the statues of orators placed on top of columns in the Rostra of the Roman Forum, each goddess gestures as if seeking to persuade the citizens of this ideal city not to stray from the virtue she embodies. The painting represents a utopian vision

of how aesthetic beauty and perfection in architectural design could be marshaled by a wise and just Renaissance prince to serve the best interests of the public.

In Walters's mind, the painting might have served, like a distant mirror, to remind him of Baltimore's Mount Vernon Place, with its own carefully designed space and assemblage of monumental structures, where he planned to erect his own Italianate museum to house his collection. One might imagine Walters looking with special interest at the magnificent palazzo, with its characteristic arches and pilasters, overlooking the square on the left side of the painting and considering it as a model for his museum, which, as we know, would include the same architectural elements. In this light, one might understand how this painting would have caught Walters's eye, captured his imagination, and attracted his interest in owning it as an exquisite expression of his own ideals about the collection and display of art for benefit of the general public.

The second large, panoramic painting that probably captured Walters's interest involved the ancient tradition of acquiring and transferring cultural treasures from the shores of one nation to another—the very activity that Walters was undertaking. The painting, entitled *Seven Wonders of the World* (now called *Panoramic Fantasy with the Abduction of Helen*) (see plate 3) depicts in its background the wonders of the classical world, including the Egyptian pyramids and the Roman Forum—places that Walters, while aboard his luxurious, 224-foot-long yacht *Narada*, had recently visited. In the foreground of the painting is depicted the abduction of Helen by Paris and the carting away of objects of art and other treasures belonging to King Menelaus to ships waiting offshore for transit to Troy. To Walters, this mythical scene probably represented more than the opening chapter in the Trojan War. It addressed the ancient Roman tradition of hauling works of art back from conquered lands to adorn their public squares and buildings, a tradition that was revived by the Venetians, reflected in Lord Elgin's shipment of the Parthenon marbles to the British Museum, and then repeated on a grand scale by Napoleon to establish the Louvre as the ultimate showcase of Western culture and civilization. With plans to load his own chartered ship with the vast collection of art belonging to Massarenti and to transfer this cultural heritage from Italy to America, Walters might have read this painting as a history lesson that linked his own ambitious effort to the legendary, albeit controversial, tradition of treasure hunting in the past.[20]

Following a tour of the collection, Walters, Laffan, and Senner sat down to discuss the terms of the sale. Two serious problems immediately threatened to scuttle the deal. First, much to Walters's surprise and consternation, he was

informed by Senner that Massarenti had raised the price of his collection by 50 percent, from $1 million to $1.5 million. Walters promptly rejected the proposal and countered with an ultimatum. He stated that he would pay $1 million for the entire art collection and that he would engage in no further negotiations regarding its price. He further asserted that if his offer was not accepted by April 16, his interest in purchasing the collection would terminate.[21]

The second controversy involved a painting that was considered to be the jewel of the Massarenti collection — a painting that was valued even more highly than Michelangelo's *Self-portrait*. It was Raphael's portrait, which Massarenti entitled *His Own Portrait at the Age of 25* (see fig. 2). The melodramatic description of this painting set forth in Massarenti's Catalogue Du Musée should have served as a strong warning that it probably was not what it purported to be:

> This bust is of a sublime majesty and style. The passionate love of beauty that drove this master and with which his works overflow, finds expression more than once here. The nobility and radiant life diffused through his features, his joyful and profound gaze, his animated brow, and his firm and noble energetic mouth are testimonies to the young and noble poetic spirit of this great man. The whole is appealing, as much for its beauty and its layout as for the golden hue of its colors. It is the expression of a sublimely passionate soul overflowing with love.[22]

In 1902, at the time when Massarenti was representing that his painting was a self-portrait by Raphael, there were three other paintings that were also known as Raphael self-portraits. The first was an easel-sized self-portrait of Raphael wearing a black cap. It was painted around 1506 when Raphael was twenty-three years old and residing in Florence. The painting had been in the collection of Cardinal Leopoldo de' Medici until 1682, when it entered the Uffizi Gallery, where it remained at the turn of the last century when Massarenti was preparing his catalogue. The second self-portrait was painted two years later when Raphael was twenty-five. Raphael included his image in his magnificent tableau of the *School of Athens*, painted for Pope Julius II between 1508 and 1510 in the Stanza della Segnatura in the Vatican. Vasari in his *Lives* identified Raphael in this painting standing next to the philosopher Zoroaster: "Next to him [Zoroaster] is the portrait of Raphael, the master of this work, who painted himself while looking in a mirror. He has a youthful head and a very modest appearance coupled with a pleasant and modest grace, and he is wearing a black beret."[23]

The third painting that was believed at that time to be a self-portrait by Raphael was owned by the Altoviti family in Rome and Florence until 1808, when it was acquired by King Ludwig for his magnificent collection at the Alte Pina-

kothek in Munich and for the first time displayed for the general public. This self-portrait grew in fame, and during the eighteenth and nineteenth centuries, engravings and lithographs of it were repeatedly made.[24] The self-portrait purportedly by Raphael that was in the Massarenti collection appears to have been modeled after one or a composite of these engravings.[25] Toward the end of the nineteenth century, questions were raised by Morelli about whether the painting in Munich should be attributed to Raphael, and as a result it was downgraded and deaccessioned. The painting was acquired in 1938 by the National Gallery of Art in Washington and is now generally recognized to be a portrait by Raphael not of himself but of his friend and patron *Bindo Altoviti*.[26]

In 1902, when Massarenti was seeking to sell his collection, the painting that was purported to be a self-portrait by Raphael was coveted by the Italian government, which wanted this painting to remain in Italy as part of its cultural heritage. Massarenti offered to give this painting to the government in return for its permission to export his collection to the United States. Walters, however, was unwilling to relinquish the painting, and a tug of war ensued. As reflected in the written contract of sale, the terms relating to Raphael's self-portrait became muddied in contradiction. Referring to Raphael's self-portrait (identified as catalogue number 132), the contract stated that "catalogue 132 [and five other works of art] were presented to the Italian government by Don Marcello Massarenti to assist in securing the necessary permit to export the collection. Said permit has now been issued by the Government and signed by his Majesty King Humbert II." However, the use of the word "presented" instead of "given" suggested that the paintings did not actually change hands. Indeed, the next sentence of the agreement, which likely was added by Walters, indicated that Walters had overridden the idea of giving these particular works of art, including Raphael's self-portrait, to the Italian government and insisted that other paintings be given instead. It ambiguously stated: "These four objects cannot be delivered but in their places have been substituted the following which have been accepted by Henry Walters." According to the agreement, one of the paintings that was to be substituted and delivered to Walters, not the Italian government, was "Raphael, Portrait of himself."

Due to the confusion, the Italian press, and apparently some officials in the Italian government, believed that Raphael's self-portrait was not included in the sale and remained in Italy.[27] They were mistaken. In the fog created by these ambiguities, Walters managed to include this painting in the shipment of art he brought to the United States. How he managed to do this remains a mystery. In any event, the painting quickly became one of the most acclaimed paintings

in Walters's collection. It not only was identified in Walters's 1909 Catalogue of Paintings as *Raphael, His Own Portrait at the Age of 25*, but also specifically praised in an article published in the *Baltimore Sun* as one of the greatest paintings Walters acquired from Massarenti.[28] Whatever joy Walters obtained from his acquisition of this celebrated painting and the favorable publicity it initially generated was dashed several years later when Walters's advisor, Bernard Berenson, declared that it was merely a rank copy unworthy of inclusion in Walters's collection.

The agreement executed on April 16, 1902, after describing on page one what items were to be excluded from the sale, turned to the critical question of price. Accepting Walters's counter-offer, the agreement called for Walters to pay 5,400,000 francs (or roughly $1 million) for the collection. The expenditure in a single transaction of $1 million for art by an American collector was unprecedented, but there is no evidence that Walters hesitated about spending this amount. To the contrary, after striking this deal and returning to New York, Walters expressed anxiety that Massarenti might renege on it. On May 13, 1902, Walters wrote to Laffan that he was concerned that "the old man in the tower" might "throw obstruction in the way, and talk a little outside with the hope of preventing the transaction."[29]

Although there was no way to gauge the monetary value of the entire Massarenti collection, Walters and Laffan had reason to believe that they had struck an excellent bargain. Based on stories in the New York press, Walters and Laffan were well aware that their friend J. P. Morgan, one year earlier, had spent $400,000 for a single altarpiece, the *Colonna Madonna* by Raphael, and a total of $600,000 for the Raphael and four other paintings.[30] They also probably knew that Morgan was planning to continue to spend hundreds of thousands of additional dollars in 1902 for collections of sculpture, tapestries, illuminated manuscripts, and other significant collections of art.[31] Walters admired Morgan, he aspired to be like him, and he likely envisioned that his purchase of the massive Massarenti collection for $1,000,000 would place him squarely in Morgan's league. In that Morgan, exercising his sage financial and aesthetic judgment, was willing to spend $600,000 for a Raphael and a handful of other paintings by Renaissance masters, the opportunity to purchase hundreds of Renaissance paintings, possibly by Raphael, Titian, Leonardo, Michelangelo, and others, as well as hundreds of other works of art in the Massarenti collection, must have seemed to Walters and Laffan a risk that was well worth taking.

Walters's payment for the Massarenti collection was due on July 1, 1902, the date by which the collection was scheduled to have been delivered by Senner,

acting for Massarenti, to a steamer docked in the nearby port of Civita Vecchia. As outlined on pages 2, 3, and 4 of the agreement, Senner was responsible for securely packing the art collection, transporting it to Civita Vecchia, storing it there until delivered on board the awaiting steamer, and paying for the costs of these services. The agreement also called for Senner to pay all export charges or costs of any kind accruing prior to the delivery of the collection on board the steamer. Walters in turn was responsible for obtaining and paying for the steamer to ship the collection to the United States.

Following the execution of the agreement, Walters promptly returned to the United States, leaving Laffan behind to assure that its terms were fully satisfied. On May 13 and again on May 29, 1902, Walters wrote to Laffan informing him that, due to his business obligations, he could not return to Rome during the month of June. Walters requested Laffan to go to Rome in his place to finalize the arrangements for shipping the collection to America, to make the financial arrangements for payment for the collection, and to help him navigate around potentially steep import fees that had to be paid to bring the collection to the United States.[32] In addition to enlisting the continued assistance of Laffan, Walters designated Emile Rey, an associate of the art dealer Jacque Seligman, to represent him with regard to some of these matters.

In 1897, the U.S. Congress had enacted the Dingley Tariff Act, which imposed on art imported into this country a hefty import duty of 20 percent of the value of the artwork. The law exempted works of art that were clearly intended to be displayed in public museums but not works of art that were destined for private homes and galleries, like that belonging to Walters. Characterized as a "tax on civilization," American collectors of art, such as Isabella Stewart Gardner and J. P. Morgan, sought ways, both legal and illegal, to assiduously avoid it.[33] Morgan, to avoid the tax, kept most of his collection at his home in England until 1909, when the law was changed and the duty eliminated.[34] Gardner, in an effort to escape the import tax, requested Berenson to arrange for a painting by Raphael to be "smuggled" to her,[35] and she misleadingly claimed that the Italian masterpieces that she acquired for herself were acquired for the public, a claim that was rejected by the federal government and resulted in the assessment of taxes and fines against her in the amount of $200,000.[36]

Unlike Morgan and Gardner, Walters did not try to completely escape the payment of import duties, but he was not above the use of misrepresentation and deception to minimize the fees he would have to pay. Walters was potentially liable for import fees in the range of $200,000, which amounted to 20 percent of the Massarenti collection's sale price of approximately $1,000,000

(5,400,000 francs). To reduce this potential assessment, Walters sought to capi-
talize on the fact that certain furniture, clocks, sculpture, and paintings be-
longing to Massarenti were not included in the sale. In reality, the objects that
Walters left behind amounted to less than 5 percent of the art in the Massarenti
collection. Walters, however, grossly exaggerated the amount of art that re-
mained in Italy, claiming that 50 percent of the Massarenti collection was not
included in the sale. By creating the impression that half of the collection had
been left in Italy, Walters hoped to cut his import tax in half. In pursuit of this
scheme, Walters urged Rey and Laffan to claim that the value of the collection
was 2,500,000 francs, or less than half of the purchase price. In his letter of May
29, 1902, to Laffan, Walters stated, "My impression is, that the collection should
be invoiced at an aggregate of 2,500,000 francs, as there is really a considerable
amount of the collection which we do not bring to America." In a letter of May
13, 1902, to Rey, Walters advanced the same scheme to reduce the import tax.
He reminded Rey that he had "sold two or three very important divisions of the
collection: all the furniture, all the clocks and the Etruscan sarcophagi tops in
the hall."[37] In an effort to garner support for this claim, Walters on May 20, 1902,
informed the *New York Times* that "he does not value the collection as high as
$1,000,000."[38]

The Massarenti collection left Italy on June 23 and arrived in the port of New
York on July 12, 1902.[39] Two days later, on July 14, 1902, Walters met with U.S.
Custom Department officials and represented in writing and under oath that
the Massarenti collection cost him $501, 985.[40] However one might judge in
hindsight the honesty of Walters's effort to minimize his taxes, it was a scheme
that worked. The U.S. Custom officials accepted Walters's representation and
charged him $90,617.20, less than half of what he actually owed.[41] Ironically,
Walters's willingness to pay this amount was applauded by members of the pub-
lic. In a letter to the editor of the *New York Times*, Walters was cited as a model
for other wealthy importers of art to follow.[42]

6

THE SACRIFICE OF CANDOR FOR ACCLAIM

After Walters's Massarenti collection arrived in New York on July 12, 1902, the art was transferred to a large, light-filled loft containing thirteen hundred feet of floor space in the Parker Building located at Fourth Avenue and Nineteenth Street, which Walters had converted into a veritable museum, with two lengthy partitions that were twelve feet high. The area provided fifteen hundred feet of running wall space to hang, inspect, authenticate, and appraise everything Walters had purchased in Rome. Although Walters initially leased this space for two years, the Massarenti collection remained in Walters's temporary Nineteenth Street museum for more than five years, until the fall of 1907, when it was shipped to Walters's new Renaissance Revival gallery in Baltimore.[1]

In November 1902, shortly after the collection was brought to its resting place in New York, its quality was sharply challenged in a highly critical article entitled "Wanted: A School for Art Collectors" that appeared in *The Nation* magazine. *The Nation* at that time was one of the most influential voices in America on cultural matters.[2] To America's new collectors, like Walters, what this magazine said mattered. As suggested by the title, the article in *The Nation* contended that Walters's purchase of the Massarenti collection was prime evidence of his inability to discern good paintings from bad and of the need to establish a school for collectors like him. The article cited the critical views of Wilhelm von Bode, the famous German connoisseur, who had examined the collection in Rome and reported that it "does not contain one noteworthy picture, one remarkable statue, or half a dozen works of respectable mediocrity." Relying on Bode's negative assessment, *The Nation* took aim at Walters's judgment and charged that "no

other American enthusiast has fallen in so deeply as the Baltimore collector."[3] As if to add salt to the wound inflicted by this criticism, The Nation contrasted Walters's amateurism to his father's professional approach to art collecting.

Walters undoubtedly was stung by the public criticism. Mindful of the accolades that had been showered on his father's collection, the notion that he had departed from this legacy by his purchase of the Massarenti collection must have been especially painful. His reaction was to deflect the criticism by agreeing with it. Accordingly, he informed the press that he was fully aware that the collection had its shortcomings but that he would remedy these problems by disposing of the inferior works of art and by placing this responsibility in the hands of "the best person in the country."[4]

Walters's assertion that he planned to hire the "the best person" to authenticate his collection of Italian masters was purely for public consumption. There is no evidence in the archival record that Walters retained any credible expert to examine and authenticate the paintings he had acquired from Massarenti during the five years they were warehoused in New York. If Walters wanted to do this, he had the means and opportunity to do so. Both Bernard Berenson and Roger Fry were in New York during this period and could have been called upon by Walters for advice. In 1904, Berenson was in New York scouting for clients, and he probably would have leaped at the opportunity to cultivate a relationship with Walters by examining his Italian paintings. In 1905, Roger Fry, who had published a well-regarded book on Giovanni Bellini, became the curator of paintings at the Metropolitan Museum of Art, where Walters was a trustee. While employed by the Metropolitan, Fry provided advice to J. P. Morgan, the museum's president, with regard to his acquisition of Italian paintings, and undoubtedly he would have assisted Walters as well if called upon to do so. Walters did not request the assistance of Berenson or Fry for the simple reason that it was not in his strategic interest. To expose his new collection of Italian paintings to further criticism at that time would have been tantamount to incurring a self-inflicted wound. He had brought the Massarenti collection to America at considerable expense to serve as the cultural centerpiece of a museum that was intended to memorialize his father. He was not about to allow any criticism from Berenson or Fry to stand in the way of this goal. Wishing to avoid any further attention to the collection while it was stored in New York, Walters informed the press that for the next few years he planned "to hide it."[5]

The 929 paintings that Walters had purchased from Massarenti arrived in 93 crates. Walters's initial task was to carefully unpack these paintings and then conduct an inventory to assure that they matched the paintings described in the

Massarenti catalogues.[6] Walters assembled a staff of twelve persons to examine the paintings, to list them alphabetically and by school, and to make a preliminary attempt to authenticate their pedigree.[7] Some of the paintings that were blatant copies of old masters were downgraded to paintings by the masters' schools or studios. For example, a copy of Titian's famous painting *Worship of Venus* was downgraded to Studio of Titian, two paintings by Filippo Lippi were downgraded to "school" of Filippo Lippi, and a painting attributed to Giorgione was downgraded to "school" of Giorgione.[8] But the team assembled by Walters did not have the expertise to unlock the erroneous attributions given to most of the paintings by Massarenti.

In the meanwhile, Walters retained William Adams Delano, who had recently graduated from architectural school, and his newly established firm of Delano and Aldrich, to design his new Italianate gallery. As recounted by Walters's biographer, William Johnston, Walters informed Delano that "I want to build a gallery in Baltimore for all the treasures my father and I have collected, and I am going to give you boys a chance, provided you do what I tell you."[9] Like Walters's risky decision to acquire the Massarenti collection, his decision to retain an inexperienced architect to house it reflected an uncanny confidence in his own judgment about matters of art. Delano proceeded to study several palazzos in Genoa that were constructed on hillsides similar to the sloping hillside at Mount Vernon Square in Baltimore where the Walters gallery would be built. He decided to model Walters's museum, especially its sky-lit courtyard and arches supported by marble, paired columns, after Genoa's Palazzo dell'Università.[10] According to Delano, it cost Walters nearly $1 million to construct his museum.[11]

Beginning in June 1907, the Massarenti collection was shipped to Baltimore. On June 20, 1907, the *Baltimore Sun* reported that "the Great Massarenti collection of art treasures, one of the greatest in the world, will be the principal feature of the display of art in the new Walters Art Gallery, at Charles and Center Streets, which is now almost ready to be turned over to its owner." The report indicated that the reputation of the collection had not lost its luster and that, as Walters had planned, it would be warmly greeted at the time of its grand opening.

The new Walters Art Gallery opened to the press and invited guests on January 30, 1909, and thereafter to the public on February 3, 1909. To those who attended the opening, the gallery must have seemed as grand as any museum in the world. It was as if Walters had magically lifted a magnificent Italian palazzo full of classical sculpture, illuminated manuscripts, and Renaissance master

paintings, transported it over the Atlantic, and gently placed it in one of the most beautiful public squares in America. Visitors entered the museum through large bronze doors under the cartouche memorializing William Walters (see fig. 1) and stepped into a magnificent, Italian courtyard with a second-story arcade with columns so perfectly placed and proportioned as to suggest that the architectural spirit of Brunelleschi guided their design. The attention of the visitors, as they entered the courtyard, was initially captured by a display of ancient Roman sarcophagi sculpted with Dionysian reliefs that later inspired Renaissance artists, numerous Roman busts and fragments of marble statues, vitrines full of porcelain, and the famous bronze statue of *The Thinker* by Auguste Rodin. All of these objects were arranged in a manner that emphasized both the encyclopedic nature of the collection and its intent to reflect intellectually the history of art.[12]

Following the exploration of ancient art on the ground level, visitors ascended a broad marble staircase to the second-level galleries where the Renaissance paintings were displayed. As revealed by vintage photographs and elaborate, handwritten plans for the installation of the paintings, Walters divided his Italian paintings into two galleries—196 were displayed in the museum's North Gallery, and 97 were displayed in the West Gallery.[13] In both galleries, the paintings lined the walls from floor to ceiling, creating, at first impression, a visual feast unrivalled in this country.

Walters's three most prestigious paintings, Michelangelo's *Self-portrait*, Raphael's *Madonna with the Candelabra*, and Raphael's *His Own Portrait at the Age of 25*, were prominently hung side by side at eye level at the center of the wall in the North Gallery, where they could not escape notice (fig. 13). On the same wall in the North Gallery and surrounding the paintings by Michelangelo and Raphael hung other paintings purportedly by famous Renaissance masters, including a painting purportedly by Andrea del Sarto entitled *His Own Portrait*, a portrait attributed to Perugino entitled *His Own Portrait*, a diptych attributed to Correggio entitled *Two Arcadian Shepherds*, three related paintings of an *Episode in the Life of a Saint*, attributed to Pintoricchio, and a painting attributed to Guido Reni entitled *Virgin in Adoration*.[14] The possession of the self-portraits alone would have placed Walters's collection among the most envied in the world. To collectors like Walters, a self-portrait by a Renaissance master stood above all of his other paintings. Its presence implied that the artist, and the spirit of the Renaissance itself, was at home in the place where the portrait rested. To see the self-portraits of Raphael, Michelangelo, Andrea del Sarto, and Perugino together on the same wall must have had an enthralling if

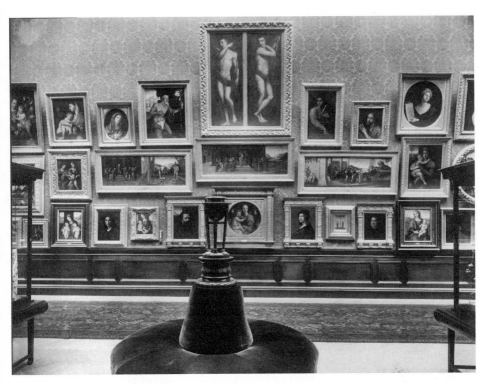

FIGURE 13. The Walters Art Gallery at the time of the grand opening of Walters's new museum in 1909. Displayed side by side at eye level in the center of the North Gallery wall were the three paintings that Walters considered to be the jewels of his collection: Michelangelo's *Self-portrait*, Raphael's *Self-portrait at the Age of 25*, and Raphael's *Madonna of the Candelabra*. Photograph WAM Archives.

not hypnotic effect on most of the American visitors, who had never seen anything quite like this before.

More than one thousand persons attended the grand opening on February 3, 1909. It was, according to the *Baltimore News*, "one of the most important artistic events of this season in the whole country."[15] Among the many dignitaries who visited the gallery that day was the First Lady, Mrs. Theodore Roosevelt. The public response to this dazzling array of portraits and other pictures by the Italian Renaissance's most famous painters was swift and glorious. On the day of the opening, the *New York Times* called the collection "magnificent" and described the Walters Art Gallery as "one of the finest temples of art in the country." The *Baltimore Sun* likewise characterized Walters's new gallery as "Baltimore's Great Temple of Art." Relying on the attributions set forth in the Walters

catalogue as well as the name plates attached to the paintings, the *Baltimore Sun* reported that "all of the paintings have the names of the artists upon them" and included a portrait by "Michal Angelo," Raphael's "Self Portrait," and three paintings by Titian.[16] The *Baltimore News* echoed this praise, reporting that "the consensus of critical opinion . . . is that the Walters collection, as it now stands, not only occupies the position of the greatest gallery in America, but it also stands high on the list of the greatest galleries in the world."[17]

Strangely, Walters stayed away from this important event. He remained in New York, acting as if he had not been invited to his own party, as if he were uninterested in his own collection and was indifferent to the public's reaction to it.[18] His absence from the gallery on this memorable occasion signaled his intent, from the outset, to keep his collection of Italian paintings at arm's length, treating the collection as if it were a gift purchased for someone else and destined to remain housed in a place he would never inhabit again. More troublesome is the likelihood that his absence silently reflected his own discomfort in displaying a collection of paintings that he knew was not quite what it seemed to be.

If Walters's absence from the opening of his new gallery was problematic, even more so was the organization and quality of the catalogue prepared for this important event. If one were to write a case study of the perils of collecting Italian Renaissance art during the Gilded Age of America, Walters's 1909 *Catalogue of Paintings* could well serve as its first chapter. For the initial, 1909 exhibition of his Italian paintings, Walters pared the Massarenti collection of 500 Italian paintings down to 293 paintings that, in his judgment, were the paintings most worthy of attention.[19] The remaining paintings were placed in a basement storage area that Walters called the "Long Museum." In describing the 293 Italian paintings that Walters chose to display, the catalogue cavalierly adopted practically all of the mistaken attributions that had been set forth in the Massarenti catalogue. Like other collectors at that time, Walters was not personally competent to determine who painted what among the hundreds of Italian paintings in his new collection. Nor was Faris C. Pitt, the Baltimore-based art dealer whom Walters retained to supervise the installation and who thereafter served as the museum's sole, albeit part-time, curator for the next twenty years.[20] Without the attention of a connoisseur like Bernard Berenson, Walters's collection of Italian paintings continued to flounder in a sea of misattributions, and this overall problem adversely affected his attempt to organize and display the paintings in a sensible manner.

The most troublesome aspect of the misattributions was not their number but the apparent willingness of Walters to shade the truth about them. As he later admitted to Berenson, Walters, when acquiring the Massarenti collection, doubted that there were many authentic masterpieces in it. Likewise, when he purchased Raphael's *Madonna with the Candelabra* in 1901, he doubted that Raphael had painted the entire picture.[21] Yet when Walters opened his gallery in 1909, he suspended these doubts in favor of enhancing both his father's and his own reputation and the related standing of the Walters collection. According to the catalogue, the new collection was full of masterpieces by the most renowned Renaissance artists, including the *Madonna with the Candelabra* that Walters attributed solely to Raphael.

In his 1909 catalogue, Walters represented that his collection included *His Own Portrait at the Age of 25*, by Raphael (no. 483); *His Own Portrait*, by Michelangelo (no. 487); *St. Veronica*, by Leonardo Da Vinci (no. 568); *His Own Portrait*, by Andrea del Sarto (no. 489); *His Own Portrait*, by Perugino (no. 478); *Christ, the Virgin and Saint John*, by Giotto (no. 634); *Portrait of Laura*, by Masaccio (no. 644); *Virgin Enthroned*, by Duccio (no. 717); *Saint John the Baptist*, by Botticelli (no. 427); *Two Arcadian Shepherds*, by Correggio (no. 486); *Christ and the Tribute Money*, by Titian (no. 583); *The Martyrdom of Saint Sebastian*, by Veronese (no. 584); and *The Martyrdom of Saint Gregory*, by Domenichino and Reni (no. 658). To reinforce the veracity of these attributions, Walters published and distributed a four-page pamphlet, which stated:

> In the next gallery, which is the North Gallery, are the Italian pictures. In the center on the north side, is "Madonna of the Candelabra," from the Borghese Collection. Next [to] it, to the right, is Raphael's own portrait from his own studio, and, to the left, Michael Angelo's portrait from his own studio. Opposite, is the "St. Christopher," the "Duke of Urbino," and the "Tribute Money," from Titian's studio. All the pictures have the names of the artists upon them.[22]

Walters's description of his greatest masterpieces sought not only to identify them but also to demonstrate their authenticity. This was not an easy task. Both self-portraits purportedly by Michelangelo and Raphael suffered from a common deficiency—they came from the Massarenti collection without any provenance of their own. In a contrived effort to overcome this problem, Walters simply created from thin air a provenance for them. Each painting, Walters claimed, came "from his own studio." This crisp and clear phrase, "from his own studio," was intended to circumvent any messy questions regarding previous ownership.

It suggested that each self-portrait came directly from the studio where it had been painted, conferring thereby a sense of clarity and purity to its chain of custody. The concluding sentence was designed to reinforce this deception. "All the pictures have the names of the artists upon them," the pamphlet exclaimed, as if the names on the pictures were tantamount to the artists' own signatures.

The 1909 catalogue also claimed that, as a result of his purchase of the Massarenti collection, Walters owned four paintings by Caravaggio: (1) *The Descent from the Cross* (otherwise known as the *Entombment*), (2) *A Musical Party*, (3) *Jesus Crowned with Thorns*, and (4) *The Magdalen*.[23] Walters did not display his paintings by Caravaggio on the same wall or near to each other. *The Descent from the Cross* was displayed in the North Gallery near the prized self-portraits of Raphael and Michelangelo, suggesting that Walters believed that this painting was the best of the four. The placement of the other three is difficult to understand. *The Magdalen* was hung under a large painting by Tiepolo even though the artists were from different regions, lived in different centuries, and painted in significantly different styles. Caravaggio's *A Musical Party* and *Jesus Crowned with Thorns* were hung high on a different thirty-foot wall where they were difficult to see.

Despite his decision to display and catalogue these four paintings, Walters probably had little interest in or knowledge about Caravaggio. Criticism of Caravaggio in the eighteenth and early nineteenth centuries had eclipsed his fame and caused his paintings to lose their value.[24] Ruskin thought that Caravaggio's paintings were crude, and Berenson rarely mentioned him in any of the books and articles written between 1895 and 1910, except to pass a disparaging comment about how Caravaggio's style of realism had contributed to the decline of Italian art. Moreover, when Berenson offered to sell to him an additional painting by Caravaggio in 1914, Walters turned down the opportunity.[25] When Walters, in 1922, finally decided to de-accession some of his paintings, three of the paintings attributed to Caravaggio, *The Descent from the Cross*, *A Music Party*, and *Jesus Crowned with Thorns* (fig. 14) were among the first to go.[26]

It soon became apparent that Walters's original plan to organize the paintings into distinct schools or geographic regions had been seriously compromised. The ten Italian paintings initially listed in the catalogue and displayed together in the North Gallery were from five different schools or regions. One was by an unidentified artist from the Lombardy School, two were by artists from the School of Bologna, two were by artists from Ferrara, three were by artists from Florence, one was by an artist from the School of Tuscany, and one was allegedly painted by El Greco. Nor were the paintings consistently installed or cata-

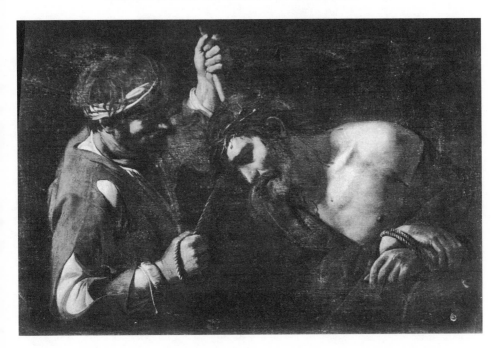

FIGURE 14. *Jesus Crowned with Thorns* attributed to Caravaggio. This painting was acquired by Walters in 1902 as part of the Massarenti collection. Massarenti and thereafter Walters attributed the painting to Caravaggio. After Berenson's examination of the collection in 1914, the painting was placed on a list of paintings "to be disposed of." Walters disposed of this painting in 1922 to an unknown recipient, and its present whereabouts are unknown. Photograph WAM Archives.

logued in a chronological manner. Although Correggio (1494–1534) and Caravaggio (1569–1609) were a generation apart, they were treated as contemporaries on page 123 of the Walters catalogue, and their paintings were hung adjacent to each other. Other than providing the name of the artist and the title of the painting in the catalogue, Walters made no effort to educate the public about the paintings and their place in art history. There were no signs informing the public about when or where the artists lived, there were no descriptions or analysis of the subject matter or iconography of the paintings, and there was no explanation about the quality of the paintings or the manner in which they were arranged and displayed. There was not a label in sight.[27]

Shortly after the initial praise for the collection subsided, critics began to target Walters's failure to organize the collection of Italian paintings in a coherent manner. The *Baltimore News* opined: "It would undoubtedly have been of far greater educational value and advantage had some attempt, at least, been

made at a chronological order in placing them. As it is, one finds representatives of different schools of different centuries hung together with small effort at relative arrangement."[28] Fueled by the numerous misattributions and the incoherent arrangement of Italian paintings, the adulatory comments initially showered on Walters's collection of Italian paintings shortly turned into a prolonged period of chilling indifference to the collection by critics here and abroad.[29]

THE
WALTERS-BERENSON
CONTRACT

Berenson did not attend the opening of the Walters Art Gallery on February 3, 1909. Around that time, he was busy cataloging the collections of John G. Johnson and Peter Widener and courting Benjamin Altman as a potential new client. When Berenson met Altman in January 1909, he was buoyed by the prospects of a very lucrative relationship. Altman initially told Berenson, "I want you to make me the finest collections of pictures in the world and make your fortune out of it too. I don't care what I spend nor how much you make." Berenson's ego and the vision of dollar signs that danced through his mind were promptly deflated by Altman's subsequent observation. Minimizing Berenson's intellect, Altman told Berenson that he had "the makings of one of the best merchants he ever saw."[1] Stung by this backhanded compliment, Berenson privately denounced Altman a "joker" and a "creature of habit."[2] Then, as the relationship between Berenson and Altman soured and the prospect for obtaining Altman's business faded, Berenson turned to Walters.

In February 1909, when Walters opened his new gallery, he and Berenson had never met one another. Walters, of course, knew Berenson through his writings and reputation. Similarly, Berenson knew of Walters as a result of his purchase of the Massarenti collection. In *Northern Italian Painters of the Renaissance*, which Berenson published in 1907, six of the paintings that Walters had purchased from Massarenti were listed. Each painting was listed as belonging to "Baltimore, U.S.A. Mr. Henry Walters."[3]

On July 8, 1909, Berenson, seeking to attract Walters as a client, contacted a mutual acquaintance, William Laffan, and asked him to convey to Walters a

proposal to prepare a catalogue of Walters's recently displayed collection of Italian paintings. Laffan informed Berenson that he thought that the offer was attractive, and he would recommend it to Walters.[4] On July 28, 1909, Laffan informed Berenson that Walters was impressed with his offer. He also conveyed that Walters was not interested in publishing a run-of-the-mill catalogue; Walters wanted something much more significant that would take the form of a "classical edition."[5] To further entice Walters to engage him to write his catalogue, Berenson, in August 1909, informed Laffan that he would not charge any money to do this.[6]

Walters did not jump at Berenson's offer. He probably was worried that Berenson already had acquired a negative impression of the Massarenti collection and that Berenson would be inclined to critically evaluate the paintings with icy derision. There was good reason for this apprehension. When Berenson wrote his Four Gospels on Venetian, Florentine, Northern Italian, and Central Italian painters, he was well aware of the Massarenti collection. But he gave no credit to Massarenti's claim that the collection included paintings by Michelangelo, Raphael, Titian, and other Italian masters. In *The Venetian Painters of the Renaissance*, published in 1894, Berenson referred to the Massarenti collection as having no significant Venetian paintings other than those by Guardi and Polidoro. In *The Central Italian Painters of the Renaissance*, Berenson referred to the Massarenti collection as having paintings only by three relatively undistinguished artists, Mariotto, Pacchiarotto, and Zagnelli. Moreover, in *The Florentine Painters of the Renaissance*, Berenson did not refer to any masterpieces in the Massarenti collection. Because Walters had adopted most of Massarenti's attributions, there was reason for him to apprehend that Berenson would discount his attributions as quickly as he had dismissed Massarenti's. Walters's reluctance to engage Berenson to examine his paintings, however, was overcome by the prospect of having the world's greatest authority on Italian Renaissance art prepare a catalogue for the Walters collection and thereby give it his invaluable stamp of approval. It was a gamble as risky as the acquisition of the Massarenti collection itself.

On September 16, 1909, Walters wrote to Berenson that, having reviewed Berenson's offer regarding his catalogue, he was "pleased at the prospect of having you undertake this for me." As reflected in this letter, Walters at that time envisioned that a catalogue of his Italian paintings endorsed by Berenson would be in great demand. He stated that it was his intention "to issue a very large edition of the catalogue," that he expected the catalogue to include reproductions of "every Italian picture" in his collection except for some minor ones, and that

he planned to distribute the catalogue to "all libraries of importance." In addition, he wanted to sell the catalogue at a nominal price at his gallery. He also hoped to publish a second, special edition of two hundred copies for private distribution, half of which he would keep and the other half he would give to Berenson. He concluded his letter with a small dose of reality. Anticipating Berenson criticism of some if not many of his paintings, Walters wrote, "I have no doubt that there are now pictures on my walls which will be removed permanently or replaced by others more worthy." In this regard, Walters deferred to Berenson, writing that "I will be governed by your suggestions."[7]

The prospect of publishing a beautiful catalogue of his Italian paintings written by Berenson must have been extremely appealing to Walters not only because it would have elevated his own status in the art world but also because the publication of beautiful books that showed off the Walters art collection had been an important part of his father's cultural legacy. During his lifetime, William Walters published a series of elaborate, richly illustrated leather-bound books about his collection, including two black leather-bound editions of the *Collection of W. T. Walters* and the *Oriental Collection of W. T. Walters,* both published in 1884. In 1897, three years after William Walters's death, a luxurious large folio entitled *Oriental Ceramic Art: Illustrated with Examples in the Collection of W. T. Walters* was published. It contained 116 large, beautifully colored lithographs mounted between double sheets of silky Oriental paper and included a preface written by William Laffan. Henry Walters distributed a limited edition of this beautiful book to various museums and libraries in the United States and abroad.[8] Walters probably had this book in mind when discussing with Berenson his plan to publish worldwide his own book of Italian paintings.

In 1909, at the time Berenson committed to producing an important, scholarly catalogue for Walters of his collection of Italian paintings, Berenson already was working on a similarly ambitious catalogue for his client John G. Johnson. The Johnson catalogue was an important and time-consuming project. Berenson characterized it as "a labour of love."[9] He periodically worked on the catalogue for five years, from 1908 to 1913. By the time of its completion, the Johnson catalogue was more than three hundred pages long and contained descriptions of over two hundred paintings, thumbnail sketches of their artists, and more than two hundred illustrations.

Walters was well aware that Berenson's work on his catalogue would have to await the completion of the Johnson catalogue. He informed Berenson that "[I] only regret that it will not be possible to have . . . [my] catalogue ready at an earlier date."[10] When Berenson showed Walters a draft of the Johnson catalogue,

Walters, according to Berenson, was "delighted" with it, and it "aroused his envy."[11] At that time, both Berenson and Walters contemplated that Walters's catalogue would be like Johnson's, that the two catalogues would be connected pedagogically, and that together they would constitute the cornerstones of any study of Renaissance art in America. Berenson expressed this idea to Johnson, stating that he hoped that both catalogues when considered together would provide American students of the Renaissance with a "pretty adequate idea of the more formal side at least of Italian painting."[12] Berenson's idea made sense. The Johnson and Walters collections of Italian paintings were related not only by the fact that they contained many of the same artists but also by the common interest of their owners in using their collections to relate the historical development of Italian Renaissance painting. Among the thirty-four paintings that Berenson would sell to Walters, nineteen were by artists who were already in the Johnson collection.[13]

As had been done in preparing the Johnson catalogue, Berenson requested that Walters provide him with photographs of all of the Italian paintings listed in Walters's 1909 catalogue. In response to Berenson's request, Walters, in October 1909, instructed his curator, Faris Pitt, to send the photographs to Berenson as soon as possible in order for Berenson "to prepare the catalogue."[14] In November 1909, Pitt sent 286 photographs, 191 of which were silver prints and 95 of which were platinum prints, to Berenson. Walters noted on the back of each photograph the identity of the artist or the school to which the painting was attributed. The photographs were accompanied by a letter dated November 13, 1909, in which Walters reiterated his request for Berenson's advice while offering the self-serving suggestion that he had already begun distinguishing the good pictures from the bad: "I do wish you would indicate what pictures you think should be withdrawn definitely from the collection. I myself have already in my mind made eliminations."[15]

Having invited Berenson to advise him about what paintings to keep and what to discard, Walters attempted to discourage him from cutting too deeply into the collection. As he had done with the exaggerated story about leaving half of the Massarenti collection in Rome, which Walters had invented to reduce the size of his import tax, Walters conveyed to Berenson that he had already disposed of most of the second-rate paintings in his collection. On January 4, 1910, he wrote to Berenson that he had already discarded "over four hundred and fifty pictures, Italian, French, Dutch and non-descript, and I am quite prepared to add to the rejected one hundred more." There is no evidence in the Walters archives to support this fanciful assertion. Indeed, Walters did not begin

to dispose of any of the paintings he had acquired from Massarenti until 1915, approximately five years later. Walters also informed Berenson that he had fifteen Italian paintings, including Raphael's *Madonna of the Candelabra*, which he had purchased independently of the Massarenti collection (see appendix B, list 3). With regard to the painting by Raphael, Walters stated that it was the "most important" individual painting he had acquired. In an effort to preempt any second-guessing by Berenson about the painting's provenance, Walters emphasized that he had carefully traced its history: "The most important one being the Madonna of the Candelabra by Raphael, which I bought from a nephew of Monro, of Novar, it having been taken from the Borghese Collection by Napoleon I and given to the Queen of Etruria, from whom it passed to the Duke of Lucca, who sold it at Christies in London, where it was bought by Mr. Monro."[16] (A copy of this entire letter is reprinted in appendix A.) It is doubtful that Berenson gave much weight to Walters's recital of the painting's provenance. As he would later state to Duveen, "You must never encourage any question of provenance. In most cases . . . it is impossible to know, and at other times impossible to tell."[17]

Berenson was dissatisfied with the quality of some of the photographs sent by Walters and requested additional photographs of more than one hundred paintings. Still believing that this effort would result in a magnificent catalogue authored by Berenson and illustrated with Walters's collection of Italian paintings, Walters replied, "I am anxious to supply you with what you require."[18] By the end of March 1910, Walters had provided Berenson with at least one photograph of every Italian painting in his collection.

In the spring of 1910, Berenson invited Walters to be his guest at I Tatti. Although they had become acquainted through their correspondence, they still had not met face to face. In response to Berenson's invitation, Walters wrote, "I am very anxious to have the pleasure of a personal acquaintance."[19] As evidenced by their subsequent correspondence, Walters and Berenson discovered that they shared a variety of mutual interests that bonded their relationship and spawned a genuine friendship. Their letters were not only about the hard, dollars-and-cents business of selling and buying paintings but also addressed personal issues related to their health, their families, their homes, their economic and political philosophies, and current events on both sides of the Atlantic. They were of similar age (in January 1910, Walters was sixty-two and Berenson was fifty-five), and they commiserated about the frailties associated with growing old. Berenson's concerns were psychological, with veiled references to suicide; Walters suffered from problems with his gallbladder. They shared similar, conservative political

philosophies, both vowing allegiance to the Republican Party and supporting
the presidency of Theodore Roosevelt. They both expressed apprehension over
the growth of communism, disappointment over America's neutrality in the face
of German hostility, and concern about the effects of the war on their business
interests. They shared a zest for the finer, material pleasures of life that their
fame and fortune had brought abundantly to both of them. And an overarching
devotion to high culture was their common religion.

During his visit to Berenson's villa in May 1910, Walters was impressed with
the quality of the Renaissance paintings that were available for sale. The overall
cost of purchasing such paintings from Italy had declined the previous year as
a result of the Payne Aldrich Tariff Bill, which had abolished import duties on
works of art that were more than one hundred years old. Mindful of this reduc-
tion, Walters inquired about the cost of the paintings that Berenson had avail-
able for sale. Upon receiving this information, on May 23, 1910, Walters sent
Berenson a note stating that he was "greatly delighted with the result" and that
he wanted to arrange the "methods of payment at present and in the future."[20]
As Berenson had planned, this led to an agreement by Walters to engage Beren-
son to acquire paintings for him.

The precise terms of this agreement were memorialized in a letter from Wal-
ters to Berenson dated May 24, 1910:

> In accordance with our understanding, it will be most interesting for me to place at
> your disposal between July 1, 1910 and July 1, 1911, the sum of Seventy Five Thousand
> Dollars ($75,000), or so much thereof as you may require during that period, to pay
> for purchases for my collection of pictures, particularly of the Italian schools, in
> order to fill out its historical value and increase its average quality . . . To give this
> arrangement a proper business relation, you are to receive as a commission from me
> upon each purchase made and at the time of each purchase ten percent of its cost.[21]

(A copy of this entire letter is reprinted in appendix A.) As further detailed in this
letter, Berenson was required to send photographs of the paintings he offered to
Walters, and Walters would respond in writing as to whether he accepted the
offer. To assure that the paintings he purchased from Berenson would be ex-
empt from any import duty under the Payne Aldrich Tariff Bill, Walters's letter
also confirmed that Berenson would identify himself as the seller of each paint-
ing and provide a written guarantee that "the object is a work of art and more
than one hundred years old."[22]

Following his acquisition of the Massarenti collection and prior to retaining
Berenson as his principal dealer, Walters had acquired fifteen Italian paintings

(see appendix B, list 3). Perhaps worried about the efforts in Italy to prevent the loss of its cultural treasures,[23] Walters approached the acquisition of these paintings as if on a secret mission. With only one exception, he retained no formal records relating to the source of these paintings, the cost of the paintings, the date of their acquisition, or the manner in which they were shipped to Baltimore. In his contract with Berenson, Walters expressed his continuing concern for secrecy. He did not want to be directly linked in a financial relationship with the original Italian seller, and he directed Berenson to serve as a buffer between them. In this regard, the terms of Walters's arrangement with Berenson provided: "I prefer to have all settlements with you directly so that my name will not except in exceptional cases appear to the seller. In other words so far as I am concerned in the settlements you pay out this money for me."[24]

Although the subject matter was high culture, the agreement was clearly intended to establish a formal business relationship. Walters made this explicitly clear by reducing the agreement to writing, by using phrases that carried an air of legality, and by expressly stating that their agreement should be treated as "a proper business relationship." The agreement contemplated but did not bind either side to a long-term relationship. Under its terms, the agreement lasted for one year, from July 1, 1910, to July 1, 1911, leaving open the possibility of annually renewing it or permitting their business relationship to be thereafter terminated at the will of either party at any time. The terms of their agreement also did not contractually bind Berenson and Walters together in any exclusive relationship. Berenson remained an independent contractor who was free to sell paintings to other collectors like John G. Johnson. Walters likewise remained free to purchase Italian paintings from anyone he chose, and he continued to purchase Italian paintings from many other sources, including A. S. Drey, a prominent dealer in Munich and New York. To effectuate the sale of paintings to Walters, Berenson agreed to ship the paintings to Maurice Pottier, Walters's shipping agent in Paris, who would forward the paintings to Walters in Baltimore.

The financial terms of the contract provided Berenson with the opportunity to earn a comfortable income that could continue for many years. If, as contemplated by the terms of the agreement, Walters spent $75,000 each year on paintings purchased from him, such expenditure would generate $7,500 annually in commissions to Berenson. By today's standards, this was equivalent to approximately $165,000 each year.[25] Although unmentioned in the contract, Berenson was eligible to receive additional compensation in the form of an "honorarium" for reviewing and approving paintings that Walters purchased from other dealers. For example, in March 1914, Walters sent Berenson a check in the amount

of $3,000 for examining paintings that Walters acquired from the A. S. Drey Gallery.[26] Retaining the freedom to engage in business with other collectors as well as dealers, Berenson's financial arrangement with Walters must have been very attractive to him.[27]

A critical provision in the agreement between Walters and Berenson involved the standard by which Berenson would select and Walters would measure the quality of the paintings that were to be added to Walters's collection. The standard used in the agreement was to acquire paintings that would "increase its [the collection's] average quality." What is striking about this standard is how modest it was. Walters was not in the market for the world's greatest Italian masterpieces. He simply wanted good paintings that, in general, were better than what he already had and that would enhance the educational value of the collection. The second unusual aspect of this standard was the difficulty of its application. This standard was not fixed or objective but soft, subjective, and comparative in nature. It related to the existing quality of Walters's collection. It implicitly required Berenson to review and evaluate the overall quality of Walters's existing collection in order to intelligently select paintings that were better than the existing collection's "average quality" and that improved its capacity to fairly represent the history of Italian art. Because Berenson and Walters had sharply different opinions about the quality of Walters's collection, the standard employed in their agreement was difficult to measure. As reflected in his 1909 catalogue, Walters at that time optimistically expressed the belief that artists in his collection included many of the masters of Renaissance art and that the collections was, in general, important enough to warrant the publication of a widely disseminated catalogue. On the other hand, Berenson, having reviewed Walters's photographs of his Italian paintings and having recognized the presence of many rank copies, perceived the "average quality" of the collection to be appreciably lower. From Berenson's viewpoint, improving the average quality of Walters's collection was an achievable standard that was easy to meet.

Although Walters, as a general rule, was very secretive and averse to publicity, he conveyed to the press that Bernard Berenson had agreed to inspect Walters's paintings and help him prepare a catalogue.[28] He recognized that the mere association of Berenson's name with his collection gave it a panache and credibility that was otherwise unattainable. On November 6, 1910, the *Baltimore News American* reported this story under this headline: "Bernard Berenson, Eminent Italian Critic, Made Careful Inspection of Henry Walters' Massarenti Collection." The column added that, based on the Walters-Berenson collaboration, "A very handsome catalogue . . . will be published."[29]

THE PAINTINGS
BERENSON SOLD TO WALTERS

Walters began acquiring paintings from Berenson in the summer of 1910. Among his initial acquisitions was an altarpiece in the form of a triptych by the Venetian artist Niccolò Rondinelli. It was entitled *Madonna and Child with Saint Michael and Saint Peter* (fig. 15).[1] Berenson subsequently described Rondinelli as "perhaps the most prominent of Bellini's followers," and he characterized the painting he sold to Walters as closely following the architectural designs and figurative drawing of this master.[2] The painting depicts Mary and Jesus enthroned under an elaborately coffered arch that corresponds with the circular lines of the Madonna's halo and serves to emphasize her divinity. To the right of the Virgin is Saint Peter, characteristically holding the papal key, while to the left is Saint Michael engaged in battle against the forces of evil. The painting is reminiscent of Giovanni Bellini's famous altarpiece of the Virgin and Child in the Church of San Zaccaria in Venice. Walters must have been delighted with this painting, for he proceeded to purchase thirteen more paintings from Berenson during the first year of their contractual relationship and an additional twelve paintings during the second year. According to their correspondence and telegrams, during the course of six years from July 1910 through July 1916, Walters purchased at least thirty-six paintings from Berenson and possibly more (see appendix B, list 1).[3]

As exemplified by Rondinelli's painting and its devotional subject matter, the paintings Walters acquired from Berenson were by Italian artists who worked primarily in the second half of the fifteenth and first quarter of the sixteenth centuries and who painted traditional religious themes and motifs that preoccupied

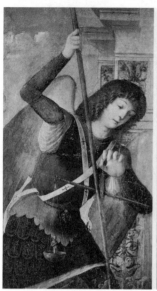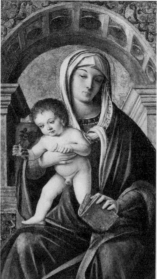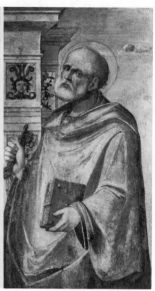

FIGURE 15. Niccolò Rondinelli, *Madonna and Child with Saint Michael and Saint Peter*, ca. 1497–1500, oil, tempera, and powdered gold on panel, 34 × 18⅜ in. WAM 37.517 A, B, C. The painting was acquired by Walters from Berenson in 1910, around the beginning of their dealer-client relationship. Berenson referred to Rondinelli as "perhaps the most prominent of Bellini's followers." Although the painting was represented to Walters as a triptych, it was later discovered that the three panels had been sawed out of a single altarpiece and repaired and repainted to conceal the damage. Photograph WAM Archives.

the artists of that time. Twenty-four of the paintings depicted the Madonna and Child either by themselves or in *Sacra Conversazione* with saints or donors by their sides. Other paintings depicted well-known episodes in the life of Jesus and Mary, such as the Annunciation or the Nativity, or episodes in the lives of saints, such as Susannah and the Elders, Saint George and the Dragon, and Saint Jerome in the Wilderness. In contrast, only six paintings depicted secular or non-Christian subjects; five were portraits and one was a mythological landscape.

Walters, as a general rule, left the selection of each painting entirely to Berenson, reserving for himself the final decision about whether to purchase it. In only two cases did Walters express an interest in acquiring a painting by a specific artist. On one occasion he requested that Berenson find him an affordable painting by Sassetta, one of the leading Sienese painters of the fifteenth century; it was a request that remained unfulfilled.[4] On another occasion, he requested Berenson to assess the quality and authenticity of a painting that a Venetian

dealer was seeking to sell to him. It was entitled *Portrait of a Woman as Cleo-patra* and was purportedly by Paris Bordone, a student of Titian and one of the most accomplished painters of portraits in Venice. With regard to the Bordone painting, Walters wrote to Berenson, "I told him [the Venetian dealer] that I could not consider it unless it were submitted to me and recommended by you."[5] Other than expressing an interest in these two paintings, Walters expressed to Berenson no preference for any particular artist, school of art, style, or subject matter.

A variety of factors influenced Berenson's selection of paintings for Walters. They included the reputation of the artists, the price of the paintings, and their availability. The issue of availability was influenced not only by the variables at play in the marketplace but also by factors over which Berenson exercised significant control. Among the thirty-four paintings that Berenson sold to Walters, eight came from Berenson's own collection.[6] One cannot state with any certainty whose interest was best served by these transactions. In proposing that Walters acquire the painting of the *Madonna and Child* by Cosimo Rosselli (fig. 16), Berenson combined spoonfuls of candor and exaggeration as if they came from the same jar. He candidly informed Walters that the painting belonged to him but that he was interested in disposing of it because his wife "Mary has the bad taste not to like it." Then, in the same sentence, Berenson added that, "it is one of the best things that this not inconsiderable artist ever did."[7] Berenson's praise of his own painting appears, in retrospect, to have been little more than a shallow effort to sell it. Years later, in illustrating what he believed were Rosselli's best paintings, Berenson referred to a painting of the *Madonna and Child* in the Kress Collection of the National Gallery of Art and a second painting in the Metropolitan Museum of Art. He made no reference to the painting he sold to Walters.[8]

Another painting that Berenson sold to Walters from his own collection was a *Madonna and Child* by Bernardo Daddi (see plate 4). In this case, Berenson's motivation for disposing of the painting seems clear. In January 1911, Berenson acquired a second painting of a Madonna and Child by Daddi, which he admired more than the other painting by Daddi.[9] In February 1911, Berenson attempted to sell his first Daddi to John G. Johnson.[10] When that failed, Berenson offered it to Walters, who acquired it in October of that year.[11]

The availability of the paintings Berenson selected for Walters was also influenced by Berenson's need to balance his obligation to find paintings for Walters against his obligation to find Italian paintings of similar quality for other clients. During the period when Berenson was actively selling Renaissance and Baroque

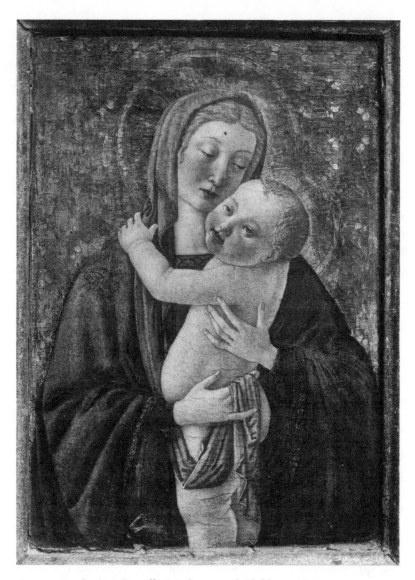

FIGURE 16. Cosimo Rosselli, *Madonna and Child*, ca. 1480, tempera on panel, 17 × 11½ in. WAM 37.518. This painting, which was in Berenson's private collection, was sold to Walters in 1911. Berenson informed Walters that it was "one of the best things that this not inconsiderable artist ever did" and that he decided to sell it to Walters because his wife had "the bad taste not to like it." Walters responded that "I am more than delighted to have the one from your collection," and with a touch of humor he added, "I thank Mrs. Berenson most sincerely for not liking it." Photograph WAM Archives.

paintings to Walters, he was also actively engaged in selling paintings in the same price range to John G. Johnson. From 1910 to 1912, Berenson was proposing paintings on a regular, weekly basis to both Walters and Johnson. Johnson had informed Berenson that he was not interested in purchasing additional paintings of the Madonna and Child, a fact that helps to explain why such paintings were regularly offered to Walters. In at least two cases, Walters was offered paintings that Berenson had previously offered to Johnson. Both of the paintings came directly from Berenson's personal collection. They were the aforementioned *Madonna and Child* by Bernardo Daddi and a *Portrait of a Baby Boy* by Bronzino (see plates 4 and 5). If Berenson gave Johnson first choice on some paintings, there were bona fide reasons for doing so. Not only had Johnson retained Berenson as an adviser several years before Walters had done but had also agreed to pay him a healthier commission of 15 percent of the price of the paintings in contrast to Walters's commission of 10 percent.

Regardless of the factors that influenced Berenson's selection of paintings for Walters, most of the artists who allegedly painted them were highly respected and well known by students of Italian art. There was nothing second-rate about them. Paintings by these artists were on display in the Uffizi and other major galleries in Florence, Venice, and Rome. Twenty-seven of these artists had been listed by Berenson as being among the "principal" Renaissance artists of Venice, Florence, Central Italy, and Northern Italy. In his Four Gospels of Italian Renaissance painters published between 1894 and 1906, Berenson provided concise descriptions of each of these artists and outlined the principal galleries, churches or private collections where their work was found.[12] These four books had become standard reference manuals for collectors, and Walters undoubtedly would have referred to them if he needed to supplement the information about the artists provided in Berenson's letters.

The thirty-six paintings sold to Walters by Berenson covered all of the regions of Italian Renaissance art. Seven of the paintings purportedly were by artists listed in Berenson's book on *Venetian Painters*, six were in his book on *Florentine Painters*, seven were in his book on *Northern Italian Painters*, and six were in his book on *Central Italian Painters*. Turning first to the seven Venetian painters, the most celebrated was Tintoretto (1518–1594), who decorated the Doges Palace but left his mark on art history by his dynamic pictorial decoration of the Scuola di S. Rocco. The other Venetian artists whose work was sold to Walters by Berenson were Marco Basaiti (1470–1530), a follower of Giovanni Bellini, who painted in a style so close to Bellini's that Berenson initially attributed Bellini's *Saint Jerome Reading*, in the Kress Collection of the National Gallery,

to him; Cima da Conegliano (1459–1518), who was considered to be one of the most captivating and creative students of Bellini and whose large altarpieces were viewed as among the most significant achievements of Venetian art; Antonio Vivarini (active 1440–1476), who remained devoted to the gothic style; Polidoro Lanzani (1515–1565), who was a follower of Titian; Bartolomeo Mantagna (1450–1523), who also was influenced by Giovanni Bellini; and, as noted above, Niccolo Rondinelli.

The six Florentine artists Berenson selected for Walters reflected the evolution of Florentine painting over two centuries. They were Bernardo Daddi (active 1300–1348), Bicci Di Lorenzo (1373–1452), Cosimo Rosselli (1439–1507), Bartolomeo Di Giovanni (active 1483–1500), Francesco Granacci (1477–1543), and, as noted above, Agnolo Bronzino (1503–1572). Bernardo Daddi was a student of Giotto and among the most prominent Florentine painters during the first half of the fourteenth century. Although Daddi painted large altarpieces, one of which is in the Uffizi, his forte was small and intimate devotional paintings, as exemplified by the painting of the *Madonna and Child* that Berenson sold to Walters. Bicci Di Lorenzo's paintings served as a bridge between the Gothic style of the fourteenth century and the realism of Masolino and Fra Angelico in the fifteenth century. His gold-leafed altarpiece of *The Annunciation* is considered one of the masterpieces in the Walters collection. Cosimo Rosselli was highly regarded in Florence and Rome, as evidenced by his selection around 1480 to join Botticelli, Ghirlandaio, and Perugino in decorating the side walls of the Sistine Chapel, where he was responsible for painting *The Crossing of the Red Sea.* Bartolomeo Di Giovanni, who was also referred to by Berenson as Alluno di Dominico, was an assistant to both Botticelli and Ghirlandaio and specialized in painting predellas and panels for fine furniture. Francesco Granacci also was a student of Ghirlandaio and a lifelong friend of Michelangelo, who sought his technical guidance about fresco painting when working on the ceiling of the Sistine Chapel. Bronzino was one of the most famous and gifted sixteenth-century mannerists and a favorite court painter of the Medici.

The eight North Italian painters selected by Berenson were Nicola Appiano, known as "Pseudo-Boccaccino," who was from Milan and active in the first quarter of the sixteenth century; Barnaba da Modena (active 1361–83), who was born in Milan but was most active in Genoa and whose patrons extended from Italy to Spain; Bartolomeo Bramantino (1460–1529), another artist from Milan, who was one of the region's most important painters and architects and who became the court painter to Duke Francesco II Sforza; Bernardino Butinone (1454–1507),

a Milanese artist whose frescoes were celebrated in that city; Ercole De'Roberti (1430–1496), who was one of the greatest Renaissance painters of Ferrara; Giovanni Batista Moroni (1520–1578), an artist born near Bergamo, who was regarded as the greatest Italian portrait painter of the sixteenth century; Giorgio Schiavone (1443–1504), who worked mainly in Padua and is known for his brilliant colors and ability to depict rare and precious stones; and Sodoma (Giovanni Antonio Bazzi) (1477–1549), one of the leading painters in Siena during the sixteenth century.

The six artists who were listed by Berenson in his book on Central Italian painters were Antoniazzo Romano (active 1460–1508), who painted mainly in Rome, working with Ghirlandaio in decorating the library of the Vatican; Bernardino Fungai (1460–1516), whose best-known paintings decorated the Siena Cathedral; Benvenuto Di Giovanni (1436–1518), another well-established Sienese artist; Fiorenzo di Lorenzo (1440–1521), an Umbrian artist whose work is sometimes confused with Pintoricchio and whose most distinguished work was painted in Perugia; Giovanni Di Paolo (1403–1482), who was one of the greatest artists in Siena during the fifteenth century and whose art moved from Gothic traditions to highly original imaginary landscapes; and Lo Spagna (1450–1528), whose real name was Giovanni di Pietro and who, although born in Spain, produced his most remarkable work in Umbria. In addition to the artists who were listed in his four books on principal Renaissance painters, Berenson sold to Walters paintings by three relatively unknown artists: Pietro Carpaccio (active 1514–26), the son of the Venetian master Vittore Carpaccio; Nicolo da Guardiagrele, a Venetian artist; and Giovanni Mansueti (active 1485–1526), a Venetian artist who studied under Giovanni Bellini.

Walters's letters to Berenson indicate that he was very satisfied with the paintings he acquired from him. He expressed not a single word of criticism about their quality or condition. To the contrary, the correspondence indicates that, to the extent that Walters looked at the paintings and paid any attention to them, he loved what he saw. For example, on February 7, 1911, he wrote to Berenson, "I am thoroughly delighted with the two portraits by Moroni and Tintoretto and with the *Saint George* by Carpaccio." He added that "I have quite fallen in love with the photograph of the Fungai." On June 9, 1912, he wrote to Berenson that, "Somehow the Cima [da Conegliano] is constantly before my eyes and also the remarkable [Francesco di] Rimini." On February 14, 1914, he wrote, "Sodoma . . . is a great picture. I have the greatest delight in studying it."[13] Walters's satisfaction with the paintings he acquired from Berenson was further evidenced by the fact that, in 1915, when Walters reorganized his collection of Italian paintings,

he hung thirty pictures acquired from Berenson in place of paintings that he previously had acquired from Massarenti.

Walters's favorable impression of the paintings offered by Berenson undoubtedly was influenced by Berenson's hyperbolic, overly effusive descriptions. His letters to Walters slide imperceptibly from scholarly advice into rank salesmanship. For example, on November 4, 1911, Berenson recommended a "suave, gracious, distinguished" *Madonna* by Fiorenzo di Lorenzo, whom he described as "one of the big wigs of Italian Painting." It was "a very great bargain," Berenson claimed, and he urged Walters to acquire it because "these things are getting visibly rarer." On December 16, 1911, Berenson urged Walters to buy Lo Spagna's painting of *The Holy Family with Saint John the Baptist*, which he described as a painting that "has always passed for a Raphael . . . In a sense one can hardly blame them, for this picture is very Raphaelesque indeed . . . It is the finest Lo Spagna I have ever seen. It is extraordinarily clear and brilliant." In the same letter Berenson recommended a painting of *Madonna and Child with Saints Mark and Peter* by Polidoro Lanzani, which he described as "near to being a Titian as any work I have ever seen . . . Here the color is as good as Titian in his very best years . . . [possessing] fully Titianesque radiance and magic." On January 16, 1912, Berenson urged Walters to purchase a painting of the *Madonna and Child* by Nicola Appiano (known as the "Pseudo-Boccaccino"), which he described as "a blend of Venetian with Milanese qualities which makes him one of the most fascinating of Leonardo's pupils in Milan. The Madonna I am proposing is as fine as any of his that I know . . . It is in excellent condition." On November 9, 1912, Berenson recommended a painting of the *Annunciation* by Bicci di Lorenzo, which he described as "one of the most delightful works painted soon after 1400, & is the masterpiece of one of the most interesting figures of that time." At the same time, Berenson proposed a painting of the *Madonna and Child* by Bernardino Butinone, which he characterized as "an appealing Leonardesque work of delicate sentiment & delicious colour . . . The naiveté of the landscape background is not easily to be surpassed, & the whole panel has an unusual sincerity & heartiness about it."[14] And, as noted above, in offering to sell his painting by Rosselli, Berenson characterized it as one of the artist's "best" paintings. As evidenced by Berenson's alluring descriptions, he was not offering to sell to Walters great paintings by Leonardo, Raphael, or Titian—Walters did not at that time covet such paintings but instead paintings by their followers that were "Leonardesque," "Raphaelesque," or "Titianesque" in flavor and that looked like they were completed by the hands of the great

TABLE 1
Italian Paintings Acquired in 1911–1913

Artist	Year Purchased	Cost	
		English Pounds	American Dollars
Niccolo da Guarolegrele	1911	200	972
Francesco da Rimini	1912	250	1,215
Giovanni Mansueti	1911	300	1,458
Antonio Vivarini	1912	350	1,701
Cosimo Rosselli	1911	500	2,430
Nicola Appiano	1912	500	2,430
Giorgio Schiavone	1913	750	3,645
Fiorenzo di Lorenzo	1911	800	3,888
Bernardo Daddi	1911	1,000	4,860
Cima da Conegliano	1912	1,000	4,860
Lo Spagna	1912	1,200	5,832
Polidoro Lanzani	1911	2,000	9,720

masters. (The letters from Berenson dated November 4, 1911; December 16, 1911; January 16, 1912; and November 9, 1912 are in appendix A.)

Walters must have been pleased with the opportunity to purchase paintings that often looked like a Raphael or a Titian but were dramatically less expensive. In comparison with the $100,000 or more that he reportedly spent for Raphael's *Madonna of the Candelabra*, the paintings he purchased from Berenson must have seemed like a bargain. Based on Walters's handwritten notes and the letters from Berenson, the prices appeared to range from approximately $1,000 to $10,000, with the average price being $3,584.[15] This average price is roughly equivalent to $50,000 in today's dollars. As evidenced by the prices he paid for these paintings, Walters's strategy was to budget $75,000 per year to acquire dozens of paintings by important, although lesser-known Italian artists, instead of spending the same amount or more to acquire one painting by Raphael, Titian, or a comparable master of Renaissance art.

Three of the paintings Berenson sold to Walters are still viewed as being among the jewels of the Italian painting collection.[16] They are Bicci di Lorenzo's *Annunciation*, Bartolomeo di Giovanni's *Myth of Io*, and Fiorenzo di Lorenzo's *Saint Jerome in the Wilderness* (now attributed to Pintoricchio) (see plates 6 to 8). These paintings, in the context of the entire collection, help to trace the progression of Italian painting from the iconic, Gothic prototypes of the fourteenth century to the realism of the fifteenth century and later to the imaginary landscapes of the early sixteenth century. In Bicci di Lorenzo's *The

Annunciation, painted around 1430, we can see a transition from the flat, golden backgrounds of Gothic art to early experiments with architectural perspective. In Pintoricchio's *Saint Jerome in the Wilderness,* painted around 1475, we are invited to interpret a painting rich in iconography, as reflected in the cardinal-red hat, the domesticated lion, the scholarly text, and the rocky, ascetic environment. And in Bartolomeo da Giovani's *Myth of Io,* painted in 1490, we see the influence of Ovid on the artist's creation of an imaginary landscape, which combines features of the Nile valley and the Tuscan countryside and which is inhabited by a remarkable ensemble of Roman gods, shepherds, and animals.

Although Walters was apparently satisfied with the paintings he acquired from Berenson, over the years a more objective and critical assessment of the overall quality of these thirty-six paintings has emerged. The problem with the paintings did not involve their price. Nor did it involve the credentials of the artists who allegedly painted them. The problem, somewhat surprisingly, is that most of Berenson's attributions have not withstood the test of time. More specifically, the attributions of twenty-two of the thirty-six paintings Berenson sold to Walters, or approximately two-thirds of Berenson's attributions, have been overridden by modern scholars and no longer carry any currency.[17] (See appendix B, list 2).

The painting of *Saint George and the Dragon* purportedly by Pietro Carpaccio (see plate 9), with which Henry Walters was "thoroughly delighted," was dismissed in 1969 as a fake by the Walters Art Museum after it discovered that it was probably painted by an unknown artist in the nineteenth century, not in the early sixteenth century when Carpaccio painted.[18] The painting by Fungai that Walters "had fallen in love with" was not by Fungai, but more likely by an unknown sixteenth-century Umbrian artist who was given the name of Master of the Liverpool Madonna.[19] The painting by Cima that was "constantly before my [Walters's] eyes," also was determined, after a careful examination, to have been painted by one of Cima's followers named Girolamo Da Udine.[20] The painting purportedly by Tintoretto, which Walters purchased from Berenson in 1911, was downgraded to the "Manner of Tintoretto" and disposed of by the Walters Art Museum in 1951.[21] The painting purportedly by Lo Spagna, which Berenson characterized as "Raphaelesque . . . [and] the finest Spagna I have ever seen," was determined to be not by Lo Spagna but by an unknown artist of the Umbro-Tuscan school who based his painting upon "Raphael prototypes."[22] The painting that Berenson attributed to Polidoro Lanzani and which he praised as being "Titianesque" also has been reattributed to an unknown artist on the

ground that "on the whole this painting differs from the artist's [Polidoro's] usual manner, and certain elements . . . are not characteristic of Polidoro's style."[23] The painting purportedly by Bramantino has been downgraded to an unknown artist from the School of Ferrara.[24] And the painting purportedly by Bernardo Daddi, which was in Berenson's private collection before he sold it to Walters, has been downgraded to a painting done primarily by Daddi's workshop.[25]

Other opinions expressed by Berenson about the paintings in the Walters collection also have not survived scrutiny. Around 1914, Walters acquired two paintings purportedly by Francesco Bonsignori, a Veronese by birth who was strongly influenced by Giovanni Bellini and other Venetian artists. The paintings, entitled *Profile of a Warrior* and *Portrait of a Prelate in Black*, were listed by Walters in the catalogue published, with Berenson's assistance, in 1915.[26] In *Venetian Paintings in America*, published in 1916, Berenson praised these paintings. He wrote that the *Profile of a Warrior* was the "finest and best constructed of Bonsignori's portraits," and its "attribution cannot be subject to dispute, for everything about it witnesses to the mind and hand of the master." Berenson also wrote that "there can be no reasonable doubt" that Bonsignori also painted the *Portrait of the Prelate*. Years later, the Walters Art Museum concluded that Bonsignori painted neither of these pictures, and they were removed from the collection. A subsequent effort to sell these paintings through Christies for five hundred dollars failed, and they were donated to charity.[27]

In addition to Berenson's misattributions, several of the paintings Berenson sold to Walters had been awkwardly restored and were not, as Berenson suggested, in pristine condition. The painting by Pseudo-Boccaccino of *Madonna and Child*, which Berenson represented as being in "excellent condition," had been trimmed on all four edges, seriously overpainted in dark blue in one area, and carelessly overpainted in a dull red color elsewhere.[28] A similar problem was discovered in the first painting that Walters purchased from Berenson, the purported triptych entitled *Madonna and Child between Saint Michael and Saint Peter*, by Niccolo Rondinelli. It originally had not been a triptych, as Berenson claimed, but instead had been a single painting that had been sawed apart, trimmed on all four sides, and in some sections repainted in an inexpert effort to restore it.[29]

How could Berenson, the preeminent connoisseur of Italian paintings who is credited with guiding the important collections of Isabella Stewart Gardner and Peter Widener and for serving virtually as an "adjunct curator" of the marvelous collection of Italian paintings at the National Gallery in Washington,[30]

have been mistaken so often when selecting paintings for Walters? There is no easy answer to this question. There is no hard evidence that Berenson intentionally misrepresented the attributions of any of the paintings he sold to Walters or intentionally concealed the poor condition of some of them. Although the attributions given by Berenson to the paintings sold to Walters appear in hindsight to often have been in error, these attributions did not at that time seem mistaken and were not challenged by other experts in the small, cutthroat league composed of connoisseurs who often promoted themselves by discrediting the attributions of others.[31]

It is difficult to measure the quality of all of the attributions given by Gilded Age connoisseurs to Renaissance paintings because there have been no firm, objective standards for doing so. Attributions given to paintings completed in Italy hundreds of years ago have not been set in stone but are subject to change based on the application of new evidence about the paintings and their artists. Accordingly, any effort to score the number of correct or incorrect attributions is relatively meaningless.[32] The field of connoisseurship at the turn of the twentieth century was an intuitive and inexact science.[33] Berenson's attributions were not objectively measured or confirmed by x-rays, microscopes, chemical analyses, and other tools of modern conservators. They were instead simply the product of his intellectual memory and eye for art, which, while extraordinary, were far more fallible than his fame and swagger suggested. There was not at that time and there is not now any acid test for conclusively determining who painted what during the Renaissance and Baroque periods of Italian art. The difference between a "signature" painting completed primarily by a master and a painting completed primarily by the talented painters in the master's workshop and under his supervision continues to be, in many cases, extremely difficult to discern. Although attributions given to Italian Renaissance and Baroque paintings based on the judgments of connoisseurs as famed as Morelli, Bode, and Berenson carry a presumption of validity, such attributions remain subject to challenge. A significant attribution—as David Alan Brown, the curator of Italian paintings at the National Gallery of Art, has observed—"is not necessarily one that we would take to be correct today. It is an attribution that was perceptive, given what was known about the artist at the time it was made. The attribution should have pointed in the right direction, even if it did not turn out to be finally correct."[34]

Berenson had no misgivings about occasionally changing his own attributions based on additional visual evidence which, in his mind, enabled him to see paintings more clearly than before.[35] In response to a question raised about an attribution to a relatively unknown artist, which he later changed, Berenson

defended his earlier error on the ground that it was based only on "rudimentary" knowledge.[36] A good example of the plasticity of Berenson's attributions involves the changing opinions he offered about whether a painting in the Walters Art Gallery entitled *Virgin and Child with Saints Peter and Mark and Two Kneeling Donors* had been painted by Giovanni Bellini (see plate 12). In *Venetian Paintings in America*, published in 1916, Berenson concluded that this painting was not painted by Bellini. "I find it hard to believe," he wrote, "that it was by Bellini himself." Instead, he assigned the painting to "assistants who are nameless."[37] In 1932, Berenson offered a somewhat different opinion. In *Italian Painters of the Renaissance*, Berenson concluded that this picture was painted "in part by the artist [Bellini]." In 1957, he offered a third opinion. In his final, two-volume edition of *Italian Painters of the Renaissance*, Berenson concluded that the painting was "in great part autograph."[38] Thus, Berenson's attributions progressed from not painted by Bellini, to painted "in part" by Bellini, to painted "in great part" by Bellini.[39]

The continuing uncertainty about the identity of the artists who painted renowned works of art is also illustrated by some of the best Italian paintings at the Walters Art Museum. One of the jewels of the collection is a painting entitled *The Madonna and Child with Saint John the Baptist* (see plate 13). The magic of the painting lies in its imaginary relationship between the vibrant figures of Mary, Jesus, and John the Baptist in the foreground and a classically designed, circular building crumbling with age, overtaken by nature, and sliding outside the frame of the picture in the background. The divine figures in the foreground and the antique structure withering away behind them were intended to remind the viewer of the beauty, permanence, and superiority of Christianity and its promise of everlasting life over the ephemeral nature of even the most magnificent antiquities of the man-made world. When the painting was in the Massarenti collection in Rome, more than one hundred years ago, it was attributed to Giulio Romano, a Roman-born painter and architect who was one of the most gifted students of Raphael and who was celebrated for combining devotional motifs with creative references to ancient Roman buildings. Walters adopted Massarenti's attribution and listed the painting as by Romano in his 1909 catalogue. Berenson, however, disagreed with this attribution and identified Bedolo, a relatively unknown painter from Parma who was a follower of Parmigiano and Correggio, as its author. Based on Berenson's advice, Walters's catalogues of 1915 and 1922 reattributed the painting to Bedolo. In 1976, Federico Zeri, one of the most highly regarded connoisseurs of Italian paintings during the second half of the twentieth century, published a comprehensive study of

the Italian paintings in the Walters Art Gallery, in which he concluded that the painting was not by Bedolo, as Berenson had suggested, but by Raffaello Dal Colle, who worked as an assistant to Giulio Romano in Raphael's workshop. Zeri's attribution was accepted by the Walters Art Museum until 1997, when the attribution was again changed, this time to "Giulio Romano and workshop." This attribution lasted for only eight years until 2005, when it was changed again by the curators of the museum to Giulio Romano. Thus, the various attributions given to this painting over the course of a century made a full 360-degree cycle beginning and ending with Giulio Romano, the artist to whom Massarenti originally had attributed the painting.[40]

It is also salutary to compare the present vitality of the attributions made by Berenson with regard to the thirty-six paintings he sold to Walters with the present vitality of the attributions that accompanied the paintings sold by a variety of other art dealers to Walters between 1900 and 1931 (see appendix B, list 3). During this time frame, Walters acquired sixty-four individual Italian paintings from dealers other than Berenson. Among the sixty-four paintings, the original attributions of six are unknown. Among the remaining fifty-six paintings, the original attributions have withstood the test of time in nineteen cases.[41] Stated otherwise, 33 percent of the attributions given to the Italian paintings sold to Walters by dealers other than Berenson have remained unchanged. This rate of success matched Berenson's. Thus, regardless of whether the Italian paintings were acquired by Walters from Berenson or other dealers, their attributions have remained intact only 33 percent of the time.

Without diminishing the difficulty of assigning attributions to Italian Renaissance paintings, the question remains whether Berenson's advice satisfied Walters's expectations established at that time. Berenson styled himself as the world's greatest connoisseur of Italian Renaissance painting. He represented that his attributions were more dependable than those of others and tantamount to guarantees of authenticity. Moreover, he represented that the paintings he was selling to Walters were not merely typical of the work of the artists but among the best work that the artists ever painted. He obligated himself contractually to sell paintings to Walters that would improve "the overall quality of the collection." The paintings that Berenson offered to Walters were predicated on these express and implied understandings. The paintings were not acquired by Walters for his own aesthetic pleasure—he rarely looked at them. They were acquired for the education and enjoyment of future generations who would visit his museum. Thus, there was a legitimate expectation that the quality of the paintings Berenson sold to Walters as well as their attributions would maintain their currency

for the indefinite future. In this light, one can only imagine how disappointed Walters would have been if he had known that most of the paintings he acquired from Berenson suffered from the same virus of misattributions as the Massarenti paintings they were intended to replace and that Berenson's attributions were no more reliable than those of other dealers.

In retrospect, Berenson's major contribution to Walters's collection of Italian paintings was in a manner neither sought nor appreciated by Walters at that time. It was clearly not in the quality of the paintings he sold to Walters, for there were surprisingly few great paintings among them. Nor was it in the scholarly, illustrated catalogue that he promised to write for Walters but never finished. Rather, as we shall see, it was in Berenson's studious criticism, which peeled away the stale and pretentious attributions Walters had adopted from Massarenti and which thereby gave the Walters collection of Italian paintings a fresh start. What Berenson contributed to the Walters collection, paradoxically, was not primarily by addition but by a refined process of subtraction.

BERENSON'S
FAUSTIAN BARGAIN
WITH DUVEEN

In an art market unrestricted by ethical standards, the dealer who was widely considered to be the most unscrupulous was Joseph Duveen. Duveen's biographer Meryle Secrest has written that he became known to the public as "a magnificent, dramatic and astute plunger."[1] Around 1905, Duveen embarked on a program to corner the market on Italian Renaissance paintings, to attribute the paintings he acquired to the most famous artists, and to sell these paintings to American millionaires at the highest possible prices. In 1906, he enlisted Berenson to help him reach these objectives. Walters did not like Duveen, he found him distasteful, and he did not want to deal with him. He expressed his feelings to Berenson. According to one account, in 1911, Berenson wrote to Walters requesting his opinion as to whether he should become a paid adviser of Duveen. Walters replied that he should have nothing to do with him because he was "dishonest."[2] In May 1912, Duveen asked Berenson to bring Walters to his gallery to acquire paintings from him. Aware of Walters's antipathy toward Duveen, Berenson deflected Duveen's request.[3]

Berenson also disliked Duveen and later would grow to despise him.[4] Berenson, to those who admired him, embodied the highest standards of cultural refinement—it was as if his life itself was a remarkable work of art. Duveen, on the other hand, was considered by many, including Berenson's wife Mary, to be coarse and vulgar, the polar opposite of Berenson.[5] Berenson was offended by Duveen's commercialization of art and endless desire to increase the costs of paintings regardless of their quality. Berenson later referred to Duveen as "evil"

and employed the pejorative phrase "king of the jungle" to express his disdain for him.[6]

Notwithstanding Walters's suggestion to Berenson that he should stay clear of Duveen and Berenson's own distrust of him, in July 1912, Berenson began negotiating with Duveen to become his partner. What influenced Berenson to become embedded with Duveen was, pure and simple, his need for financial security as he was advancing through the middle years of his life.[7] Earlier that year, Berenson, in a very personal letter, had revealed to Walters his anxiety about this. "At forty we begin to look at things with the cold eye of reason, & reason is suicidal . . . The truth is life is a miracle enacted for the delectation of childhood & youth. Grownups go on till middle age on the impetus derived from earlier years. But after forty, it really does require faith, hope & very much charity to live without being a bad nuisance to one's self, & worse yet one's neighbors."[8] (A copy of the letter is in appendix A.) Around the same time, Berenson wrote to his longtime friend Henry Adams expressing concern about his "old" age and suggesting that his world was "coming to an end."[9]

Among the variables that caused Berenson to worry about his financial security was the difficulty he was having in retaining the allegiance of individual collectors. By the summer of 1912, it had become clear to Berenson that he could not count on the continued patronage of Walters and his shrinking coterie of individual clients. Although Walters was Berenson's most active client during the two-year period from July 1910 to July 1912, Walters had repeatedly signaled to Berenson that his passion for acquiring Italian paintings was losing steam and that he was unwilling to spend large amounts of money for individual paintings. During the first two years of his relationship with Berenson, Walters had conveyed in a lighthearted, tongue-in-cheek manner that his resources for buying Italian paintings were not unlimited. This was initially conveyed in a letter of August 25, 1910, which stated that that, due to budgetary constraints, he had to "live the life of a recluse to avoid any additional temptations."[10]

On May 30, 1911, Walters's alleged budgetary problems had more immediate consequences, resulting in his declining of a painting by Benozzo Gozzoli, the Florentine artist whose fame had been enshrined in 1463 by his decoration of the chapel in the Medici Palace. On October 26, 1911, Walters again facetiously expressed his financial limitations by asking, "I wonder if you [Berenson] are going to be able to find me an interesting Sassetta at a poor man's price."[11] During the second year of their contract, Berenson had to coax Walters to use the $75,000 that had been budgeted for acquiring Italian paintings. In this regard,

on May 13, 1912, Berenson wrote to Walters that he was "anxious" to hear from him and concerned because he had spent only $35,000 out of the $75,000 in the current budget.[12] At Berenson's request, Walters returned to I Tatti in May 1912 to purchase more paintings, but this turned out to be his last visit there.[13] On July 24, 1912, Walters clearly conveyed to Berenson that he was unwilling to budget the same amount of money to purchase Italian paintings as before. More specifically, Walters informed Berenson that he declined to purchase a painting by Giovanni Bellini because the "price makes it impossible even to consider." He added that "I am in a [financial] condition that I cannot consider anything for the next three months."[14]

What was probably even more troubling to Berenson was Walters's surprising indifference to the paintings Berenson had acquired for him. Prior to purchasing most of the paintings acquired from Berenson, Walters had not actually seen them in person. His decisions to purchase the paintings were based primarily on Berenson's recommendations and descriptions accompanied by small black-and-white photographs of them.[15] If Walters felt any passion for Italian Renaissance painting and excitement over the paintings that he was acquiring, he almost certainly would have hastened to Baltimore upon their arrival to feast his eyes on their color, design, and overall beauty and to compare them to other paintings in his collection. However, Walters did not do that. He allowed the paintings to languish in their crates for months before taking the time to see them. In response to Berenson's letters inquiring about paintings that had been shipped to Baltimore, Walters apologetically wrote that he was preoccupied with other matters and unable to pay any attention to most of them.

Walters's letters to Berenson document the fact that he spent very little time at his gallery in Baltimore, and months would pass between his occasional visits. On August 25, 1910, Walters wrote that, since his return from Italy in the spring, "I have been able so far . . . to spend almost no time in Baltimore." On October 7, 1910, he wrote again that "I have not been able to make my trip to Baltimore." On February 7, 1911, Walters apologized for not writing to Berenson about the paintings he had purchased: "I feel that I have been very remiss in writing you, but it has really been because I have not been able to become properly acquainted with the pictures you have been sending me." On October 26, 1911, Walters again wrote that, since his return from Italy that spring, "I have spent no time in Baltimore and have not been able to unpack any of my pictures, nor have I been able to do any work at all at the galleries." On December 22, 1913, he wrote to Berenson again conveying his apparent indifference to his new Italian paintings: "I have still been unable to open any boxes that came from Europe

to the Art Gallery last summer, so you will have to understand how unsettled I have been."[16] On July 16, 1912, the Walters Art Gallery had received three cases full of paintings. The cases remained unopened for twenty months until March 1914, when Berenson's visit to the gallery prompted Walters to travel to Baltimore and finally look at them.[17]

While Walters was expressing a lack of interest in Italian painting and a reluctance to part with large sums of money to acquire it, Berenson was keenly aware that the amount of money that other wealthy Americans were willing to spend on Italian Renaissance art was rising dramatically, as was illustrated by Henry Clay Frick's purchase in 1911 of a painting by Velázquez for $500,000 and by P. A. B. Widener's purchase two years later of the *Small Cowper Madonna* by Raphael for $700,000.[18] He also was keenly aware that Frick, Widener, and many other big spenders, such as Benjamin Altman, S. H. Kress, and Andrew Mellon, were clients of Duveen. The prospect of teaming with Duveen to encourage America's top echelon of collectors to purchase expensive Italian Renaissance paintings and to substantially profit thereby was a Faustian bargain that Berenson found irresistible even if Walters were to become the first casualty along the way.

The five-year agreement between Berenson and Duveen was signed in mid-October, but it went into effect retroactively as of July 1, 1912.[19] The agreement, by its express terms, was secret, and Berenson's identity, as a party to the agreement, was concealed by his use of the fictitious name "Doris." Under the terms of the agreement, Berenson was obligated to bring to Duveen's attention any "first class Italian pictures" that he came across; to provide Duveen with the opportunity to purchase these paintings at favorable terms; and to further provide Duveen with written certificates, based on Berenson's opinion, about the authenticity and value of each work of art. If Duveen did not want to purchase a painting offered to him by Berenson, this fact, under the terms of the agreement, would never be disclosed to any individual collector, like Henry Walters, to whom Berenson might thereafter offer the painting. The contract provided that Berenson, in return for his services, would receive 25 percent of the net profits Duveen derived from the sale of Italian paintings that had Berenson's stamp of approval. Tacitly recognizing the ethically troublesome nature of their profit-sharing arrangement, which tied Berenson's compensation to the level and value of his attributions, the agreement provided that "neither party shall divulge the fact, or leave anybody to infer that Doris [Berenson] is paid by D.B. [Duveen Brothers] on a percentage basis."[20]

The provision of this agreement that had the most effect on Walters involved Berenson's obligation to offer "first class Italian pictures" to Duveen for resale

to Duveen's sizable clientele before offering these paintings to other collectors, like Walters. The agreement required Berenson to inform Duveen about "everything he comes across" and to give him the right of first refusal.[21] If Berenson were to comply with the terms of this agreement, the only paintings he could offer to Walters were those which, in his judgment, were not "first class" or had been offered to and rejected by Duveen and his clientele. As a result of this agreement, Walters was placed behind Duveen and his sizable group of clients in the marketplace of Italian art, and Walters's opportunity to obtain first-class Italian paintings from Berenson was significantly compromised.

From Berenson's standpoint, whatever conflicts of interest arose between his contractual obligations to Duveen and his obligations to Walters were unlikely to have any significant impact on either. Walters had placed himself in a different league from that of Widener, Frick, Altman, and the other free-spending Duveen clients. Moreover, in July 1912, following the completion of the second year of their contract, Berenson no longer was contractually bound on any long-term basis to Walters. The second year of their annual contract had expired on June 30, 1912, and three weeks later Walters's letter of July 24 conveyed to Berenson that he was not prepared to renew the agreement for another year. As a result, at the time he entered into the contract with Duveen, Berenson was a free agent.

At that stage, there would have been nothing wrong with Berenson's decision to tie himself contractually to Duveen if he had been open about this and candidly disclosed the matter to Walters. The problem was that he did not. Berenson was not candid with either Walters or Duveen. While contracting with Duveen to give him and his clientele preference for all "first class Italian pictures," Berenson tried to hide this fact from Walters and at the same time endeavored to hold onto his business by suggesting that he remained devoted to his interests. On the other hand, while trying to hold onto Walters's business, Berenson conveyed to Joseph Duveen that he was completely dedicated to satisfying the business interests of his firm, which he characterized as an "unswerving and absolute loyalty, my honorable devotion to your interests."[22] To Berenson, it seems, the concept of "loyalty" had a transitory meaning that swirled as easily as a revolving door.

On October 12, 1912, at a time that coincided with the execution of Berenson's contract with Duveen, Berenson wrote to Walters that he was having difficulty finding worthwhile paintings to offer him: "My runners have gathered in a very scant harvest." Elaborating on this theme, Berenson exclaimed, "I have never found so little to tempt one. Italy is really as good as exhausted."[23] The temporal

proximity between Berenson's message to Walters and the execution of his contract with Duveen suggests that it was designed to conceal Berenson's contractual obligation to offer every first-rate painting to Duveen. Berenson's duplicity is underscored by a letter that he had sent two weeks earlier, on September 25, 1912, to John G. Johnson. In his letter to Johnson, Berenson sang a different tune about the availability of Italian paintings. Contrary to the notion that he could find no worthwhile paintings, Berenson informed Johnson that he recently had come across two Italian paintings that he urged him to buy. One was a painting by Bramantino, which Berenson characterized as "one of the most exquisite works by Bramantino that I have ever come across."[24] Berenson's effort to retain Walters's business and sell him more paintings while concealing his conflicting agreement with Duveen was emblematic of the manner in which Berenson, time and again, employed duplicity to reconcile the colliding relationships he maintained with collectors and dealers.

Berenson's willingness to become engaged simultaneously with buyers and sellers while maintaining the pretense of devotion to each was repeated on an ad hoc basis for several years until ripening in 1912 into his formal contract with Duveen. This symbiotic arrangement between Berenson and Duveen was predicated on their mutual intent to shrewdly capitalize to the full extent on the realities of the market for Italian Renaissance paintings. Although the availability of Italian Renaissance art for purchase by American buyers was expanding, the acquisition of Italian art remained a high-stakes gamble due to the widespread problem of unreliable attributions. Because Berenson's attributions were considered as practically sacrosanct, his authentications naturally added significant value to works of art, elevating their price as well as the substantial profits he and Duveen shared. In this connection, the contract between Berenson and Duveen expressly recognized that "this agreement is based upon the very considerable value attaching to the opinion and belief of the Expert [Berenson] concerning the authenticity, history or criticism of Italian pictures and other works of art."[25]Although there is no hard evidence that Berenson intentionally fabricated an attribution or certified that a painting was authored by the hand of a master instead of a follower in order to increase its value, his secret arrangement with Duveen provided substantial incentive for him to do so and logically raised ethical questions as to whether he had fallen into an irreconcilable conflict of interest.[26] It ensnarled Berenson in the widespread deceptive and unscrupulous dealings of the art market, ultimately tarnishing his reputation.[27] And it prompted even Berenson's old friend and disciple Sir Kenneth Clark to lament that Berenson "was perched on the pinnacle of a mountain of corruption."[28]

The business relationship between Berenson and Duveen, although repeatedly torn by the clash of cultural values, remained awkwardly glued together for close to thirty years by their common venality. In 1953, after his partnership with Duveen had ended, Berenson, in his autobiographical *Sketch for a Self-portrait*, berated himself over the election he made to compromise his intellectual integrity and to forsake the trust of his friends and clients in exchange for the fortune he obtained, estimated at over one million dollars, as a result of his partnership with Duveen.[29] Writing as his own harshest critic, Berenson recalled "the wrong turn" he had taken in entering Duveen's commercial jungle and in becoming "a refined and affectionate cannibal."[30]

The questions of whether and when Walters became aware of Berenson's contract with Duveen cannot be answered with any certainty. There is no extant document, memoir, or other form of evidence that definitively addresses this issue. The circumstantial evidence, however, indicates that, in early July 1912, Walters learned of Berenson's impending contract with Duveen, and this information motivated his letter of July 24 that informed Berenson of his unwillingness to re-enter another annual contract with him. The primary source of Walters's information was probably Berenson himself, who had forewarned Walters of his interest in becoming employed by Duveen. Walters undoubtedly remained vigilant to the possibility that Berenson, despite his opposition, would consummate this plan. As an active and influential trustee of the Metropolitan Museum of Art and one of the most sophisticated and cosmopolitan collectors in the world, with an endless network of dealers who were coveting his business, Walters, at that time, was perched like an eagle on the highest platform of the art world from which he could observe firsthand or learn from others who was buying what Italian paintings, from which dealer, at what price, and based on whose advice. As revealed by his letters to Berenson, Walters took pride in revealing his inside information about the inscrutable dealings in the market for high-priced art.[31] Although Walters probably was unaware of the precise terms of Berenson's contract with Duveen, he almost certainly heard the rumors that Berenson had tied himself to Duveen.[32] From Walters's standpoint, Berenson's new arrangement with Duveen provided ample reason to distrust him, and it probably was the motivating reason for his decision to discontinue his annual $75,000 contract with him.

Although Walters did not want to tie himself to another annual contract with Berenson, Walters did not want to completely sever his relationship with him. What Walters wanted was a healthy separation but not a divorce. He remained dependent on Berenson to help him analyze and refine his collection of Italian

paintings and to write the scholarly catalogue that would bear Berenson's name and hopefully provide the collection with Berenson's valued imprimatur. To maintain this connection, Walters continued to occasionally purchase paintings from Berenson, but the total number of paintings he acquired from Berenson after Berenson became embedded with Duveen dramatically declined. In contrast to the twenty-six paintings that Walters acquired from Berenson during the two years between July 1, 1910, and June 30, 1912, Walters acquired only three paintings from Berenson between July 1, 1912, and June 30, 1913; two paintings from July 1, 1913, to June 30, 1914; two paintings from July 1, 1914, to June 30, 1915; and three paintings between July 1, 1915, and June 30, 1916 (see appendix B, list 1). In an effort to explain to Berenson this decline in acquisitions, Walters pretended that he was financially strapped and could not afford to purchase paintings from Berenson at the same rate as before.

In the business relationship between Walters and Berenson, perfect candor was not part of the equation. Neither had ever placed veracity high on their personal scales of moral values. As part of the give and take of salesmanship, each recognized that the other had an implicit license to shade the truth. Berenson, as previously illustrated, would regularly overstate the quality or importance of the paintings he proposed and, to convince Walters to buy them, pepper his letters with exaggerated warnings that paintings of such quality were disappearing from the market. Walters would counter Berenson's overtures by exaggerating the financial problems he was encountering or fabricate some other reason for not purchasing more paintings from him. As illustrated by his fabricated claim about the cost of the Massarenti collection, which was intended to decrease his taxes, and about the endless masterpieces it contained, which was intended to increase his fame, Walters had become a virtuoso at slicing the truth to achieve his aims. Mary Berenson once described Walters as a "shrewd old bachelor."[33] In this description, "shrewd" was the operative word. It was a word that clearly fit Berenson as well. Shrewdness was a shared characteristic that strangely bound Walters and Berenson together as they artfully danced a minuet around the truth.

The evidence of Walters's mounting prosperity from 1912 to 1914 serves to discredit the representations he made to Berenson that he was financially unable at that time to purchase more Italian paintings. During this period, Walters remained the chairman of the board and the major stockholder of the Atlantic Coast Line Railroad holding company. By reason of his position and extensive control over the railroad industry on the East Coast, Walters became known as "the railroad king of this country."[34] Between 1909 and the outbreak of the Great

War in 1914, Walters's railroad business enjoyed a pronounced upswing in business and became increasingly profitable. Its net income dramatically increased from $2.8 million in 1907/08 to $7.3 million in 1913/14.[35] In 1910, Walters was placed on the Board of Directors of the United States Steel Corporation, succeeding John D. Rockefeller. To enjoy his mounting wealth and prestige, Walters, in 1911, erected a fourteen-room beachside cottage in Wilmington, North Carolina, for his use during the summer months.[36] Described as "the richest man in the South," Walters had a personal fortune that continued to grow, reaching an estimated $30 million to $40 million.[37]

Meanwhile, Walters continued to purchase sizable quantities of art, including ancient bronzes from South Italy, Renaissance bronzes and enamels at an auction at Christie's, Egyptian antiquities and Islamic objects and manuscripts from the dealer Dikran Kelekian, and French paintings from his family's long-time dealer, Arnold Seligman.[38] Records of the works of art shipped from Europe to Walters in 1913 and 1914 reveal that he received huge shipments of art on almost a weekly basis.[39] A former curator of ancient art at the Walters Art Museum, who was very knowledgeable about the patterns of Walters's acquisitions, has written that "Henry Walters was always collecting everything . . . He never cut down on his buying even during the Great War."[40] Another knowledgeable observer calculated that, from 1900 to the time of his death in 1931, Walters "spent on an average of over a million dollars annually in the acquisition of works of art."[41]

Contrary to the claim made to Berenson about his inability to purchase more Italian pictures, Walters also continued to buy a significant number of Italian paintings from other dealers. Between July 1912 and September 1917, Walters acquired more than thirty Italian paintings from other dealers while purchasing only ten paintings from Berenson.[42] (See appendix B, list 3.) After informing Berenson in July 1912 that he could not afford to acquire a painting by Giovanni Bellini, Walters acquired Bellini's *Virgin and Child with Saints Peter and Mark and Two Kneeling Donors* from another source.[43] As evidenced by Walters's acquisition of this painting, it was not his interest in acquiring Italian painting that had declined but his interest in using Berenson as the primary source for doing so.

THE JUDGMENT
OF BERENSON

In June 1913, Berenson completed the catalogue of the Johnson collection. He was proud of his work and asked Johnson to provide him with one hundred copies to send to friends and colleagues. In December of that year, Berenson and his wife Mary returned to the United States for several months, seeking to attract new, wealthy clients for Berenson and Duveen. While in New York, Berenson escorted members of the Rockefeller family to Duveen's gallery and met with a succession of millionaires whom he hoped to add to his clientele.[1]

In early March of 1914, Berenson suspended his business development activities to visit the Walters Art Gallery in Baltimore. More than four years had passed since Berenson had proposed to inspect the Massarenti paintings and to write a major catalogue about Walters's collection of Italian paintings. Despite this passage of time, Berenson had not visited the gallery and personally inspected the art. Although Berenson had photographs of all of Walters's notable Italian paintings, Berenson knew that photographs alone were insufficient to judge the validity of the attributions. Berenson had emphatically warned his client John G. Johnson about the limitations of photography: "Bear in mind, please, that photographs tell only so much, and that they are very loose and dumb about the very important questions of whether or not the original they represent is a forgery."[2] Accordingly, Berenson's visit to Baltimore to examine Walters's paintings was both vital and long overdue.

In March 1914, at the time of Berenson's visit, the relationship between Walters and Berenson remained cordial but was decidedly cooler and more distant than before. Berenson's cozy relationship with Duveen had driven a wedge

between them. Walters and Berenson had not seen each other for more than a year, a departure from the pattern of annual visits in 1910–12. Walters had not visited Berenson at the Villa I Tatti in 1913. Moreover, he acquired only four paintings from Berenson from July 1912 to the time of Berenson's visit in March 1914. Most emblematic of the distance that had developed in their relationship, Walters did not invite Berenson and his wife to stay at Walters's spacious home connected to the gallery during the week when they were inspecting his paintings.[3] As a result, they checked into a neighboring hotel. In an effort to mitigate any hard feeling caused by this oversight, Walters sent Berenson a note of apology stating that "I was very sorry not to have been able to lodge you in my own house at Mount Vernon Place."[4] If the apology had been intended to soften Berenson's assessment of his collection, it did not work.

The delay in Berenson's visit to the Walters Art Gallery was the product of Berenson's preoccupation with more lucrative projects. By 1914, Walters had become only a marginal figure in Berenson's business world. The delay might also have been a reflection of Walters's increased ambivalence about whether it was in his interest to obtain Berenson's opinion of his collection. Walters had already felt the painful consequences of Berenson's analysis of one of his most treasured paintings, Raphael's *His Own Portrait at the Age of 25*. On April 15, 1911, Walters shipped this painting to the Villa I Tatti to have Berenson inspect it firsthand. Following Berenson's analysis, it was returned to Walters on November 24, 1911.[5] Berenson's verdict was what Walters hoped not to hear: the painting was not by Raphael. Thus, the painting that had been publicized in the *New York Times* and *Baltimore Sun* as being one of the jewels of Walters's new collections, that Walters had obtained through hard negotiations with Massarenti, and that had been proudly displayed by Walters next to his *Madonna of the Candelabra* at the 1909 grand opening, was quietly removed from the walls of his gallery. Berenson's opinion discrediting Raphael's alleged self-portrait was to Walters a dreadful harbinger of how Berenson might assess the rest of his collection.

On March 4, 1914, Bernard Berenson, accompanied by his wife, arrived at Walters's gallery in Baltimore; they remained in Baltimore for nearly one week. While touring the collection, they were joined by Belle da Costa Greene, who was a leading figure in the international art world and, perhaps more important to Bernard Berenson, his paramour. Greene later became the director of the Morgan Library and, following Walters's death, a key advisor to the new Walters Art Gallery. According to her own account, she "visited the [Walters] collection more often than anyone else, except, perhaps, Mr. Walters himself."[6] When the

Berensons and Greene entered the Walters Gallery in 1914, they were aghast at what they found. Mary Berenson observed that Walters had some "splendid things," but these things were "hopelessly lost and buried in masses of indifferent stuff, and actual rubbish."[7] Greene described the collection in even harsher terms. She said that it looked like "all the trash of the world had been swept up and dumped into that poor building."[8]

Berenson, with the assistance of his wife Mary, approached the task of weeding through the problematic paintings and assessing the collection in a careful and methodical manner. Using a copy of Walters's 1909 catalogue, Berenson recorded his impression of each Italian painting listed in the catalogue. Berenson questioned most of the attributions in Walters's collection, and he noted the changes in attributions that he wanted to make. He also made several marginal notes about the quality of some of the paintings, as exemplified by his praise of Filippo Lippi's *Virgin and Child* (see plate 10), which he wrote was "one of the loveliest in existence." More often, however, he indicated his dissatisfaction with the paintings. He placed an X over 106 paintings, designating them for removal. After looking at the paintings on display, Berenson also prepared a memorandum, entitled "Further suggestions of removal," which listed, according to their location, additional paintings that should be removed. Based on Berenson's advice, a six-page memorandum, entitled "Pictures to be Removed from the Walters Collection," was prepared. Berenson and Walters both retained a copy of this memorandum.[9] One hundred nineteen paintings, which amounted to approximately 40 percent of the Italian paintings in the 1909 catalogue, were on that list.

Berenson also looked at the paintings that Walters had purchased after the publication of the 1909 catalogue. On the blank pages in the front and the back of the 1909 catalogue, Mary Berenson compiled a handwritten list of fifty-two paintings that she characterized as "New Acquisitions." Twenty-five paintings that Berenson previously had sold to Walters were included on this list.[10] Most of the "New Acquisitions" would replace the paintings that had been earmarked for removal.

Toward the end of the week, Mary Berenson summarized what had been accomplished. She wrote that Berenson had divided the Italian paintings into three categories — "good, bad and indifferent" — and had recommended that Walters dispose of the bad paintings, which he considered to be nothing more than "rubbish and . . . forgeries."[11] Although in the space of one week Berenson had decimated Walters's collection of famous Italian artists, Walters accepted Berenson's criticism like a gentleman, with a stiff upper lip. On March 10, 1914, Walters wrote Berenson a thank-you note, stating that he "was elated to have the

pleasure of [his] week with Mrs. Berenson and yourself in Baltimore."[12] Following Berenson's critique of his collection, Walters closed his gallery for ten months for the purpose of removing the objectionable paintings, changing the attributions of many of the remaining paintings, rehanging the collection, and publishing a revised catalogue.

Shortly after closing his gallery, Walters received a request from Lorinda Munson Bryant, who was writing a book entitled *What Pictures to See in America*. Bryant had obtained the permission of the most important museums and individual collectors in the country to include paintings from their collections in her book, and she sought the same access and permission from Walters. Walters, however, turned her down. In a letter to Bryant, Walters, without expressly referring to Berenson, explained that he was in the process of removing "a great many pictures which were upon the walls and which I intend to replace with others." Referring specifically to his Italian paintings, he continued, "I have rehung entirely my Italian pictures and have discarded a very large number and have added many new ones." The word "entirely," chosen by Walters, precisely reflected the sweeping changes that resulted from Berenson's analysis. Signaling an important change in the nature of his collection of Italian paintings, Walters concluded his letter to Bryant by stating that "I have endeavored more particularly in my Italian pictures to represent the history of Italian art rather than fill my gallery with masterpieces."[13] Consistent with the information she received from Walters, Bryant wrote in her book that "the [Walters] collection has always held a unique place because of its value as an educator, but this is particularly true since the pictures have been carefully culled and rehung."[14]

The changes recommended by Berenson transformed the collection. Among the 293 Italian paintings listed in the 1909 catalogue, only 30 survived unchanged. No collection in American history had undergone such radical surgery so quickly. The 1909 catalogue had been rendered obsolete, necessitating the prompt preparation of a new catalogue to identify the new paintings and the changes in attributions.

Walters viewed the new catalogue as an interim step in the preparation of the grand, illustrated catalogue that would later be authored by Berenson. In July 1914, Walters wrote to Berenson informing him that he was in the process of preparing a "temporary approximate catalogue" that would reflect all of the changes that had been made.[15] Later that summer, Walters met with Berenson in Paris and reviewed the new catalogue.[16] On January 23, 1915, Walters reported to Berenson that he had revised the catalogue and sent it to the printers.[17] One month later, on February 23, 1915, the new catalogue was delivered to the gal-

lery.[18] The gallery's superintendent, James Anderson, documented this event in his calendar: "New Catalogue (70 copies, of Ed 5000) Rec'd this day. Sent Mr. Walters 12 copies. Sent Yale Library University Copy New catalogue."[19]

Walters promptly sent a copy of this catalogue to Berenson. It was accompanied by a letter in which Walters acknowledged that the catalogue contained several errors: "I have mailed you the new issue of my catalogue. You may find some typographical errors in it, as I was not able to give the proof personal correction and had to rely on others."[20] A few days later, Walters sent another letter to Berenson acknowledging that there were a few erroneous attributions in the catalogue involving paintings by Raffaello Dei Carli and at least one other artist. Walters informed Berenson that he intended to correct these errors by "pasting the proper attribution in each copy of the catalogue."[21]

The new catalogue did not expressly refer to Berenson by name. The reason his name was missing was because both Walters and Berenson viewed this catalogue as a work-in-progress that ultimately would culminate in the grand, illustrated catalogue that would bear Berenson's name. Although the catalogue did not expressly refer to Berenson, his fingerprints were indelibly upon it. Consistent with Berenson's notes and directions, 137 of the Italian paintings listed in the 1909 catalogue, most of which had been acquired from Massarenti, were removed entirely from the new catalogue. Moreover, among the remaining 156 Italian paintings, the attributions of 126 were changed. In summary, among the 293 Italian paintings listed in the 1909 catalogue, 263 of these paintings, or 90 percent, were removed or had their attributions changed in the 1915 catalogue. Eliminated from the new catalogue were almost all of the previous attributions to the great masters of the Italian Renaissance. The self-portrait attributed to Raphael was reattributed to either Bugiardino or Soligani, whose names have long faded from art history, and the self-portrait allegedly by Michelangelo was assigned to an anonymous Central Italian artist.

To take the place of many of the removed paintings, Walters added approximately fifty-five new Italian paintings. Thirty of these paintings had been acquired from Berenson during the previous four years (see appendix B, list 1). The new catalogue also adopted thumbnail descriptions of the artists, which Berenson previously had written and published in his Four Gospels of Renaissance paintings. For example, in *Venetian Painters of the Renaissance*, Berenson described Polidoro Lanzani as follows: "Imitator of Titian, influenced by Bonifazio and Pordenone; later by Paul Veronese." In the 1915 catalogue, Berenson's description was adopted word for word and comma for comma. Perhaps the most important, conceptual change in the new catalogue was that it placed

each artist in historical context. As illustrated by the description of Polidoro Lanzani, each artist was identified not only by his "school" but also by the earlier masters who had taught or influenced him. In this manner, Walters's collection was transformed under Berenson's guidance from a collection of individual paintings to one that explored these paintings in the context of art history.

Berenson's role in transforming Walters's collection of Italian paintings was no secret at the time. When Walters reopened his gallery in January 1915, the sweeping changes that had been made based on Berenson's advice were readily apparent to the press. One newspaper account of this pivotal event stated: "Last winter the North Gallery was examined by Bernard Berenson whose word concerning an old Italian painting carries the seal of authority perhaps as absolutely as that of any other living expert. The evidence presented today shows that Mr. Berenson weeded out right and left."[22]

In describing Berenson's decisions to eliminate many of the paintings, another reporter used the word "censorship," as if to suggest that Walters's prior misattributions were so deficient as to be unmentionable. The *Baltimore News* reported that "a great many changes have been made in the arrangement of the north gallery, where hung works by Italian masters." According to this account, "two hundred of the familiar paintings" had been removed and "80 unfamiliar ones" put in their place.[23] Another story focused on the two paintings purportedly by Raphael that Walters had once proudly displayed side by side. This column reported that Berenson concluded that the famed self-portrait by Raphael was "not by the artist himself" and that the *Madonna of the Candelabra* was not painted exclusively by Raphael. While the elimination or downgrading of the old-master paintings must have been disheartening to Walters and to the art lovers who flocked to his gallery, Walters used Berenson's name to put a positive spin on this unsettling development. The press reported, apparently with Walters's encouragement, that "every picture now in place, it is said, has been passed upon by him [Berenson] so that its authenticity can be taken with at least a reasonable degree of certainty."[24]

Although Walters removed the copies of old-master paintings from his walls, he was very hesitant to actually dispose of them. In February 1915, Walters turned reluctantly to this task. From Berenson's long list of 119 paintings, Walters initially selected only 8 paintings for disposition. These eight paintings, when juxtaposed with Walters's three favorite paintings, serve like key pieces of a puzzle that lead to a visualization of Walters's sensibilities and taste in Italian art. Walters's three favorite paintings in his collection were all similarly sized, beautiful, devotional pictures of the Madonna and Child painted on panel by Filippo Lippi, Carlo

Crivelli, and Raphael (see plates 1, 10, and 11) during the fifteenth and early six-
teenth centuries.[25] The images were, by the standards of Renaissance painting,
classical. There was nothing risky or avant-garde about them. Walters's identifica-
tion with these paintings revealed his affection for the great art of the distant past.

Although an adventurous collector, Walters was decidedly timid when it
came to art that challenged the tenets of the past. As he expressed to Berenson,
Walters had little interest in exploring the new art of the late nineteenth and
early twentieth century that had become popular in the United States after the
war.[26] The eight paintings that Walters selected for disposition were products of
the seventeenth century that involved secular themes and reflected an interest
in naturalism. They stood in polar contrast to the religious works of art that
Walters cherished. Three of these paintings were by the renowned seventeenth-
century artist Salvator Rosa. One was a handsome and powerful portrait of a
soldier dressed in armor and carrying with both hands a red and blue banner;
he was guardedly turning his head to peer over his right shoulder as he was
greeted with a ray of light. The second painting was a psychological study of a
common soldier wearing a rustic fur hat; the soldier's hunched shoulders, fur-
rowed brow, and pensive eyes convey a troubled state of mind as he cups with
both hands a drinking bowl and lifts it to his mouth. The third painting was an
unusual portrait of a wealthy, vain man overdressed like a dandy in a luxurious,
red velvet jacket with a white fur collar and wearing a red velvet hat with plumes
of white and orange flowers that extend across the plane of the painting.

In addition to the three paintings by Rosa, Walters decided to dispose of
Giovanni Moroni's *Portrait of a Warrior*, a painting of *Venice* by the School of
Canaletto, Pietro Liberi's *Allegorical Figure*, and Guido Canalassi's *Lucretia*.
According to Roman legend, Lucretia, after being raped by the son of a tyranni-
cal king, obtained the promise of her family to avenge her honor by killing the
rapist and then plunged a dagger into her heart. Her martyrdom led to the end
of the Roman monarchy and the beginning of a republic. In Canalassi's beau-
tiful painting of the nude, ivory-like figure of Lucretia, she is seen looking for-
lornly away from the viewer and awaiting her death after piercing her heart
with a dagger, which remained in her hand and rested on a blood-red robe that
had fallen to her waist. The painting by Liberi depicts a beautiful, youthful, and
seductive Venus flirting with the viewer while squeezing her left breast. The
painting alludes to the Greek myth about the milk that spurted from Venus's
breast to form the Milky Way.

Walters decided to donate these paintings to the Cape Fear Club, a venerable
men's club in Wilmington, North Carolina, which he had joined years earlier

while residing with the Joneses and where he remained a frequent guest. Walters probably thought that the paintings of warriors and the two paintings of female nude figures would appeal to the masculine values or titillate the prurient interests of the members of this "old boys" club. All of these paintings remain prominently displayed at the club, with four being hung in the library that now bears Henry Walters's name.[27]

THE UNFINISHED
CATALOGUE

After Europe descended into war in August 1914, the market for Italian Renais-
sance paintings, like the market for European art in general, initially came
to a standstill. Any interest in buying art when the world was at war seemed frivo-
lous if not incomprehensible. The American stock market fell precipitously,
and money was not readily available to purchase luxuries. Dealers, such as Du-
veen Brothers, promptly closed their galleries on the European mainland and
moved their inventories to safer locations. The company instituted a moratorium
on its sale of art and temporarily halted any payments to Berenson for paintings
that were previously sold based on Berenson's imprimatur. Without the support
of Duveen, Berenson fell heavily into debt and begged Duveen for money to
pay his bills.

In a letter to Henry Duveen dated September 23, 1914, Berenson implored:

> Much as I dislike troubling you I must beg you to be ready to let me have 10,000
> . . . It will take every penny of that to meet my engagements, and even then I shall
> be obliged, unless you will give me more, to live on next to nothing at all. The truth
> is that due to your monopolizing my services, and to your delay in paying me, I
> have been reduced to borrowing from my bankers. They not only refuse to advance
> me more money, but insist on being paid the considerable sums I owe them al-
> ready. Unless therefore you give me 10,000 directly . . . , I shall be threatened with
> bankruptcy.[1]

On October 2, 1914, Berenson again pleaded to Duveen that he was in desperate
need of money and that he was "half dead with worry and anxiety." And he
threatened that if he did not receive a payment immediately, "I shall have to let

very important people know that my financial difficulties are due to your failure to pay but a part of what you owe me.[2] On October 10, 1914, Berenson, writing from England, informed Duveen that unless he received some money by November 5, he would be in "ruin" and could not return to Italy.[3]

Although Berenson was able to obtain enough money from Duveen to return to Italy in 1915, the market for art remained equally stagnant that year. After the sinking of the *Lusitania* by a German submarine and the loss of 1,198 passengers and crew on May 7, 1915, very few collectors were willing to hazard transatlantic shipments of art. Wartime travel within Italy also became increasingly difficult, especially after Italy declared war on Austria on May 23, 1915 and fighting ensued along the Italian frontier with Austria. When Berenson attempted to scout for art that month in an area around Urbino, he was arrested and briefly imprisoned on suspicion of being a German spy.[4] Towards the end of 1915, Berenson, looking back on the effects of the war, wrote, "For a year I have lived an all but cloistered life."[5]

The war and its initial economic consequences likewise brought Walters's interest in acquiring Italian Renaissance art to a temporary halt. On September 14, 1914, just one month after the war began, Walters wrote to Berenson expressing his anxiety over the capacity of Germany to destroy England's commerce, his sympathy for Berenson's situation in Italy and his concern about the economic conditions in the United States, especially the financial plight of his railroad. With regard to Berenson, he wrote, "I feel deeply for your situation in connection with your home in Florence and the temporary stagnation of everything in connection with the arts and sciences." He described the economic conditions in the United States as being in "a desperate state." And he informed Berenson that in light of the war, "I am not inclined to buy any works of art at all."[6] On December 31, 1914, Walters wrote to Berenson that the income of his railroad had fallen almost fifty percent during the year, and he could "spend no money on luxuries." In this letter, Walters rejected the opportunity to purchase a painting by Caravaggio, and he repeated that, "it is utterly impossible for me to entertain the purchase of any works of art during the present condition of despair in business in America."[7] Two months later, on February 25, 1915, Walters restated his unwillingness to purchase more paintings, stating, "I am sorry to say that I cannot see any chance of buying any art objects for some time soon."[8] True to his word, Walters purchased no paintings from Berenson that year.

As a result of the rupture in the market for Italian Renaissance art caused by the war, Berenson by necessity reduced the time he spent as a merchant of art and returned to the more satisfying and cerebral work of a scholar. Walters ex-

pected Berenson to use this time to finally undertake the writing of his cata-
logue. Duveen Brothers, however, had other plans for Berenson. In December
1914, Henry Duveen requested Berenson to write a series articles for *Art in Amer-
ica*, a relatively new journal that was financially backed by Duveen Brothers and
used by that firm for marketing its services and advertising that paintings that it
had available for sale.[9] Berenson frowned upon this initially, but recognizing
the need to remain on good terms with Henry Duveen, agreed to "do you [Du-
veen] a favor" and write the articles.[10]

In January 1915, the publisher of *Art in America* contacted Walters and re-
quested photographs of the paintings in his collection which were to be dis-
cussed in Berenson's upcoming articles. Walters declined to cooperate. Walters
was annoyed that Berenson had again tabled any work on his catalogue. It was
very unusual for Walters to overtly express any sense of outrage, but in this case
he could not bite his tongue. He promptly wrote to Berenson objecting to the
publication of magazine articles discussing his paintings before his own cata-
logue was completed. He stated:

> I was called up by the publisher of *Art in America* in regard to your article, which
> he had received. It is essential that I should not take any affirmative action in the
> matter as I have declined so many applications from magazines and other papers
> to supply them with photographs, upon the ground that I was myself preparing a
> catalogue and did not wish to sanction publications with photographic reproduc-
> tions until my catalogue came out.

While expressing his displeasure and reluctance to provide photographs of
his paintings, Walters informed Berenson that he would not stand in the way
of the publication.[11] The first three articles appeared in February, April, and
June 1915 issues of the magazine. Walters read these articles and was not happy
with the manner in which Berenson described his paintings. On August 18, 1915,
he expressed his dismay in a terse letter that referred to the articles without of-
fering a single complimentary word about them. His displeasure was expressed
in one icy sentence which stated: "I have read your articles and noted what you
have to say about some of my pictures."[12]

Thereafter, several of the letters sent by Walters to Berenson began to carry
a tone of contention. For example, in Walters's letter of February 29, 1916, he
cautioned Berenson not to disappoint him. The specific issue involved a paint-
ing by Mantagna that Berenson had sold to Walters based on a photograph. "I
shall be dreadfully disappointed," wrote Walters, "if the picture does not come
up to the promise of the photograph."[13] While this statement in isolation might

not sound very adversarial, in comparison to the warm and friendly tone of the earlier letters, it likely was intended as a proverbial shot across the bow.

Berenson's articles in *Art in America* were collected and expanded upon in a volume entitled *Venetian Painting in America* published in 1916.[14] Walters received a copy of this book, which contained additional references to Walters's paintings, on December 27, 1916.[15] At first glance, Walters was probably proud that his collection of Venetian paintings commanded more attention in Berenson's book than any other collection. Berenson referred to twenty-seven Venetian paintings that were in Walters's collection. In contrast, Berenson referred to only eight Venetian paintings at the Metropolitan Museum of Art, three in the collection of J. P. Morgan, three in the collection of Henry Frick, three in the collection of Philip Lehman, and two in the collection of Joseph Widener. In sheer numbers of Venetian paintings, it appeared that among the New York millionaires, Walters was king of the hill.

Whatever satisfaction Walters obtained from Berenson's attention must have turned quickly into embarrassment after carefully reading Berenson's description and analysis of his paintings. Among the twenty-seven paintings, seventeen were purchased by Walters as part of the Massarenti collection or from dealers other than Berenson and seven were purchased directly from Berenson. Berenson, as expected, praised the paintings he sold to Walters. On the other hand, Berenson dismissed many of the paintings which Walters had purchased from Massarenti and other dealers, sometimes referring to their artists as "tenth rate." More specifically, he described a painting in Walters's collection by Antonello Da Serravalle of *The Madonna and Child* as "a very poor thing indeed . . . by a tenth-rater painter." He similarly characterized a painting by Speranza of *The Savior Blessing* as an "imitation" by another "tenth-rate artist." He described an early triptych of the Venetian School as "mediocre." In describing a painting by the Studio of Antonio Vivarini, he opined that the faces of the women were "ugly . . . without alleviation or excuse," and the drawing was too "poor" to be ascribed to Vivarini. He characterized a painting by Alvice Vivarini of *The Madonna and Child* as "only a quite average achievement." And he wrote that a *Madonna and Four Saints* by Catena was "the crudest, driest, and most timid" of his paintings and "an inadequate representation of Catena's evolution." [16]

Having experienced Berenson's purge of his Italian paintings in 1914 and read Berenson's articles in *Art in America*, Walters could not have been surprised that Berenson remained critical of many of his paintings. What must have surprised Walters were the particular paintings that Berenson selected for criticism. The paintings by Serravalle, Speranza, and Catena, which Berenson

criticized, had been placed in Walters's 1915 catalogue and hung in his gallery with Berenson's knowledge and tacit approval. If Berenson did not approve of these paintings, why did he not propose their removal from Walters's collection along with the many other paintings which he viewed as inferior?

Walters had even stronger grounds to be annoyed by Berenson's book. It represented not only a lack of discretion on Berenson's part but more importantly a breach of trust. It was one thing for Berenson to privately convey to Walters his critical opinion about the quality of his paintings; it was quite another thing for him to tell the whole world. Having entrusted Berenson with photographs of all of the paintings in his collection, having sought his private advice regarding which paintings to retain or discard and having engaged him to write a catalogue of these paintings which would trumpet their virtues, Walters could not have been pleased that his trust in Berenson had come back to bite him.

In the fall of 1917, seven years after Berenson proposed to write a grand catalogue for Walters, he finally turned to the task. Although it is not clear what triggered Berenson's action, it is likely that he apprehended that his collector/dealer relationship with Walters was on the verge of collapse and that he needed to rejuvenate the relationship in order to recapture his business. There was good reason for such concern. Walters had not acquired a painting from Berenson in over a year. The last purchase was in April 1916, when Walters acquired *Saint Jerome in the Wilderness* which Berenson had attributed to Fiorenzo di Lorenzo (see plate 8). Meanwhile, Walters had acquired several Italian paintings from other sources, including an important fourteenth-century painting of *The Massacre of the Innocents* by the Sienese artist Bartolo di Fredi. Berenson was well aware that Walters had left his camp and was using other dealers to acquire Italian art.

When he finally began working on the catalogue, Berenson, with his wife Mary's assistance, organized Walters's collection of Italian paintings into six groups: Florentine, Sienese, Central Italian, Venetian, Northern Italian and Late Italian. Mary created a preliminary list of 156 paintings that were in Walters's 1915, "provisional" catalogue and which were earmarked for inclusion in the catalogue Berenson was planning to write.[17] Berenson's analysis of the collection initially focused on the paintings by Venetian and Sienese artists. As reflected in fifty-six handwritten pages, Berenson carefully described the most important paintings in the Walters's collection by these artists, comparing each painting to other works by the same artist and evaluating its quality and significance in art historical terms. He alluded to but did not replicate descriptions of

some of these paintings that previously appeared in *Venetian Paintings in America*. Berenson did not inflate or deflate the quality of the paintings but described each analytically as truthfully and evenhandedly as Berenson saw them. The descriptions were decidedly more sober and scholarly than the manner in which Berenson described paintings to Walters when seeking to sell them. His writing was a reflection of Berenson at his best, as a scholar not a merchant. For example, in describing Carlo Crivelli's *Madonna with SS Francis and Bernardino* (see plate 11), Berenson tempered his praise with criticism, writing that, "the Madonna is full of grace, but the Francis is over expressive in sentiment." One of his favorite paintings was Bartolo di Fredi's *The Massacre of the Innocents*, which he characterized as one of Bartolo's most important paintings and, from the standpoint of color alone, one of the best to have been created during the late Middle Ages.[18] (See plate 14.) Based on the fifty-six handwritten pages, Berenson clearly intended this catalogue to be comparable to, if not better than, the catalogues he previously prepared for Johnson and Widener. If Walters would have seen what Berenson had written, he likely would have been delighted with it. But as suddenly as Berenson began writing the catalogue, after the fifty-sixth page he stopped, never to return to the unfinished project.

What motivated Berenson in 1910 to propose the catalogue to Walters was what caused him in 1917 to abruptly stop: the prospect of Walters's business. In early September 1917, Berenson sent a letter to Walters informing him that he finally had begun to write the catalogue and had completed the section on Venetian and Sienese art. He also expressed his intent to continue to work on the catalogue that winter while visiting Rome and to turn at that time to the "late" or Baroque paintings in Walters's collection. Although Berenson probably expected this news to please Walters, it had a different effect. It served to exacerbate Walters's frustration over the amount of time it was taking Berenson to finish the project. It made Walters realize that despite the passage of time, Berenson had barely begun to write his catalogue; that Berenson was progressing at a glacial pace; and that the catalogue remained more than a year away from completion. On September 25, 1917, Walters replied to Berenson's news and expressed his exasperation over the interminable delays with a dash of cynicism. "Perhaps I may live to see that Catalogue completed, illustrated and published," he wrote.[19]

In the same letter, Walters conveyed to Berenson that he did not envision any resumption of their commercial relationship, and he had cancelled on his books any financial obligations that they had to one another. Emphasizing this point, the letter stated, "So that today our money obligations to each other are

'nil.'" Walters concluded his letter by stating that, "I am anxious to have this acceptable to you."[20] What Walters should have realized, but somewhat naively did not, was that the letter that served to extinguish their financial ties also served, like a wet blanket, to douse any interest by Berenson in completing the long awaited catalogue.

While severing his financial ties with Berenson, Walters avoided any direct criticism of Berenson and claimed that the separation was due to superseding events. He told Berenson that his decision to end their financial relationship was due to the decision in April 1917 by the United States to enter the war. He conveyed to Berenson that he planned to contribute eighty percent of his income to the war effort.[21] True to his word, Walters was no armchair patriot. In addition to his financial support, Walters began to actively serve on the staff of the Director of the U.S Railway Administration, which had taken possession of the railroads in the United States to coordinate their support of the war effort. He also loaned *Narada*, his sizable yacht, to the United States Navy to help safeguard the nation's shores; he allowed a house he owned on Fifty First Street in New York City to be used by the White Cross Committee for the shelter and care of women who had become destitute as a result of the war; and he purchased an ambulance and gave it to the Red Cross for use in France.

On December 2, 1918, shortly after the armistice ending the war, Berenson made an abbreviated effort to recapture Walters as a client. He wrote to Walters seeking to entice him into buying some of the paintings he had collected during the war. On January 8, 1919, Walters replied to his letter declining Berenson's invitation. The rationale advanced this time by Walters was that the "socialist tendencies" of some elements of American society and new taxes curtailed his ability to purchase art.[22] Walters again conveyed to Berenson that while their relationship as merchant and collector had ended, he hoped that their friendship would continue. He concluded his letter with a friendly farewell that stated: "If I go abroad next year, I will hunt you up and worry you a bit."[23] It was the last known letter between the two.

Walters's reasons for severing his collector/dealer relationship with Berenson were never candidly expressed to him in any clear, direct and coherent manner. Likewise, Berenson never informed Walters that he had placed his work on the catalogue aside and had no intention to return to it. Each kept the other in the dark about matters that were vital to their relationship. As a result, Walters for the rest of his life clung to the hope that Berenson one day would return to the original task of writing the illustrated catalogue of his collection of Italian paintings. In January 1927, ten years after Berenson ceased doing any work on

the catalogue, Walters directed the gallery's building superintendent, James Anderson, not to furnish any photographs of his Italian paintings to a visiting scholar and to inform him that, "I [Walters] am under obligations not to distribute photographs until my illustrated catalogue appears at some future date."[24] In 1929, just two years before Walters's death, he likewise told a reporter for the *Baltimore Sun* that Berenson's long awaited study of his collection, which would resolve any remaining questions about attributions, was in the process of completion.[25] Like the principal characters in Beckett's *Waiting for Godot*, Walters waited endlessly for Berenson to deliver a catalogue that would never arrive.

When Berenson realized that Walters had permanently severed their dealer-collector relationship, he acted as if the reason for Walters's action was some sort of a mystery.[26] In an effort to rationalize Berenson's loss of Walters as a client, Mary Berenson suggested that, "Walters did not dare [purchase any paintings] for fear of socialist outcry against spending on mere works of art."[27] A different rationale was offered by Edward Fowles, a long-term employee of Duveen and friend of Berenson. He claimed that Walters's defection was due to the fact that the art dealer Seligman "concocted all sorts of stories against all of us."[28]

Berenson, of course, knew better. He knew that the rupture in his business relationship with Walters was not due to any isolated incident or defamatory statement but instead due to a series of actions by him which in effect marginalized Walters and resulted in the forfeiture of Walters's trust. The chain of events began with Berenson's decision to contract with Duveen even though Walters had discouraged this union. It continued with Berenson's effort to conceal the fact that his arrangement with Duveen effectively placed Walters behind other collectors in the market for first class Italian paintings. To this was added Berenson's decision to delay his work on Walters's catalogue for years, and to place this project at the bottom of his list of priorities. The chain of events concluded with Berenson's publication of his book on Venetian paintings which was sharply critical of several paintings in Walters's collection.

Mary Berenson once characterized Walters as a "jolly, good natured" bachelor, perhaps misreading his understated, affable nature as an absence of inner strength. In the same vein, Bernard Berenson's treatment of Walters suggests that he viewed him as client who was easy to manipulate. It was this miscalculation which ultimately caused Berenson to lose Walters's allegiance. Walters was not a man who was use to having his interests ignored or marginalized. He did not become one of the wealthiest and most powerful railroad magnates in the United States, rise to the level of vice presidency of the Metropolitan Museum of Art and earn a seat on the board of U.S. Steel because of any proclivity to

subjugate his own interests to those of others. Although he rarely found any need to raise his voice or stamp his foot to get his point across, he was no shrinking violet. When Walters in 1917 informed Berenson that their obligations to each other were "nil" and later informed him that he would "hunt" him up when he returned to Europe, it was Walters's gentlemanly way of saying that their relationship as collector and dealer was over.

12

A MUSEUM IN REPOSE

The year 1922 was, for Walters, a year of transition. Within a period of seven weeks, a number of interrelated events occurred that changed Walters's life and the future of his gallery. On February 18, 1922, Faris Pitt, the gallery's sole curator and de facto director, died, and Walters decided not to replace him. Four days later, on February 22, Walters, as if engaged in some final act of catharsis, disposed of fifty-three Italian paintings that once were among his most prized possessions, including paintings that had been attributed to Correggio, Veronese, Tintoretto, Domenichino, Reni, and Caravaggio. Then, on April 11, 1922, Walters, at the age of seventy-three, married Sadie Jones, the widow of his old friend Pembroke Jones. On the very same day, Walters executed his last will and testament bequeathing his collection and gallery to the Mayor and City Council of Baltimore "for the benefit of the public."[1] That same year, Walters made some minor, housekeeping revisions to the catalogue that previously had been orchestrated by Berenson, adding seven Italian paintings that had been acquired since 1915. They would be the last changes to the catalogue of paintings that he would oversee.[2] What tied these events together was not just their temporal proximity but Walters's belief that he had essentially fulfilled his obligations to his gallery in Baltimore, and it was time to move on.

All fifty-three of the Italian paintings that were disposed of by Walters had been on display when he opened his gallery in 1909. Following Berenson's evaluation of the collection in 1914, they had been removed from display, put in storage in the basement of the gallery and placed by Berenson on his list of "Pictures to be removed from Mr. Walters' collection." Berenson's list, however,

TABLE 2
Partial List of Paintings Disposed of by Walters in 1922

1909 Catalogue #	Name of Artist	Name of Painting
456	Guercino	*Virgin and Child*
466	Caravaggio	*The Descent from the Cross*
486	Correggio	*Two Arcadian Shepherds*
508	Dosso Dossi	*The Nativity—with Saints and Angels*
517	Vasari	*Saint Sebastian*
542	Caravaggio	*Jesus Crowned with Thorns*
584	Veronese	*Martyrdom of Saint Sebastian*
586	Tintoretto	*Portrait of a Venetian Lady*
658	Domenichino and Guido Reni	*Martyrdom of St. Gregory*
736	Gentile da Fabriano	*Virgin and Child on Throne*

contained the names of 119 paintings, not just 53, and it is not known why Walters selected some of the listed paintings for disposition but elected to retain the others. Also unknown are most of the surrounding circumstances of the disposition. There are no extant documents that disclose the means by which Walters disposed of these paintings, whether they were sold or given away, who were the recipients and who owns them now. Nor will we likely ever know whether there were any very valuable works of art among them. The question of whether, as seems unlikely, Caravaggio painted Walters's picture of *Jesus Crowned with Thorns* (see fig. 16)—which appears from its vintage photograph to reflect the dramatic contrast of light and darkness that characterized Caravaggio's paintings—or whether the painting was a fine example of the work of his followers, is simply unanswerable. We can only speculate as to whether Berenson's criticism of Walters's paintings might have been just as mistaken in certain cases as the exaggerated praise that colored his description of many the paintings he sold to Walters.

Among the paintings that Walters disposed of in 1922 were those listed in table 2. One can imagine Walters's pain in parting with paintings by artists of this stature, unless he secretly doubted their attributions in the first place.

The event in 1922 that had the most immediate impact on the museum was the death of the gallery's curator, Faris C. Pitt. Because Walters rarely traveled from New York to Baltimore to visit his gallery, Pitt had been instrumental in managing the day-to-day operations of the museum. Walters's decision not to replace him constituted a watershed moment in the early history of the gallery.

It signaled Walters's intent to begin using the gallery more as a distant outpost to store unopened crates of art that were being left to the City of Baltimore than a place to look at art and enjoy its visual and intellectual pleasures.

The impact of Walters's decision was made graphically clear several months later. In January 1923, Walters received a request from the American Association of Museums to provide certain information about his gallery and to permit a group to visit it. In turning down this request, Walters wrote, "I presume you know my Galleries in Baltimore are in no sense a public museum, and I have no curator or director. At one time a former friend of mine [Pitt] was in a certain sense in charge, but he died and I have never replaced him, but attend to all the questions myself personally."[3]

Without the attention of any curator or director, the Walters Art Gallery became a dark and desolate place. It was managed by a Building Superintendent, James C. Anderson, who was granted little discretion. Anderson's primary duties were to receive, document and store the shipments of art that continued to arrive at the gallery each week, to supervise the gallery's upkeep and maintenance and to guard the gallery like a fortress and prevent any unauthorized person from entering. Although Walters, consistent with the precedent established by his father, allowed members of the public to visit the gallery two days each week during the months of January through April, Walters kept the gallery off-limits to the general public during the rest of the year. He covered the skylights and windows of the museum, causing the gallery to remain dark and, as he reminded Anderson, "in no condition for the public to see."[4]

Anyone wanting to visit the gallery to see the art had to obtain written permission directly from Walters. Walters routinely discouraged such requests. On the rare occasions when Walters permitted a visit, he would provide the guest with a card signed personally by him which authorized the guest's admission for a specific date and send a telegram to Anderson instructing him to permit the visitor to enter the museum "upon presentation of [his/her] card." Walters's instructions to Anderson usually concluded with the strict reminder to "be governed accordingly."[5] Walters also gave Anderson strict instructions regarding when, if ever, to permit a visitor to leave the gallery and then return. He wrote: "If anyone presents a card from me and should want to leave the gallery for lunch and return again on the same day, you would be justified in letting them do it. You would not be justified in letting them come back on another day on the same card; they would have to get another card of admission."[6] In this manner, Walters firmly restricted the public's access to his gallery.

Even if a visitor were acquainted with Walters, gaining access to his gallery was not an easy or pleasant experience. On one occasion, H. G. Kelekian, a relative of one of Walters's principal dealers, requested the opportunity to visit the gallery. Walters responded, "I am sorry the Galley is all covered up and all disarranged . . . all the skylights are covered with heavy canvas." Walters concluded his letter by informing Kelekian that he would be admitted by his superintendent, Mr. Anderson, but that "you will not be able to see much."[7] In response to a request from his stepson, Pembroke Jones, Jr., to visit the gallery, Walters reminded him that, "between about the 15th of May and the 1st of November, covers are over pretty much everything, including the skylights, so that in the summertime very little can be seen."[8]

One of the few persons who recorded an impression of the Walters Gallery was Walters's dealer, Arnold Seligman, who was invited in 1924 by Walters to meet him at his gallery. Upon entering the main building, Seligman found a "vast and gloomy hall" filled with over two hundred unopened cases piled on top of one another and objects that were, in his judgment, either copies or out-and-out fakes. It looked more like a "wilderness" than a well-organized gallery of art, and, as he later recalled, the haphazard nature of Walters's gallery placed him in "a state of shock." In an effort to explain the reason for the chaotic condition of the collection, Walters informed Seligman that "he had no time to arrange or catalogue it."[9]

Walters at that time also acknowledged that he simply did not have the interest or resources to unpack the crates of art that continued to flow into his gallery. When Seligman inquired about a work of art that he had sold to Walters the previous year, Walters replied that it had never been unpacked. And then, referring to all of the unopened crates of art, Walters added: "I probably won't live to see them all opened . . . but you can imagine the surprise of those who will unpack them after I am gone."[10]

In light of its condition, it is no surprise that Walters, after 1922, made little effort to publicize his gallery. The *American Art Annual*, which served during that era as the central source of information about American museums, contained only the address of the Walters Art Gallery and the few dates when it was opened to the public. When Walters was asked by that magazine "to provide more information about the contents of your great Gallery," he declined.[11] In June 1925, the magazine *Art and Archeology* devoted its entire issue to "Baltimore as an Art Center."[12] The issue contained separate articles about the recently established Baltimore Museum of Art, the Maryland Institute of Art, the

Archeological Museum at the Johns Hopkins University, and the Maryland Historical Museum. The Walters Art Gallery, however, was not even mentioned in the magazine's table of contents. The only reference to the gallery was buried in the section on private art collections.

Walters not only avoided publicity but ceased using the gallery for private, social affairs. Unlike the grand parties hosted years earlier by his father to proudly show off his collection of French paintings, Henry Walters hosted no social events in Baltimore to show off his Italian paintings to his circle of wealthy friends and collectors living in New York or to his associates at the Metropolitan Museum of Art. The daily log of the building superintendent, which documented the names of visitors, did not record any visits by any members of the Metropolitan's Board.[13] Walters rarely invited anyone to his gallery, and it appears likely that he never even brought his wife from New York to Baltimore to visit it.[14] Perhaps embarrassed by what had happened to his once-famous collection of Italian paintings, Walters began to act as if he would rather hide his museum than show it. As a result, the Walters Art Gallery during the remainder of Walters's life gradually disappeared from the consciousness of art lovers in Baltimore and elsewhere.

THE LINE
BETWEEN FACT
AND FICTION

In June 1923, the Metropolitan Museum of Art was the target of a potentially embarrassing inquiry about the bona fides of some of its art. Charges had been filed that there were many pieces of spurious Gothic art in the collection. Henry Walters, who had served as a trustee of the Metropolitan since 1905 and had been elevated to vice president, was asked to respond to the claims. Walters was painfully familiar with the widespread problem of mislabeled art. Ever since his purported masterpieces had been swept away by Berenson, the once stellar reputation of his gallery in Baltimore had faded from public memory. To deflect the criticism directed at the Metropolitan, Walters informed the *New York Times* that there was not a museum or significant collection in the United States into which bad pieces had not found their way. Then, referring to his own collection of art, Walters made an unusual admission. He stated, "I have an art collection . . . and I keep a special case into which I put pieces which I discover to be spurious. There are, perhaps, thirty false pieces in that case now, and they represent approximately $100,000." The headline in the *New York Times* that introduced this story stated: "Walters, Metropolitan's Vice President, Says Any Fakes That Are Found Must Go." Immediately below this headline was a second, more abbreviated headline which, like a dagger, stabbed at Walters personally. Referring to Walters and the troubled history of his collection, the headline, in bold letters, stated: "ADMITS HIS ART MISTAKES."[1]

Walters's admission, however, represented only a small slice of the truth. The "special case" was in reality a cavernous room in the basement of Walters's gallery which he had labeled as the "Long Museum" and in which he continued to

retain over one hundred paintings of dubious authenticity. Most of these paintings had been condemned by Berenson during his inspection of the collection in 1914. Walters had disposed of some of these paintings in 1915 and 1922, but they represented only a fraction of the paintings that were problematic. Although Walters preached, in his interview with the *New York Times*, that spurious works of art should be discarded, when it came to such paintings in his own collection, Walters remained hesitant to pull the trigger. For the remainder of his life, Walters sequestered in his Long Museum scores of misattributed paintings which he had acquired from Massarenti, including the self-portraits allegedly by Raphael and Michelangelo and other pictures that had been erroneously attributed to Giotto, Botticelli, Giorgione, Titian, Andrea del Sarto, Antonio Pollaiuolo, and Andrea Mantegna.[2]

The year after Walters's admission, Edith Wharton published a novella about the tribulations of a father and son whose desire to establish an important collection of Italian Renaissance masters was foiled by the pervasive problem of misattributions. The story in many ways was reminiscent of William and Henry Walters. Edith Wharton (1862–1937) and Henry Walters (1848–1931) were contemporaries who traveled in the same circle of high society and likely knew each other personally or indirectly through their mutual friendship with Berenson. They both visited the Villa I Tatti in the spring of 1912, and their paths might well have crossed there. Wharton remained a close friend and confidant of Berenson and enjoyed the luxury of her own suite with writing room at I Tatti, where she spent about one month each year. Wharton always had her ears perked high to absorb any tidbits of information about the manners, morals, and values of the members of New York's upper class and the tribulations that accompanied their wealth. Whether through Berenson or other art lovers she met at I Tatti, Wharton would have been aware of and keenly interested in the fate of Henry Walters's famous collection of Italian paintings.[3]

In Wharton's short story *False Dawn* (which was the first story in the book *Old New York*), Halston Raycie, a wealthy member of New York's establishment, was planning to open a private gallery which would proudly display many of the well-known masters of Italian Renaissance art, such as Raphael and Giotto. He entrusted his son Lewis, who was traveling to Italy on the grand tour, with a substantial sum of money to acquire original works of art by the great masters, and he instructed him to assiduously avoid any copies. "Copies," he emphasized, "are for the less discriminating or for those less blessed with this world's goods." Much to his father's consternation, Lewis returned without any authentic painting by Raphael but instead with a slew of copies and paintings by relatively

unknown Italian artists. He told his son that he could not bear the idea of displaying paintings by artists whose names were unfamiliar to his friends. "God, my son," Halston exclaimed, "do you realize you had a trust to carry out?" Following his father's death, Lewis Raycie converted his house into an art gallery to show his Italian pictures. At first, the gallery was crowded with visitors, but gradually they disappeared. Without any professional staff to assist him, Lewis found himself alone in a deserted gallery hung with paintings by unknown artists and haunted by the notion that his collection constituted an affront to his father's memory.

When Walters read Wharton's story—we can safely assume that he did—he must have seen traces of his own persona in the fictional character of Lewis Raycie. The similarities likely registered on Walters's conscience with a disquieting ring: the relationship between the father and son and the son's obligation to honor the memory of his father; the disappointment in discovering that a prized painting by Raphael was merely by an unknown artist; the endless copies of old-master paintings that tarnished the collection's reputation; the criticism by the press; and the loneliness of a deserted museum with no one left to care for it. From Walters's viewpoint, the story as a whole must have felt like an uncomfortable pair of shoes which did not quite fit but had been tailor-made for the owner. Strangely, just as the plight of Raycie seems to have been patterned after Walters, after the publication of Wharton's book, Walters's gallery seems to have followed a similar path as Raycie's fictional gallery, as the separate lines of fact and fiction began to merge.[4]

By 1929, the Walters Art Gallery had become an even lonelier place. Although Walters, consistent with the precedent established by his father, continued to allow the public to enter the gallery three days each week from February to May, the once enthusiastic crowds had dwindled to occasional visitors and the once proud reputation of the gallery as a "Temple of Art" had been reduced to a distant memory. The few who visited the gallery complained that it was so dark that little could be adequately seen. In January 1929, this prompted the gallery's building superintendent to inform Walters that "I have had several requests for artificial light even on bright sun lit days, but I do not feel justified in turning them on under your instructions not to do so." In an effort to convince Walters to grant such permission, the superintendent delicately observed, "It seems to me that the galleries are getting darker and darker every season."[5]

Like the paintings that were increasingly hard to see, information about where they came from and what they cost was hidden by Walters from the public. When James Anderson provided such information to a visiting scholar, Walters

gave him a tongue lashing. "You made a great mistake," Walters wrote to Anderson, "in telling Professor Goldschmidt from whom I bought certain objects. Please impress upon your mind that I don't want this ever done again, and I will also especially never want anybody told anything about prices of things I have bought."[6]

On January 20, 1929, an article appeared in the *Baltimore Sun* about the loss of public interest in the Walters Art Gallery. "The Walters Galleries remain deserted," it reported. The reason for the loss of interest, according to the reporter, was that the museum had discarded almost all of its Italian masterpieces, the attributions of many of its remaining paintings were questionable, and, most discouragingly, visitors would find "little immediate beauty." The report stated:

> It is true that only one master of the first rate, namely Raphael, in his Madonna of the Candelabra is worthily represented, and even then with reservations . . . The Italians in the Walters collection do not commend themselves to the beginner without effort on his part . . . The attributions are in a number of cases doubtful, and will remain so until Mr. B. Berenson, the eminent critic, who is making a study of the collection, has completed his work.[7]

At the end of that year, the *Baltimore Sun* printed an editorial bemoaning the absence of visitors to the Walters Art Gallery. It raised the following rhetorical but unanswerable question: "Why so many Baltimoreans overlook the Walters Gallery is not easy to say."[8]

Around that time, Walters confided to a friend that he had one regret about his interest in art. The regret involved his inattention to the art collection he had assembled in Baltimore. Although Walters accomplished his original goals of acquiring a collection of paintings that broadly represented the history of Italian art, that elevated his own status as a collector of Italian art and that served as the cultural centerpiece of a palazzo in Baltimore memorializing his father, he was troubled that his collection of Italian paintings would appear, like the Massarenti collection thirty years earlier, unrefined. He confided to his friend that he was "greatly distressed" by his failure to discard "objects of inferior importance."[9]

Walters's disappointment about his own failure to refine his collection of Italian paintings continued to haunt him. In January 1931, while providing a personal tour of his collection to a reporter, Walters disclosed "with some dismay" his belief that he had failed to live up to the standards established by his father in caring for his collection of paintings. He stated:

When my father was alive we made a practice each year of taking everything off the wall and judging it calmly, to decide which of all the works we wanted to put back up for another year. Thus we eliminated those which we felt could be dispensed with. I keep promising myself to do the same thing now, but I never do, and I cannot bring myself to take any of the paintings down singly. One becomes attached to them.[10]

It was the last thing Walters is known to have said about his collection of paintings prior to his death later that year.

FADED MEMORIES

Following Walters's death, at the age of eighty-three, on November 31, 1931, very little was written in the obituaries about his once famous collection of Italian paintings, and the little that was written was largely inaccurate. The obituary which appeared in the *New York Times* the day after Walters's death headlined that he had a "Rare Private Art Collection, Begun by His Father, at his Home in Baltimore," but the article made no specific reference to Walters's large and once famous collection of Italian paintings. According to the *New York Times*, the highlights of the collection were: "watches, jade, paintings and sculpture. The original of Rodin's *The Thinker* is there. Much of the Egyptian sculpture Mr. Walters collected cannot be duplicated in any private gallery."[1] The Metropolitan Museum of Art, in its *Memoriam* to Walters, mentioned that Walters was a "citizen of a distant city" who served the interests of the Metropolitan with unfailing loyalty; the memorial made no specific reference to Walters's gallery in Baltimore or to his collection of paintings.[2]

The *Baltimore Sun* carried a story that narrated the major events in Walters's life as well as a short obituary. Both revealed how little was actually known about Walters and his collection of art. His obscurity, as the *Baltimore Sun* explained, was in part due to the fact that he spent most of his time either in New York or at his homes in Newport, Rhode Island, Palm Beach, Florida, and Wilmington, North Carolina, and rarely came to Baltimore. Another reason why so little was known about him, according to the *Sun*, was because he disliked public occasions, detested speech making and was hostile to giving interviews. It concluded that Walters was a great, but "almost silent" man. As if to demonstrate the reporter's own lack of knowledge, the article claimed that Walters left behind a

"priceless collection of treasures on canvas," which included "invaluable" paintings by Michelangelo, Titian, Botticelli and Andrea del Sarto, even though the paintings purportedly by these masters had been removed from the walls of the gallery, at Berenson's behest, sixteen years earlier.[3]

The reason so little was known at the time of Walters's death was not only because Walters was a secretive, "almost silent" man, but also because his entire collection of art, almost from beginning to end, had been left in such disarray that hardly anyone knew for sure what remained in it. The pervasiveness of the problem was expressed in a preliminary report of the gallery's Advisory Committee to the new Board of Trustees. Under the heading, "Cataloguing and Indexing," the report stated: "At the time of Mr. Walters' death, no record of more than twenty thousand items existed other than the legal inventory furnished to the City by the executors. No scholarly classification or knowledgeable catalogue was available except in a fragmentary and unsystematic form."[4]

Walters left behind 243 unopened cases of art in the basement of his gallery. Hundreds of paintings never seen by the public also were found crammed together in the same area. A reporter for the *Baltimore Sun* described what he saw as follows. "The basement of the Walters Gallery," he reported, "presents one of the strangest sights in the cultural history of America. One large room down there looks like the hold of a ship. There are great mysterious acres of art packed under lashed tarpaulins. One cannot imagine what those tarpaulins conceal."[5] Walters's collection of books was also in a shambles. On May 30, 1934, Dorothy Minor, the museum's first librarian, wrote to Belle da Costa Greene, who was then serving on the museum's Advisory Committee, that "Everything . . . removed from the library is piled helter-skelter into various closets in the downstairs offices."[6] One of the museum's trustees, Philip Pearlman, approached the problem in a more lighthearted way. "Other galleries have to go abroad if they want anything," he joked, "but with us we have only to go onto the cellar."[7] The task facing the new staff, however, was no joking matter. They estimated that it would take at least twenty-four years before everything in the gallery could be studied, catalogued and properly shown.[8] Placing a positive light on the uncertain quality of the collection, the new Trustees of the Gallery in their First Annual Report wrote, "The importance of Mr. Walters' generous gift to the people of Baltimore will not be fully appreciated for many years."[9]

In the midst of all of the thousands of unidentified objects, paintings and books that cluttered the Walters Gallery, almost all of the books and documents pertaining to Berenson disappeared. Whether by accident or design, all of the books written by Berenson that Walters once had, most of the letters that Berenson had

written to Walters, any notes written by Berenson in 1914 about his assessment of the collection of Italian paintings and any documents pertaining to the grand, illustrated catalogue that Berenson promised to write were all lost or removed from the gallery.[10] Moreover, the provisional catalogue that Berenson virtually wrote for Walters in 1915, that transformed Walters's collection of Italian paintings, was never identified as such by the museum's new staff. Instead, it was erroneously identified as an anonymous catalogue published in 1922. As a result, scholars until now have been left in the dark about the significant impact that Berenson had on Walters's collection of Italian paintings.

The cloak that shrouded Berenson's connection to Walters was in part stitched by Berenson himself. In 1938, the staff of the Walters Art Gallery was planning to publish the first issue of the *Journal of the Walters Art Gallery*. An invitation was extended by the administrator of the gallery, C. M. Marshall, to Berenson to write an essay about his relationship with Walters. When Berenson initially balked at the idea, Berenson's intimate friend, Belle da Costa Greene, wrote another letter on behalf of the gallery to Berenson, reminding him of his close friendship with Walters and encouraging him to reconsider and contribute an article. Although no one knows what passed through Berenson's mind, the invitation likely posed for Berenson an uncomfortable dilemma. If he accepted the offer and honestly wrote an essay about his relationship with Walters and the services he provided for him, would he not have had to reveal his failure to complete the scholarly catalogue that he had promised to write? Would he not have had to come to grips with and explain the reasons why Walters severed their relationship? Would such an essay have led inevitably to questions about Berenson's trustworthiness? In short, the invitation to write an essay about his relationship with Walters was like an offer to expose a scar on his character that had not fully healed. It was an offer that was not in Berenson's own interest to accept. In an effort to sidestep the invitation, Berenson seized upon the date when the article was due and responded that his ability to meet that deadline was "out of the question."[11] Thus, Berenson elected to obscure the work and the advice he had provided to Walters rather than shine any light on it.

In 1952, Berenson, at the age of eighty-seven, was preparing to revise his final book of lists on the Italian painters of the Renaissance. He contacted the Walters Art Gallery for assistance with regard to the identity of several paintings that he had evaluated for Walters years before. The director of the gallery at that time, Edward King, responded to his request. King was completely unaware that Walters had engaged Berenson to write a comprehensive catalogue about his Italian paintings or that Berenson had, years earlier, begun working on the project. King

informed Berenson that he planned to write such a catalogue himself, and he offered to include "some mention" of Berenson in the catalogue if Berenson would tell him what he did for Walters. Doubting that Berenson ever played any significant role in the development of Walters's collection, King stated: "There is no record here, that we have been able to find, as to the period when you were considering the Walters Italian paintings as a whole, if, indeed, such was the case."[12] Berenson never responded to King's inquiry or made any effort to set the record straight.

AFTERWORD

Edith Wharton's story about the collection of Italian paintings owned by James Raycie had a bitter-sweet ending. The collection that was frowned upon during Raycie's lifetime was reevaluated years after his death and judged to be one of the most beautiful collections of Italian primitives in the world. If Wharton had Walters in mind, her story was prophetic. Forty-five years after Walters's death, his collection of Italian paintings was given a similar redemption.

In 1962, the Walters Art Gallery engaged Federico Zeri, one of the world's most renowned connoisseurs of Italian Renaissance painting, to write a comprehensive catalogue of the gallery's Italian paintings. Zeri initially was puzzled by the collection. He characterized it as "mysterious," and he observed that most of the artists were "obscure." He leveled his most biting criticism at the absence of any scholarly catalogue. It was, he stated, a "tremendous mistake."[1] Zeri, like the staff of the museum at that time, was unaware that Walters had engaged Berenson many years earlier to study the collection and to write a grand, illustrated catalogue. He was also oblivious to the fact that Walters, based on Berenson's advice, had published an important, interim catalogue in 1915. By the time Zeri undertook this project, both Walters and Berenson were dead, and Zeri had no one to turn to for any firsthand account about the details of their relationship.[2] The documents that evidenced Berenson's impact on the Walters collection of Italian paintings would remain buried in the archives of the Villa I Tatti and the Walters Art Museum and unknown to scholars for many years to come.[3]

In 1976, Zeri completed his catalogue. Although he never discovered the records that would detail the relationship between Walters and Berenson, he was able to intuit that Berenson's advice was instrumental in refining and improving the collection.[4]

Zeri also found something of much more lasting importance. It was that the Walters' Italian paintings, although without the fanfare associated with masterpieces by Raphael, Leonardo, Michelangelo, Caravaggio, and Titian, had a character that was unique to American art collections. Like a collection assembled by a noble Italian family for a private galleria, the Walters collection, according to Zeri, constitutes a homogeneous ensemble of Italian artists of every period "offering a balanced and uninterrupted survey of the history of Italian painting."[5] As an American collector who styled himself as a Renaissance prince, and as a connoisseur who helped to transform the collection, both Walters and Berenson would have rejoiced upon reading those words.

Appendix A
Selected Correspondence between Walters and Berenson

LETTERS FROM BERENSON TO WALTERS

Settignano, Florence Nov. 4, 1911

My Dear Mr. Walters,

I have received yr. cable whereby you take my Rosselli & Trotti's Guardiagrele. I enclose photographs of three other pictures in every way worthy of your attention & your collection.

1) A large cassone front representing the telescoped myths of *Io & Europa*. It is in brisk, youthfully joyous narrative style, & it is delightfully golden in colour, & truly poetical in landscape. It is a capital specimen of the work of a man to whom I have devoted a great deal of study. I have given a chapter to him in my book on Florentine Drawings, & the same appeared magnificently illustrated in the first number of the Burlington Magazine. Since writing those, the actual name of the painter has been discovered. It was Bartolomeo di Giovanni. But I prefer to continue calling him by the descriptive & more euphonious appellation of Alunno di Domenico. Looking at the photograph of the panel I am now offering you, you will not be surprised to learn that he was a prolific book illustrator. I have no doubt that you will find in your own library many a book printed at Florence toward 1500, filled with his woodcuts—The price of this picture is Ł 1000 (one thousand pounds) which I venture to call a bargain. If you will have it kindly cable YALUNNO.

2) A Madonna by Fiorenzo di Lorenzo. She is suave, gracious, distinguished, a thoroughly representative work by one of the big wigs of Italian Painting. You may recall his pictures at Perugia of the native school of which he was the greatest figure. He doubtless learned his trade under Verrocchio, but he influenced Perugino & taught Pintoricchio. This panel is again a very great bargain for it is only Ł 800 (eight hundred pounds) export duty included. If yu will take it kindly cable YEREZO.

3) Madonna probably by Mausuerti, an attractive rather meticulous but quite jewell-like work. Mausuerti was a Venetian of the school of gentile Bellini & Carpaccio in companionship with both of whom he worked. I am not certain that this Madonna is by him but think it very likely. At all events it is a very agreeable & yet impressive picture. Its price is Ł 300 (three hundred pounds). If it pleases you cable YESUETI.

As these things are getting visibly rarer you will be well advised to take them all, & in that case please cable simply YEALL.

I can not remember an autumn so beautiful. I have been home a mont & one day has been more sunny, more still than another. I have got to work, & my new secretary promises to be a tower of strength. The house is delightful. The frescoes have disappeared from the big library, & the little new one is a jewell I am eager to show you. All would be well if my heath would only let up. My doctor urges me to go to Combes at Lausanne, & I fear I shall have to submit—Otherwise no news. The Italians are mad with the last of slaughter of flies.

I wonder under what skies & how different from these you will be in when you read these lines. I hope in some soft fair haven down south.

> With best regards
> Ever yrs.
> B. Berenson

December 16, 1911

I Tatti
Settignano (Florence)

My Dear Mr. Walters,

First & foremost our combined best wishes to you for a Merry Xmas & a Happy New Year. The sooner it brings you over to this side the more we shall like it, & before 1912 is past we ourselves will probably be over on your side.

Meanwhile I am working as hard as my stupidly bad heath allow me. And altho' I do get dead beat daily, I thoroughly enjoy my work. Happily there is little futher to annoy me with regard to the house & my new secretary is almost the ideal person for the job.

I received yoyr cable whereby you took the Alunno de Domenico, the Fiorenzo di Lorenzo & the Mausuerti. They are probably all at Pottier's by now. The payment for them has not reached me yet, but there is no hurry of course.

I am sending you rolled up four photographs too large to go with this, of two pictures I want you to buy.

One is a Holy Family by Lo Spagna. I need not tell you that hitherto it has always passed for a Raphael, & in a sense one can scarcely blame them, for this picture is very Raphaelesque indeed. It is by Lo Spagna nevertheless, the most gifted of raphael's pupils under Perugino (It is he, by the way, who in my opinion painted the famous Sposalezio always ascribed to Perugino himself) And this panel now offered to you is in every way the fiest Lo Spagna I have ever seen. It is extraordinarily clear & brilliant, & the photograph gives you a perfect idea of it. Its price is very reasonable, 1,200 (twelve thousand pounds). Please cable YESPAN if you want it.

The two other photographs are unfortunately both very poor representatives of a very remarkable picture that I have known for quite a while. Its fond owner was so convinced that it was by Titian himself that he refused an offer of Ł 5,000 for it made by Bourgeoise of Cologne just before he died.

. . . this picture comes as near to being a Titian as any work I have ever seen that I am sure is not by him. Here the colour is as good as a Titian in his very best years, & it is only a somewhat subtly inferior in the style & in the drawing which makes me quite certain that it is not his. Besides I am as certain that it is by the ablest of his early followers, Polidoro Lanzani, many of whose paintings not so good as this one pass for Titian's in the Louvre & in the other great European collections.

I want you to buy this canvas not only on its intrinsic merits which really are all but the highest, but also because short of a miracle we are not likely ever to come across a real Titian of the "Santa Conversazione" type. Even if we did, the price would be fabulous. This canvas on the contrary we can have at the very reasonable figure of Ł 2000 (two thousand pounds). I am confident that when the picture reaches you, it will surprise you by its fully Titianesque radiance and magic. It is interesting on other grounds too. Thus the subject matter is quite unique. It is evidently the Blessed Virgin, St. Peter & the Holy Child, all three together, dictating to St. Maark the Gospel that goes under his name. So if you will have it please cable YEDORO, & if you will have the Spagno as well, as I wish you would, cable YEBOTH.

There is nothing new. The unspeakable war in Tripoli is keeping out Italian acquaintances away from us. They are too well aware what they would think of any one else who committed murder & robbery in this fashion upon peaceable householders— I am not referring to the so-called massacre which I believe to be foul calumny, but to the ethics of falling upon Tripoli as the Italians have done. The economic effect upon Italy will be disastrous but nothing comparable to the moral debasement. A people like the Ialians which so recently became a nation not by its own strength but thro' the sympathy, pity & powerful aid of stronger nations, has no right to become the cowardly oppressor of weaker races.

I do not know Mrs. Jones's address, so will you be my angel & give her & Miss Sadie my good wishes for a Happy New Year?

Sincerely yours,

B. Berenson

Jan. 16, 1912 I Tatti
 Settignano (Florence)
My Dear Mr. Walters,

Many thanks for your delightful letter of the 5th. I regret that you were bothered by my telling you that the money for Fiorenzo, Iunno di Domenico, etc. had not arrived. As a matter of fact Messers Barrings wrote a day or two later to tell me they had arrived.

I am so glad you are taking the Polidoro Lanzani & the Spagna, each the finest of its kind. I am confient the originals will not disappoint you.

This time I have two more pictures to bring to your notice. The finer is a truly lovely & poetical Madonna by Niccolo Appiani. Nic. App better known as the "Pseudo-Boccaccino" is at the same time a follower of Alvise Vivarini & of Leonardo da Vinci.

The consequence is a blend of Venetian with Milanese qualities which makes him one of the most fascinating of Leonardo's pupils at Milan. The Madonna I am proposing is as fine as any of his that I Know. I am acquainted with larger & more elaborate works by him, but none finer. It is in excellent condition. The price is Ł 500, & I think it will be amply worth that to your collection.

The other Madonna is by Antonio Vivarini, the brother of Bartolommeo, & the uncle of Alvise. He was thus at least the patriarch of the Muranese branch of the Venetian school, & in a sense the founder of the whole. For any historical collection like yours a work by him is obviously very desirable, & for that reason alone it would be advisable to acquire a picture by him. The Madonna I am proposing however has decided merits of its own, as you will see for yourself. It is on a gold ground. Its price is modest, being Ł 350.

If you will have them both, kindly cable YEBOTH. If only the Nic. Appiani YENIC; if only the Vivarini YEANT. I think however YEBOTH would be well.

I am afraid that I agree only to well with what you say about the unrest that has overtaken this tiny pebble of an earth during the last ten years. You think it is worst in our country. I, who live over here, think it is worst in Europe, & most of all in Italy. And bad it really is. One can't conceive it getting still worse without society disintegrating utterly. And I should be ashamed to tell you how full of dread I am for the future, & of regrest for the past, all of the decencies & homlinesses & old-world (relatively) conditions I was brought up among.

And yet it has always been so. Since man has beedn advanced enough to leave record of his thought, he has taught that after him only the deluge could mend things. And the deluge never comes, but children are born into the world, & pass happy enough childhoods. Then comes love with all its joys and sorrows, & life is very precious. But at forty we begin to look at things with the cold eye of reason, & reason is suicidal. The truth is life is a miracle enacted for the delectation of childhood & youth. Grownups go on till middle age on the impetus derived from earlier years. But after forty, it really does require faith, hope, & charity to live without being a b nuisance to one's self, & a worse to one's neighbors.

I need not say we look forward with real pleasure to your visit. Pray let us know as soon as you decide on your plans when we may hope to see you, here. We are both in fair health, & I am working as hard as I can, & enjoying it thoroughly.

<div style="text-align: right;">
With our kindest regards

Sincerely yours

B. Berenson
</div>

Nov. 9, 1912

<div style="text-align: right;">
I Tatti

Settignano (Florence)
</div>

My Dear Mr. Walters,

I wrote about three weeks ago to propose an interesting Madonna by Gregorio Schiavone. I hope the letter reached you. I told you that as soon as I got the photo-

graphs I should write you of several other pictures. I do so now, seding you the photographs rolled up separately by registered post.

The large photograph is of an altarpiece by Bicci di Lorenzo. It is one of the most delightful works painted soon after 1400, & is the masterpiece of one of the most interesting figures of that time. It has never suffered the least touch of restoration, but unfortunately, the ultramarine has been strpped off the Virgin's mantle leaving that white spot which you will recognize in the photograph. Putting that "scar" aside it is one of the completest & most elaborate & really satisfactory Italian paintings that have been on the market for quite a while.

It is on wood of course 1.6 × 1.44 m. high, & its price is Ł 2200 (two thousand two hundred pounds).

The second picture consists of two panels, originally no doubt forming part of some polyptych, & representing the Annunciation. They come from the Saracein Collection at Siena whence also came the Paoplo di Giovanni predella that you got from Grassi in May 1911. These are immaculately free from retouching as those, & they were painted by a far more remarkable artist, namely by Andrea Vanni of Siena. He was the friend of St. Catherine, the master of Sassetta, & the painter of the Madonna on my staircase which you like so much.

They are to be had for a very reasonable price, Ł 600 (six hundred pounds) & I think you will take great pleasure in them if you get them. If you want them please cable YEVANNI.

The third photograph is of an appealing Leonardesque work of delicate sentiment & delicious colour by Butinone, one of the most interesting painters of Milan in the 15th century. It is a late work by him, influenced on the one hand by Leonardo & on the other anticipating the most delightful Milanese master of the next generation, I mean Borgognone. The naïvete of the landscape background is not easily to be surpassed, & the whole panel has an unusual sincerity & heartiness about it. It is in perfect condition.

Its price too is quite modest being Ł 750 (seven hundred and fifty pounds). If you want it please cable YEBUTINONE.

Or if you will take them all please cable YEALL. I strongly urge you to, as pictures worth having are getting distressingly rare.

Our elections are over, & I hope we are none the worse for the election of Roosevelt in 1916. Short of a miracle the democrats will spoil their best chances & give Ted a free run for next time. I confess though that I feel almost as bad over the collapse of the Republican party as I do over that of Turkey. I too haave got to the age when I'd rather not see such startling even though long prepared innovations.

Please do not forget the catalogue you kindly promised to send me if you can find a copy.

<div style="text-align: right">

With kindest regards
Sincerely
B Berenson

</div>

LETTERS FROM WALTERS TO BERENSON

H. Walters
Room 916
Empire Building
71 Broadway
New York

January 4th, 1910

My Dear Mr. Berenson:

I have your two letters of the 6th and 7th of December, upon returning from an extended trip to the South.

My photographer has gone for a sea voyage to South America and will not be back until near the end of January. As soon as he returns he will carry out your wishes as to larger negatives and details. Doubtless also by that time I will have from you other memorandum as to the details of other paintings, photographs of which I have sent you.

In buying the Massarenti collection I understood quite well there were few pictures therein which could be considered masterpieces. I do, however, believe I could retain a sufficient number of works to present fairly a history of Italian Art, it being my intention to add, from time to time, a few important Italian pictures to improve the average.

I had already discarded when you saw the Galleries, over four hundred and fifty pictures, Italian, French, Dutch and nondescript, and I am quite prepared to add to the rejected one hundred more.

About fifteen of the Italian pictures now hung were not of the Massarenti Collection: the most important one being the Madonna of the Candelabra by Raphael, which I bought from a nephew of Monro, of Novar, it having been taken from the Borghese Collection by Napoleon I and given to the Queen of Eturia, from whom it passed to the Duke of Lucca, who sold it at Christie's in London, where it was bought by Mr. Munro. A fine copy of this picture was taken to Paris from Rome by Ingres. It was sold at his death with the contents of his studio and bought by a poor English clergyman. At his death, with other copies of pictures, it was sold at Christies and bought by Sir Robinson for seven Pounds, who now claims it as an original and has been trying for several years in vain to sell it to the National Gallery.

Like others, I doubt if Raphael painted the two angels, but there are few obtainable pictures by him that I would have in preference to the Madonna of the Candlabra.

With best wishes for a happy New Year.

Yours very truly,
H. Walters

Robinson was curator of Queen Victoria's pictures.
You doubtless know him.

Grand Hôtel
Florence
Meme Maison
Hotel Italie — Florence

Florence, May 24, 1910

My Dear Mr. Berenson,

In accordance with our understanding it will be most interesting for me to place at your disposal between July 1, 1910 and July 1, 1911 the sum of Seventy Five Thousand Dollars ($75,000), or so much thereof as you may require during that period, to pay for purchases for my collection of pictures particularly of the Italian schools, in order to fill out its historical value and increase its average quality.

Before purchasing, each picture to be submitted to me by photograph and my acceptance or other decision to be transmitted to you promptly (preferably by cable).

To give this arrangement a proper business relation you are to receive as commission from me upon each purchase made and at the time of each purchase ten per cent of its cost. Export duties and other expenses of shipment from place of purchase to Paris are to be paid by me and not included in the $75,000. All purchases are to be consigned to Monsieur Pottier, 14 Rue Gaillou, Paris, who will attend to the Consular invoice, packing and shipment to America. It will be necessary however for you or the seller to to furnish Pottier with your name as seller and a guarantee that the object is a work of art and more than one hundred year old.

At the time I transmit to you my acceptance of each of your recommendations, I will at the same time send you by mail exchange on London, Paris or Italy as you may desire made to your order for 115% of the purchase price. You are to attend to the payment of export duties if any and it seems to me most desirable if possible to make the price of purchase include delivery to Pottier for yor account, you afterwards in each case giving Pottier instructions to ship the object to me at Baltimore, and at the same time furnish him with the necessary guarantee as to art and antiquity, and the name of seller all of which is required under the United States import laws.

The above method of payment will of course require from time to time financial adjustments between us.

You will note from above that I prefer to have all settlements with you direct so that my name will not except in exceptional cases appear to the seller. In other words so far as I am concerned in the settlements you pay out this money for me. I hope this will not be objectionable to you.

Sincerely yours
H. Walters

Appendix B
Lists of Paintings

LIST 1. PAINTINGS WALTERS ACQUIRED FROM BERENSON

The artist is the painter to whom the work was attributed by Berenson at the time of the acquisition; the catalogue number (Cat. #) is the number of the painting in Walters's *Catalogue of Paintings* published in 1915; the WAM number is the accessions number of the Walters Art Museum; and the date in parentheses refers to the date or dates of the letter or letters or telegrams between Walters and Berenson in which the painting was offered, discussed, or acquired.

July 1, 1910–June 30, 1911
(Initial Year of Walters-Berenson Contract)

1. Niccolo Rondinelli, *Madonna and Child with Saints Michael and Peter*, Cat. #517, WAM #37.517A, B, and C (August 25, 1910)
2. Ercole De'Roberti, *The Story of Susannah*, Cat. #476, WAM #37.476 (October 7, 1910)
3. Antoniazzo Romano, later attributed by Berenson to Raffaello dei Carli, *Madonna and Child with Saint Nicolas and a Bishop Saint*, Cat. #644, WAM #37.644 (October 7, 1910; February 27, 1915)
4. Giovanni Batista Moroni, *Portrait of a Gentleman with a Dog*, Cat. #501, WAM #37.501 (February 27, 1911)
5. Bernardino Fungai, *Madonna and Child*, Cat. #482, WAM #37.482 (February 7, 1911)
6. Tintoretto, *Portrait of Zaccaria Vendramin*, Cat. #528, WAM #37.528 (February 7, 1911)
7. Pietro Carpaccio, *Saint George and the Dragon*, Cat. #466, WAM #37.466 (February 7, 1911)
8. Giovanni Di Paolo, *Madonna and Child with Saints*, Cat. #554, WAM #37.554 (February 23, 1911)
9. Bartolomeo Bramantino, *Madonna and Child*, Cat. #500, WAM #37.500 (February 23, 1911)
10. Barnaba Da Modena, *Madonna and Child with Angels and Two Donors*, Cat. #443, WAM #37.443 (February 23, 1911)
11. Francesco Granacci (history after acquisition unknown) (February 23, 1911)

12. School of Sicily, *Saint Rosalie Crowned by Angels*, Cat. #433, WAM #37.433 (June 14, 1911)

13. Paris Bordone, *Portrait of a Woman as Cleopatra*, Cat. #534, WAM #37.534 (acquired from F. Ongania based on Berenson's recommendation) (June 15, 1911)

14. Bronzino, *Portrait of a Baby Boy*, Cat. #451, WAM #37.451

<div align="center">JULY 1, 1911–JUNE 30, 1912</div>

15. Bernardo Daddi, *Madonna and Child*, Cat. #533, WAM #37.553 (October 8, 1911)

16. Cosimo Rosselli, *Madonna and Child*, Cat. #518, WAM #37.518 (October 26, 1911; November 4, 1911)

17. Niccolo da Guardiagrele, *Virgin and Child on Gold Ground*, Cat. #513, WAM #37.513 (October 26, 1911; November 4, 1911)

18. Giovanni Mansueti, *Madonna* (history after acquisition unknown) (November 4, 1911; December 1, 1911)

19. Bartolomeo Di Giovanni, known as Alluno di Domenico, *Myth of Io*, Cat. #421, WAM #37.421 (November 4, 1911; December 1, 1911)

20. Fiorenzo di Lorenzo, *Virgin and Child with Cherubs*, Cat. #477, WAM #37.477 (November 4, 1911; December 1, 1911)

21. Lo Spagno, *Holy Family with Saint John the Baptist*, Cat. #526, WAM #37.526 (December 16, 1911; January 5, 1912)

22. Polidoro Lanziani, *Madonna and Child with SS Mark and Peter*, Cat. #515, WAM #37.515 (December 16, 1911; January 5, 1912)

23. Niccolo Appiana, referred to as Pseudo Boccaccino, *Madonna and Child*, Cat. #545 (as Agostino da Lodi), WAM #37.545 (January 16, 1912)

24. Cima da Conegliana, *Madonna and Child*, Cat. #470, WAM #37.470 (June 1, 1912)

25. Francesco da Rimini, *Virgin and Child*, Cat. #488, WAM #37.488 (June 9, 1912)

26. Antonio Vivarini, *Madonna of Humility*, Cat. #537, WAM #37.537 (January 16, 1912)

<div align="center">JULY 1, 1912–JUNE 30, 1913</div>

27. Bicci de Lorenzo, *The Annunciation*, Cat. #488, WAM #37.448 (November 9, 1912; January 8, 1913)

28. Bernardino Butinone, *Madonna and Child*, Cat. #455, WAM #37.455 (November 9, 1912; January 8, 1913)

29. Gregorio Schiavone, *Virgin and Child*, Cat. #519, WAM #37.519 (October 21, 1912, November 9, 1912; January 8, 1913)

JULY 1, 1913–JUNE 30, 1914

30. Sodoma, *The Holy Family with Saint Elizabeth and the Infant Saint John the Baptist*, Cat. #522, WAM #37.522 (February 14, 1914)
31. Giovanni Martini da Udine, *Dead Christ Supported by Angels*, WAM #37.1056

JULY 1, 1914–JUNE 30, 1915

32. Marco Basaiti, *Portrait of a Young Man with Fur Collar*, Cat. #444, WAM #37.444 (January 16, 1915)
33. Giovanni Baptista Utile, *Virgin and Infant Saint John Adoring the Child*, Cat. #506, WAM 37.506

JULY 1, 1915–JUNE 30, 1916

34. Benvenuto di Giovanni, *Virgin and Child with Saints*, WAM #37.743 (February 29, 1916)
35. Bartolomeo Montagna, *Madonna and Child*, WAM #37.1036 (February 29, 1916)
36. Fiorenzo di Lorenzo, *Saint Jerome in the Wilderness*, WAM #37.1089 (April 24, 1916)

LIST 2. BERENSON'S ATTRIBUTIONS OF PAINTINGS SOLD TO WALTERS AS REVISED

The "WAM #" is the accessions number of the Walters Art Museum; the "Berenson Attribution" is the painter to whom the work was attributed by Berenson at the time it was sold to Walters; and the "Zeri/Walters Subsequent Attribution" is the painter to whom Federico Zeri attributed the painting in his *Italian Paintings in the Walters Art Gallery* published in 1976 or the painter to whom another specialist at the Walters Art Museum has attribution the painting. "(Unknown)" indicates that the identity of the artist is presently unknown.

WAM #	Berenson Attribution	Zeri/Walters Subsequent Attribution
37.517	Niccolo Rondinelli	same
37.476	Ercole de'Roberti	Lorenzo Costa
37.644	Antoniazzo Romano/ Raffaelle dei Carli	School of Umbria (Unknown)
37.501	Giovanni Batasta Moroni	same
37.482	Bernardino Fungai	Master of the Liverpool Madonna (Unknown)
37.582	Tintoretto	(Unknown) (painting deaccessioned in 1951)
37.466	Pietro Carpaccio	(Unknown) (Forgery)

WAM #	Berenson Attribution	Zeri/Walters Subsequent Attribution
37.554	Giovanni Di Paolo	Giovanni Di Paolo and workshop
37.500	Bartolomeo Bramantino	School of Ferrara (Unknown)
37.443	Barnaba da Modena	Francesco Anguilla
37.433	School of Sicily	Attributed to Antonello da Messina
37.534	Paris Bordone	School of Venice (Unknown)
37.451	Bronzino	same
37.553	Bernardo Daddi	Workshop of Bernardo Daddi
37. 518	Cosimo Rosselli	same
37.513	Niccolo da Guardiagrele	Michele Di Matteo
37.421	Bartlomeo Di Giovanni	same
37.477	Fiorenzo di Lorenzo	Master of the Gardner Annunciation (Unknown)
37.526	Lo Spagno	Umbro-Tuscan School (Unknown)
37.515	Polidoro Lanziani	Uncertain
37.545	Niccolo Appiana	School of Lombardy (Unknown)
37.470	Cima da Conegliana	Giralamo Da Udine
37.488	Francesco da Rimini	Follower of Vittore Carpacio
37.537	Antonio Vivarini	Michele Giambono
37.448	Bicci di Lorenzo	same
37.455	Bernardino Butinone	Master of the Sforza Alterpiece (Unknown)
37.519	Gregorio Schiavone	School of Padua (Unknown)
37.522	Sodoma	same
37.444	Marco Basaiti	same
37.506	Giovanni Batista Utile	School of Umbria
37.743	Benvenuto Di Giovanni	Girolamo Di Benvenuto (son)
37.1036	Bartolomeo Montagna	same
37.1089	Fiorenzo di Lorenzo	Pinturicchio
37.1056	Giovanni Martini da Udine	Filippo Mazzola

LIST 3. ITALIAN PAINTINGS ACQUIRED BY WALTERS FROM SOURCES OTHER THAN BERENSON AND MASSARENTI (1901–1931)

The information given is the WAM number, the attribution of the artist at the time of acquisition, the present attribution, the name of the painting, and the source of the painting. An asterisk denotes a painting referred to in *Masterpieces of Italian Painting: The Walters Art Museum.*

1901

WAM 37.484: Raphael, now Raphael and Workshop, *Madonna of the Candelabra*, Hugh Andrew Johnstone Munro, Novar, Scotland.*

Between 1902 and 1909

WAM 37.243: Henrich Goltzius, now attributed to Luca Giordano, *Ecce Homo*, unknown source*

WAM 37.397: Condé (French School), now attributed to Pietro Longhi, *The Music Lesson*, unknown source*

WAM 37.475: Pietro Perugino, *Madonna and Child*, unknown source

WAM 37.494: Innocenzo da Imola, now attributed to Biagio Pupini, *Madonna and Child with Saints*, unknown source

WAM 37.502: Venetian School, now attributed to Antonio Solario, *The Holy Family with Young Saint John the Baptist*, unknown source

WAM 37.512: Sabastiani Rici, now attributed to Giovanni Pittoni, *The Sacrifice of Polyxena*, acquired in 1907 from Glaenzer and Co., New York

WAM 37.540: Scipio Pulzone, now attributed to School of Florence, *Portrait of a Child Prince*, unknown source

WAM 37.552: Lodovico Cardi, now attributed to Alessandro Turchi, *Saint Peter and Angel Appearing to Saint Agatha in Prison*, unknown source

WAM 37.576: Tintoretto, now attributed to Palma Il Giovane, *The Fall of Man*, unknown source

WAM 37.608: Venetian School, now attributed to Carlo Ceresa, *Portrait of a Girl*, unknown source

WAM 37.610: Venetian School, now attributed to unknown copyist of Bellini, *The Supper at Emmaus*, unknown source

WAM 37.635: Catarino Veneziano, *Madonna and Child, the Crucifixion, and Saints*, Piccoli, Venice

WAM 37.737: School of Giotto, now attributed to Nadda Ceccarelli, *The Crucifixion*, unknown source

WAM 37.742: School of Fra Angelico, now attributed to School of Rome, *The Communion and Consecration of the Blessed Francesca Romana*, unknown source

Between 1909 and 1912

1911

WAM 37.452: Domenico Brusasorci, removed from collection without attribution, *Portrait Bust of an Old Man* (unknown source)

WAM 37.460: Canaletto, now attributed to Follower of Canaletto, *The Reception of Foreign Ambassadors by the Doge in the Sala del Collegio*, unknown source

WAM 37.476: Ercole di Giulio Cesare Grandi, now attributed to Lorenzo Costa, *The Story of Susannah*, unknown private collection, Paris

WAM 37.489 A, B, C and D: Giovanni di Paolo (four panels), *The Resurrection of Lazarus, The Way to Calvary, The Descent from the Cross*, and *The Entombment*, Luigi Grassi, Florence*

WAM 37.1090: Bernardino Luini, *Saint John the Baptist* (copy of Leonardo da Vinci's *Saint John the Baptist*), reattributed to unknown artist and de-accessioned, unknown source

1912

WAM 37.439: Antonio da Fabriano, *Saint Jerome in His Study*, A. S. Drey*

WAM 37.481: School of Foppa, now attributed to Antonio Della Corna, *Christ before the Caiaphas*, Trotti Galleries, Paris

WAM 37.880: Michael Coltellini, *Madonna and Child Enthroned with Saints*, Tavazzi, Rome

WAM 37.1057: Alvaro Di Pietro, *Head of the Virgin* (acquired after 1911), unknown source

BETWEEN 1913 AND 1915

WAM 37.441: Amico Aspertini, *Portrait of a Young Woman Holding a Book*, A. S. Drey*

WAM 37.446: School of Giovanni Bellini, *Madonna and Child with Saints Peter and Mark and Three Venetian Procurators*, source unknown*

WAM 37.449: Francesco Bonsignori, reattributed to unknown artist and deaccessioned, *Profile of a Warrior* (before 1915), source unknown

WAM 37.450: Francesco Bonsignori, reattributed to an unknown artist and deaccessioned, *Portrait of a Prelate in Black* (before 1915), unknown source

WAM 37.456: School of Camerino, now attributed to Bartolomeo Di Tommaso, *The Funeral and Canonization of Saint Francis of Assisi*, A. S. Drey

WAM 37.457: School of Camerino, now attributed to School of Marches, *Madonna and Child Enthroned before a Rose Hedge*, source unknown

WAM 37.461: Raffello dei Carli, now attributed to School of Venice, *Madonna and Child between Saint Francis and Jerome* (before 1915), unknown source

WAM 37.467: Master of the Castello Nativity, *Madonna and Child*, private collection, Paris

WAM 37.478: Florentine School, now attributed to Lorenzo Bicci, *Oval, Virgin and Child*, N. H. Carlo Zeni, Milan

WAM 37.481: School of Foppa, now attributed to Antonio Della Corna, *Christ before Pilate*, Trotti Galleries

WAM 37.488: Giovanni Francesco da Rimini, *Madonna and Child*, A. S. Drey

WAM 37.491: Guido Reni, now attributed to Follower of Guido Reni, *Cupid Lying on the Seashore*, source unknown

WAM 37.497: Maestro Dei Garofani, *Virgin behind Parapet, Child Standing on Cushion*, source unknown

WAM 37.508 A–D: P. M. Pennacchi, now attributed to School of Venice, *Saint Peter, Saint John, Saint Roch, Saint James the Great*, unknown source

WAM 37.509: Albertino Piazza, now attributed to follower of Andrea Solario, *Mary Magdalen*, source unknown

WAM 37.514: Pinturicchio, now attributed to Francesca De Monterale, *Nativity*, unknown source

WAM 37.520: Luca Signorelli, *The Archangel Gabriel*, source unknown

WAM 37.524: Giovanni Antonio Sogliani, *Madonna and Child with St. John the Baptist*, source unknown

WAM 37.527: Tuscan School, now attributed to Giovanni Speranza, *The Savior*, source unknown

WAM 37.529: Tuscan School now attributed to Francesco Da Rimini, *The Virgin in Adoration*, source unknown

WAM 37.531 A, B, C: Venetian School, now attributed to Christoforo Caselli, *Saint Francis of Assisi between Saint Louis of Toulouse and the Blessed John Capistrano*, source unknown

WAM 37.532: School of Venice, *Madonna and Child*, unknown source

WAM 37.533: School of Venice, *Finding of Moses*, source unknown

WAM 37.536: School of Verrocchio, now attributed to School of Florence, *Madonna and Child*, source unknown

WAM 37.541: Zelotti, now attributed to Veronese, *Portrait of Countess Livia da Porto Thiene and Her Daughter Porzia*, Paola Paolini, Rome*

WAM 37.542: Marco Zoppo, *Saint Jerome Beating His Breast*, source unknown

WAM 37.586: Matteo di Giovanni, now attributed to Guidoccio Cozzarelli, *Madonna and Child with Two Angels*, A. S. Drey

WAM 37.1162: Original attribution unknown, now attributed to Giovanni Corenti, *Saint John Baptiste dans un paysage*, unknown source

WAM 37.1180: Original attribution unknown, now attributed to Master of the Stories of Helen, *The Reception of Helen*, unknown source

BETWEEN 1916 AND 1922

1916

WAM 37.1035: Style of Benvenuti di Giovanni, *Madonna and Child Holding a Bird*, unknown source (removed from collection)

1917

WAM 37.1918: Bartolo Di Fredi, *Massacre of the Innocents*, Demotte, Paris*

1920

WAM 37.1159: Pietro Lorenzetti, now attributed to Naddo Ceccarelli, *Reliquary Tabernacle with Virgin and Child*, Arnold Seligman Rey and Co.*

WAM 37.1024: Simone Martini, now attributed to Master of Monte Oliveto, *The Crucifixion with Virgin, Saint John and Saint Magdalen*, unknown source.

WAM 37.1034: Bernardino Martini, now attributed to Francesco Di Giorgio, *Madonna and Child*, Arnold Seligman Rey and Co.

BETWEEN 1923 AND 1929

1924

WAM 37.1163: Original attribution unknown, now attributed to Master of the Castello Nativity, *Madonna and Child*, A. S. Drey

1925

WAM 37.1026: Giorgio Schiavone, *Madonna and Child with Angels*, A. S.Drey*

WAM 37.1050: Matteo Di Giovanni, *Madonna and Child with Saints and Angels*, Kleinberger Galleries, New York

1926
WAM 37.1028: Original attribution unknown, now attributed to Lippi-Pesellino Imitators, *Madonna and Child*, Kelekian, Paris

1927
WAM 37.1016: G. Moroni, now attributed to Sofonisba Anguissola, *Portrait of a Young Noble*, acquired at the Stillman sale*

1929
37.1046: Sienese, not reattributed and withdrawn from collection, *Madonna and Child*, Sambon

1930–1931

1930
37.1033: Original attribution unknown, now attributed to Siena School, *Madonna Nursing the Child with Saint Bernardine and Saint Anthony*, A. S. Drey

Notes

PROLOGUE

1. On this general subject, see Jones, "The Renaissance and American Origins," 140–151; Saltzman, *Old Masters, New World*; Santori, *The Melancholy of Masterpieces*, 71–98; Tomkins, *Merchants and Masterpieces*, 69–83; Strouse, "The Collector J. Pierpont Morgan"; and Wilson, "Architecture and the Reinterpretation of the Past in American Renaissance," 69–87.

2. Johnston, *William and Henry Walters, the Reticent Collectors*, 153.

3. See Santori, *The Melancholy of the Masterpieces*, 29, 277nn9, 10.

4. *Baltimore Sun*, May 14, 1902. The suggestion, as reported in both the *Baltimore Sun* and the *New York Times*, that Walters and Massarenti continued to negotiate over the sale of the collection throughout April, May, and June of 1902 was erroneous. The contract of sale was executed on April 16, 1902, but due to Walters's concern that the deal could become unraveled by publicity, he withheld this information until the collection had safely arrived in New York in July 1902.

5. "Massaranti [*sic*] Collection Here From Italy," *NYT*, July 13, 1902. On May 20, 1902, the *New York Times* reported that there had been several offers to purchase individual objects, especially in the field of Greek and Roman art, from the Massarenti collection but that these efforts had been rejected because of Massarenti's interest in keeping the entire collection together.

6. *Baltimore Sun*, July 13, 1902. The *Baltimore Sun*'s optimistic belief that Raphael's self-portrait was on its way to Baltimore was based apparently on a description of this painting in Massarenti's 1897 Catalogue.

7. Henry Walters's careful reading of the newspaper accounts of his purchase of the Massarenti collection is documented in his letters to William Laffan and Emile Rey dated May 13, 1902, both of which are in the Walters Art Museum's archives. In his letter to Rey, Walters wrote that he refused to be interviewed by the press about his purchase, but "the papers keep on commenting." Although Walters objected to the press coverage, he conceded in his letter that "it is always a pleasure to know that other people appreciate things which you own." In his letter to Laffan, Walters enclosed articles from the *Baltimore Sun* and *New York Times*.

8. In 1898, the art dealer Joel Duveen (Joseph's father), after visiting the Massarenti collection, dismissively noted: "Everything *ghadish* (imitation) . . . Practically all

the great names in this lot are copies or daubs by minor artists." Duveen, *House of Duveen*, 187. Likewise, Wilhelm von Bode, after inspecting the Massarenti collection, wrote that it "would be difficult to name a second [collection] that is so void of good things and contains so many mediocre pictures and forgeries of great names." "Wanted: A School for Art Collectors," *The Nation*, 416.

9. *NYT*, July 13, 1902. Walters's claim that he could replace 25 percent of the Massarenti collection because he had "better pieces of work of the same kind" was fallacious. When Walters acquired the Massarenti collection, he owned only fifteen Italian Renaissance paintings.

10. For examples of the laudatory articles written in the nineteenth century about William T. Walters's art collection, see "Mr. William T. Walters," in *Harpers Weekly*, Dec. 1, 1894, 1132 ("one of the finest private art collections in the world"), and "The Walters Collection of Art Treasures," in *Magazine of American History*, 27, no. 4, April 1892, 241–262 (a collection of "unrivalled magnitude and far-reaching influence").

11. Hill, "William T. Walters and Henry Walters," 178–186, 180, 184.

12. *NYT*, January 30, 1909.

13. *Baltimore Sun*, January 30, 1909.

14. Letter from Bernard Berenson to John G. Johnson dated December 10, 1910, Archives Philadelphia Art Museum.

15. Letter from Henry Walters to Bernard Berenson dated October 26, 1911, Archives Villa I Tatti.

16. *Baltimore News*, January 12, 1915, "Isabel Smith Clippings," Archives Walters Art Museum.

17. Bernard Berenson, *Venetian Painting in America*, 173.

18. For a comparison of the quality and quantity of Italian Renaissance and Baroque paintings in American public collections, see Fredericksen and Zeri, *Census of Pre-Nineteenth-Century Paintings*, 555. The authors describe the Walters collection of Italian paintings as "wonderful" and state that "the Italian paintings constitute the second largest group in the United States" (after the collection in the Metropolitan Museum of Art). See also Brown, Review of *Italian Paintings in the Walters Art Gallery*, 367–369 ("The Italian paintings in the Walters Art Gallery in Baltimore form one of the most significant collections in America.").

Chapter 1. BERENSON'S MISSION

1. Sizer, "James Jackson Jarves," 339.

2. There are several good articles relating to Jarves's art collections, including Santori, "James Jackson Jarves," 177–206, and Sizer, "James Jackson Jarves," 328–352.

3. Jarves, "A Lesson for Merchant Princes," 361–380.

4. Ibid., 379.

5. Pater, *The Renaissance*.

6. Barolsky, "Walter Pater and Bernard Berenson," 47. For Pater's influence on Berenson, see also Secrest, *Being Bernard Berenson*, 69–71.

7. Seiler, *Walter Pater*, 5.

8. With regard to Berenson's influence on collectors around the turn of the century, see Samuels, *Bernard Berenson: The Making of a Connoisseur*, 353–376, 418–432 (hereafter cited as Samuels, *Connoisseur*); Secrest, *Being Bernard Berenson*, 136–157; and Brown, *Berenson and Italian Painting*, 13–29.

9. See Calo, "Bernard Berenson and America," 8–18, 9, and Barolsky, "Walter Pater and Bernard Berenson," 7. For the reference to the "Four Gospels," see Walker, *Self-portrait with Donors*, 95. (Walker refers to these four essays as "the best introduction to Italian painting ever written.") The four essays were later collectively published in 1930 and in 1952 (with illustration) as *The Italian Painters of the Renaissance*.

10. Brown, *Berenson and Italian Painting*, 16–17.

11. By 1910, the Italian dealers and intermediaries who were bringing paintings to I Tatti had become so numerous that Berenson retained the services of an employee whose job was "to do all the mediating work in buying pictures, seeing the dealers, beating down the prices and arranging to get the pictures safely out of the country." Samuels, *Bernard Berenson: The Making of a Legend*, 103 (quoting letter from Berenson) (hereafter cited as Samuels, *Legend*).

12. Brown, *Raphael in America*, 41.

13. For descriptions of the social life at I Tatti and the art that was available to purchase there, see Samuels, *Legend*, 54, 123, 137 (there was morning traffic of dealers from all over Italy beating a path to Berenson's door and offering their purported treasures); see also Clark, *Another Part of the Wood*, 127, 128, 152–157. For a description of the art and library at I Tatti, see Rubin, "Berenson, Villa I Tatti, and Visualization," 209–213.

14. The quotation is from one of Berenson's neighbors and guests, Iris Origo. It is found in Dwight, *Edith Wharton: An Extraordinary Life*, 265–266.

15. Behrman, *Duveen*, 154, 155.

16. For a firsthand description of Berenson's ritualistic method of disclosing the identity of the artist, see Clark, *Another Part of the Wood*, 138.

17. Fry, Review of *The Study and Criticism of Italian Art*, 668–669.

18. See Berenson, *Venetian Paintings in America*.

19. Berenson made substantial contributions to the catalogues of John G. Johnson and Peter and Joseph Widener. See Samuels, *Legend*, 74, 77, 78. For Berenson's contribution to the catalogue of John G. Johnson, see Berenson, *Catalogue of a Collection of Paintings*, vol. 1. For Berenson's contribution to the catalogue of Joseph Widener's collection, see *Paintings in the Collection of Joseph Widener at Lynnewood Hall* (privately printed, 1923).

20. Behrman, *Duveen*, 176; Brown, *Berenson and Italian Painting*, 24.

21. Hadley, *Letters of Berenson and Gardner*, 45. For a good analysis of Gardner's relationship with Berenson and the tension that arose due to the deceptive manner in which Berenson acquired and inflated the price of paintings, see Saltzman, *Old Masters, New World*, 67–92.

22. See Samuels, *Connoisseur*, 431; Tompkins, *Merchants and Masterpieces*, 104.

23. Kenneth Clark has described the art market during the thirty years from 1900 to 1930 as "in an unusually depraved condition." Clark, *Another Part of the Wood*, 140.

24. Samuels, *Connoisseur*, 301–309.

25. Hadley, *Letters of Berenson and Gardner*, 154, 155.

26. Saltzman, Old Masters, New World, 82–84.

27. The most thorough description of Bernard and Mary Berenson's trip to the United States is in Samuels, *Connoisseur*, 402–432.

28. For Mary Berenson's account of her and Bernard's impression of the collections in America, including her impression of a collection that included many Monets and which she characterized as the "most revolting spectacle BB has seen," see Gilmore, "The Berensons and Villa I Tatti."

29. Samuels, *Connoisseur*, 421, 427.

30. Ibid., 422.

31. *NYT*, March 21, 1904, p. 9.

32. Samuels, *Connoisseur*, 431.

33. In 1902, Richard Norton, while at the American Academy of Rome, called Berenson "dishonest" and warned friends about him. Walters at that time was a principal supporter of the American Academy and knew Norton. The growing list of Berenson enemies is also reflected in an exchange of correspondence between Isabella Stewart Gardner and Mary Berenson in January 1904. On January 19, 1904, Gardner wrote to Mary Berenson that, at a dinner party she attended, vile and horrible remarks had been made by Berenson's "enemies" about his character. On January 21, 1904, Mary Berenson responded that "B.B. is very much hated," and she categorized his enemies into four groups: (1) the owners of pictures whose attributions had been challenged by Berenson, (2) competing collectors, (3) dealers whom Berenson believed were selling pictures having false attributions, and (4) other writers about art who were jealous of Berenson's success. Hadley, *Letters of Berenson and Gardner*, 329–331.

34. See Simpson, *Artful Partners*, 96–98. According to Simpson, Berenson was reported to have seen photographs of the Massarenti collection and to have participated in a conspiracy to dupe Henry Walters into buying it. Simpson's dubious account should be treated with considerable skepticism. His references to Henry Walters in his book are full of errors. He misidentified Henry Walters as "John T. Walters" (pp. 97–98, 120); erroneously asserted that, in 1902, Berenson wrote to Walters that he had seen photographs of the Massarenti collection and that Walters was being duped; and stated that, as a result of this letter, Walters closed his gallery and would not let anyone see the Massarenti collection until the "imposters were weeded out" (p. 98). There is no evidence that Berenson ever wrote such a letter to Walters, and the Massarenti collection was not in the Walters Gallery of Art at that time but in a warehouse in New York. On the other hand, there is good reason to believe that Berenson saw the Massarenti collection in Rome before Walters acquired it and that Berenson was not favorably impressed by it.

Chapter 2. WALTERS'S CULTIVATION

1. Sutton, "Connoisseur's Haven," 2.

2. See "His Mother's Idea," *Wilmington Messenger*, Nov. 27, 1894. For a collection of newspaper clippings about William and Henry Walters, see "Bill Reaves Collection,"

New Hanover Public Library, Wilmington, North Carolina. I want to thank the library, and especially Beverly Tetterton, for bringing this information to my attention.

3. Johnston, *William and Henry Walters*, 14. Johnston's book is the best source for information about William T. Walters, especially at pp. 1–111.

4. Ibid., 34–40.

5. See King, *The Judgment of Paris*, 202–205.

6. Matthews, "Walters Art Collection of Baltimore," 4.

7. "The Walters Collection of Art Treasures," 242.

8. Johnston, William and Henry Walters, 68, 79, 108, 254n79.

9. Johnston, "William Thompson Walters," in *The Taste of Maryland: Art Collecting in Maryland, 1800–1934*, pp. 50–56, 50. In considering the laudatory assessments of William Walters's collection, it is salutary to bear in mind that, in the second half of the nineteenth century in America, there were very few private art collections of distinction. Except for the collections of James Jarves and Isabella Stewart Gardner, there were no private collections in the United States that featured Italian Renaissance old-master paintings. See Venturi, "Private Collections of Italian Paintings," 168–177.

10. Matthews, "Walters Art Collection of Baltimore," 2.

11. "The Walters Collection of Art Treasures," 264.

12. "Mr. William T. Walters," *Harper's Weekly*, 1132.

13. Zeri, "The Italian Pictures," 26.

14. Sutton, "Connoisseur's Haven," p.7.

15. Johnston, *William and Henry Walters*, 50–52.

16. Ibid., 47, 63.

17. The Baedeker guide to Italy was originally published in Germany. After it was translated into English in 1876, it served as the standard for English travelers to Italy for the remainder of the nineteenth century. The three-volume guidebook relied heavily on Crowe and Calvavcaselle, *New History of Italian Painting*, published in 1867. In preparing for his tour of Italy, Walters probably referred to both the Baedeker guide and the English translation of Burckhardt's *The Cicerone*.

18. Henry Walters's Notebook—Trip to Italy (1879), Archives Walters Art Museum.

19. See Baedeker, *Handbook for Travellers*, 392, 393.

20. For Berenson's reference to the famous Tribuna, see the notes he wrote in 1914 about the painting *Public Square*, painting #677 in the 1909 Walters *Catalogue of Paintings*, Archives Villa I Tatti, Florence.

21. Henry Walters's Notebook, Archives Walters Art Museum.

22. The *Baltimore Sun's* report of this event was quoted in a later article about William and Henry Walters. See May Irene Copinger, "The Walters' Gift Gains Stature," *Baltimore Sun*, Jan. 14, 1934.

23. Matthews, "Walters Art Collection in Baltimore," 14.

24. Block, *Airlie: The Gardens of Wilmington*, 27.

25. Ibid., 26.

26. Ibid., 35–37, 48, 54, 66–68.

27. Johnston, *William and Henry Walters*, 113, 264n5.

28. Ibid., 113.

29. Ibid., 116–119.

30. Ibid., 130.

31. See *The Walters Collection* (1889), Archives Walters Art Museum. The 1899 catalogue listed 173 paintings. The previous catalogue prepared in 1884 listed 149 paintings. See *The Art Collection of Mr. Wm T. Walters* (1884), Archives Walters Art Museum.

32. Mark S. Watson, "Adventures in Art Collecting," *Baltimore Sun*, January 25, 1931.

33. See "Henry Walters," a speech given by Henry Watson Kent, secretary of the Metropolitan Museum of Art, on January 27, 1940, Archives Walters Art Museum.

34. Sutton, "Connoisseur's Haven," 12.

35. Santori, "Turning Points."

36. Hill, "The Classical Collection," 352–354.

37. Hadley, *Letters of Berenson and Gardner*, 92.

38. Brown, *Raphael in America*, 73, 77–79, 106n225; Johnston, *William and Henry Walters*, 139, 140. In the view of Federico Zeri, the painting "is largely a workshop piece." Zeri, *Italian Paintings in the Walters*, 349.

39. Walters informed Berenson that he acquired the painting from "a nephew of [Hugh Andrew Johnstone] Munro of Novar [Scotland]," who previously had bought it at Christies, London. Letter from Henry Walters to Bernard Berenson, January 4, 1910, Archives Villa I Tatti, Florence.

40. See "A $200,000 Picture for the Walters Art Gallery," *Wilmington Messenger*, July 7, 1901. See also "Madonna of the Candelabra," *Baltimore News*, Jan. 1, 1910, in Walters Archives—Isabel C. Smith Clippings ("No less than $100,000 is said to have been paid for the Madonna").

41. Letter from Henry Walters to Bernard Berenson dated January 4, 1910, Archives Villa I Tatti, Florence.

Chapter 3. ONE COPY ON TOP OF ANOTHER

1. Vasari, *The Lives of the Artists*, 2:317–318, quotation on 318.

2. Barkan, *Unearthing the Past*, 276–277, quotation on 277.

3. Findlen, "Possessing the Past," 112, 113.

4. Pepper, "Reni's Practice of Repeating Compositions," 27–54. "Reni, especially, in his sacred images, repeated almost each and every one multiple times, making in most cases small variations on his basic theme, and these in turn became sources for repetitions." (47)

5. O'Malley, *The Business of Art*, 91, 222. For a thorough discussion of the two existing versions of Leonardo's *Virgin of the Rocks*, see Marani, *Leonardo Da Vinci*, 124–155. Marani argues that the painting in the Louvre is the original painted around 1483–86 and the painting in the National Gallery in London is a copy made around 1491–95 at Leonardo's direction by two of his most able assistants, Marco D'Oggino and Giovan Antonio Boltraffio.

6. Holmes, "Copying Practices and Marketing Strategies," 38–74, 60.

7. Vasari, *Lives of the Artists*, 338.

8. Tietze-Conrat, "Titian's Workshop," 80.

9. Walker, *Self-portrait with Donors*, 93. See also Schmitter, "Virtuous Riches," 943, 944 (discussing the culture of emulation in the cittadini class in Venice), and Fantoni, *The Art Market in Italy*, 21, 22.

10. O'Malley, *The Business of Art*, 8, 90–96; Spear, "Di Sua Mono," 79–98, 80.

11. Tietze-Conrat, "Titian's Workshop," 76–88.

12. Spear, "Di Sua Mono," 80.

13. Vasari, *The Lives of the Artists*, trans. Julia Conaway Bondanella and Peter Bondanella (Oxford University Press, 1991), 338.

14. Prior to 1970, the portrait of Julius II in London's National Gallery was considered as a copy of a painting by Raphael in the Uffizi Gallery. For a discussion about the change in attributions, see Beck, "The Portrait of Julius II," 69–95.

15. Loh, *Titian Remade*; Loh, "New and Improved," 477–504.

16. For a discussion of Borromeo's use of copies in the context of the practice during the Italian Renaissance and Baroque periods, see Spear, "Di Sua Mano," 79–98, 92.

17. For an excellent analysis of the purposes and accomplishments of the Ambrosiana and its use of copies of paintings, see Jones, *Federico Borromeo and the Ambrosiana*, 54, 55, 65, 146, 147, 187.

18. Heisinger, "The Paintings of Vincenzo Camuccini," 301, 314 (app. A).

19. For an interesting discussion about the obscure difference between types of copies, see Kennick, "Art and Inauthenticity," 3–12.

20. Although no one knows the number or percentage of notable paintings in Italy at the turn of the last century whose attributions were mistaken or unknown, one scholar has estimated that "most Italian Renaissance paintings were wrongly attributed and at least half of them were unlisted." Waterhouse, Book Review, 476.

21. For a good discussion of Morelli's scientific method and its influence on the field of connoisseurship, see Wollheim, "Morelli and the Origin," 176–201.

22. Gibson-Wood, *Theory of Connoisseurship*, 219–226.

23. Samuels, *Connoisseur*, 97–105.

24. Berenson, *Lorenzo Lotto*, x, 101.

25. Berenson, *Lorenzo Lotto: An Essay in Constructive Art Criticism* (1895) and *The Study and Criticism of Italian Art* (1902). For a good discussion of Morelli's influence on Berenson, see Gibson-Wood, *Theory of Connoisseurship*, 238–247.

26. For an excellent discussion of Morelli's role in the flourishing market for Italian paintings during the Risorgimento, see Fleming, "Art Dealing and the Risorgimento," 7. With regard to the question of the accuracy of Morelli's attributions, Berenson in 1956 lamented some mistakes he made by relying to heavily on Morelli. See Berenson, *Lorenzo Lotto*, xi.

27. Anderson, Review of "La Raccolta Morelli," 468–470.

28. See Levey, *Later Italian Pictures*, 17 (tracing the purchase of Italian copies to the early Stuarts in the seventeenth century).

29. Berenson's critique initially was published as a forty-two-page pamphlet in March 1895. It was republished in 1901. See Berenson, "Venetian Painting, Chiefly before Titian," in *The Study and Criticism of Italian Art*, 1:91–146.

30. For a discussion of Berenson's "devastating" attack on the attributions given by the English aristocracy to their Venetian paintings and how it helped to launch his career, see Secrest, *Being Bernard Berenson*, 132–135, and Samuels, *Connoisseur*, 221–223.

31. Berenson, *The Study and Criticism of Italian Art*, 1:92.

32. Berenson, "Rudiments of Connoisseurship," *The Study and Criticism of Italian Art*, Second Series, pp. vii, 111–148.

33. Jarves, "Italian Experience," 578–586.

34. Santori, "James Jackson Jarves," 191, 192.

35. Gilman, "Museums of Fine Art," 28–44.

36. "Old Masters Themselves Were Adept in Copyist's Art," *New York Times Magazine*, June 20, 1909; see also Bode, "More Spurious Pictures Abroad."

37. Walker, *National Gallery of Art*, 104.

38. Strehkle, *Italian Paintings*.

39. Letter from Bernard Berenson to John G. Johnson dated August 18, 1904, Archives Philadelphia Museum of Art.

40. See Hadley, *Letters of Berenson and Gardner*, 427, 428; see also Brown, *Berenson and Connoisseuship*, 19. For an article about the source of Widener's misattributed paintings, see Lopez, "Gross False Pretenses."

41. For an excellent article tracing the history of the Widener collection, see Quodbach, "The Last of the American Versailles," 42–96, 81.

42. Strouse, *Morgan: American Financier*, 630, 631.

Chapter 4. THE MASSARENTI COLLECTION

1. For references to Massarenti's reputation, see Duveen, "The Mazzarenti [*sic*] Collection," 185, and Simpson, *Artful Partners*, 97. For two brief sketches of Massarenti's life written in the 1930s, see letter written by Augusto Jandolo, dated November 2, 1936, and letter from Bartolomeo Nogara, dated October 20, 1936, Archives Walters Art Museum.

2. Sutton, "Connoisseur's Haven," 9. Sutton asserts that the Massarenti collection numbered 1,540 works. However, the written agreement between Henry Walters and Massarenti dated April 16, 1902, and the Massarenti catalogues indicate that there were more than sixteen hundred works of art. More specifically, the contract referred to "paintings numbered 1 to 865" in the 1897 catalogue and to "paintings numbered 1 to 62" in the 1900 supplement. This suggests that there were a total of 927 paintings. However, the 1897 catalogue skips some numbers, reducing the number of paintings by my analysis to 910. The written agreement also refers to 501 terra cottas and bronzes, 149 marbles, and 35 other objects. See Agreement dated April 6, 1902, between Henry Walters and Dr. J. H. Sennet (Massarenti's agent), Archives Walters Art Museum.

3. *Catalogue d'une Collection de Tableux de Diverses Ecoles* (Rome, 1881), Archives Walters Art Museum.

4. For a sympathetic description of Massarenti at the time of the sale of his collection, see Memorandum of Regina Soria, June 2, 1958, "Massarenti files," Archives Walters Art Museum.

5. Edouard Van Esbroeck, *Catalogue du Musée de Pienture, Sculpture et Archeologie*, (Rome, 1897), and *Supplement* (Rome, 1900), Archives Walters Art Museum (hereafter cited as Massarenti Catalogue).

6. There are forty-nine photographs of the Massarenti collection as it appeared in Rome shortly before 1902, when Walters purchased the collection. The photographs are not dated and do not identify the photographer. Archives Walters Art Museum.

7. Zeri, *Italian Paintings*, xiv.

8. *NYT*, July 13, 1902, 1.

9. Duveen, "The Mazzarenti [*sic*] Collection," 186, 187.

10. Massarenti Catalogue, p. 25, no. 133.

11. Condivi, *The Life of Michelangelo*.

12. Symonds, *The Life of Michelangelo Buonarroti*.

13. Hill, "The Portraits of Michelangelo," 345–346. Hill notes that Michelangelo did not paint any self-portrait, and he argues that he did not do so because he did not consider portraiture to be a good vehicle for his ideas. Although there is no evidence that Michelangelo painted a typical self-portrait of the kind attributed to him by Massarenti, Michelangelo probably alluded to himself in his fresco of *The Last Judgment* in the Sistine Chapel and in the sculpted figure of Nicodemus in the *Pietà* in the Museo dell'Opera del Duomo in Florence. See Hartt, "Michelangelo in Heaven," 191–209. See also Paoletti, "Michelangelo's Masks," 423–440. Paoletti argues that Michelangelo also revealed his image in the figure of Night in the Tomb of Giuliano dei Medici, Medici Chapel, S. Lorenzo, Florence.

14. The process by which Volterra sculpted the bust of Michelangelo is disputed. According to Symonds, Volterra made it from a wax model of Michelangelo's face at the time of Michelangelo's death. Symonds, *The Life of Michelangelo Buonarroti*, 267–270. According to Hugo Chapman, *Michelangelo Drawings*, 262, 263, Volterra used an earlier lead point and black chalk portrait that he drew around 1550 as the model for his bronze bust of Michelangelo.

15. Massarenti Catalogue, nos. 174, 175, Archives Walters Art Museum.

16. Walters Gallery, *Catalogue of Paintings*, (1909), 137, nos. 655 and 658. Henry Walters published three catalogues of his paintings between 1909 and 1922. Each was entitled *Catalogue of Paintings*. The first catalogue was published in 1909 around the time of the grand opening of his new museum and featured the paintings, including the alleged masterpieces attributed to Michelangelo and Raphael, that Walters had acquired from Massarenti. The second catalogue was published in 1915, and most of the attributions in the 1909 catalogue were changed based on the advice of Berenson. The third catalogue was published in 1922 and reflects the relatively modest additional paintings that were acquired between 1915 and 1922. The catalogues did not contain publication dates, and this omission generated a lot of confusion. After Walters's death, the 1915 catalogue was erroneously inscribed with a handwritten date of 1922, and the 1922 catalogue was erroneously inscribed with a handwritten date of 1929.

17. There were three different accounts of these paintings written in the seventeenth century by Passari, Malvasia, and Bellori. For a discussion of these accounts, see Pepper, "Reni's Roman Account Book—II," 372–386.

18. The question of whether Domenichino received this commission from Reni or obtained it through his mentor Annibale Carracci remains a subject of debate among the leading scholars and historians of Baroque art. See Pepper et al., "State of Research," 305–309.

19. For a discussion of the contrasting styles of Domenichino and Reni, see Spear, *Domenichino*, 54–57, and Pepper, *Guido Reni*, 24.

20. This comparison was made by Pepper in "Guido Reni's Roman Account Book—II," 376.

21. Baedeker, *Handbook for Travellers*, Central Italy and Rome, p. 250; Burckhardt, *The Cicerone: An Art Guide to Painting in Italy*, translated by Mrs. A. H. Clough, p. 240.

22. Pepper, "Guido Reni's Roman Account Book," 379.

23. Massarenti Catalogue Supplement (1900), no. 19.

24. For a good analysis of Caravaggio's working methods, see Puglisi, *Caravaggio*, 369–393. For a rebuttal of the notion that Caravaggio created many replicas of his paintings, see Christiansen, "Caravaggio's Second Versions," 502–504.

25. For an extensive study of the influence of Caravaggio on other painters in Rome in the early seventeenth century, see Brown, *The Genius of Rome*.

26. Moir, *Caravaggio and His Copyists*, 19, 22, 23, 35 (illustrating more than one hundred notable copies of Caravaggio's most famous paintings).

27. For a good analysis of this painting and its influence on Italian art, see Graeve, "The Stone of Unction." See also Friedlander, *Caravaggio Studies*, 186–188.

28. Bellori's quotation is found in Friedlander, *Caravaggio Studies*, 186.

29. Berenson, *Caravaggio*, 28–30, 108.

30. See Hiesinger, "The Paintings of Vincenzo Camuccini," 301.

31. For references and images of more than one hundred renditions of Caravaggio's *Entombment*, see Friedlander, *Caravaggio Studies*.

32. Matthew 22:21, *The Oxford Study Bible* (Oxford University Press, 1992), 1293.

33. Askew, "Parable Paintings of Domenico Fetti," 21–45.

34. For a discussion of Fetti's painting and how it differs from Titian's, see Shilpa Prasad, "Domenico Fetti, 1588/89–1623," in *Masterpieces of Italian Painting: The Walters Art Museum*, 116–119.

35. Walters Gallery, *Catalogue of Paintings* (1915) [the 1915 catalogue was erroneously hand dated 1922], 126, no. 596.

36. Hansen and Spicer, *Masterpieces of Italian Painting*, 96–99. See also Strehlke, *Pontormo, Bronzino and the Medici*, 19–27 (essay by Elizabeth Cropper), 120–121, 149–151. For an account of Alessandro's assassination and its effects on Maria de Salviati, Cosimo I, and Guilia, see Cochrane, *Florence in the Forgotten Centuries*, 13–21.

37. Zeri, *Italian Paintings*, 147–150. Zeri notes that the following artists or schools of art have been credited with painting *The Ideal City*: Pintoricchio, Fra Carnevale, Luciana Laurana, Bernardino Baldi, Piero della Francesca, School of Piera della Fran-

cesca, Francesca Giorgio Martini, Giuliano Sangallo, Baccio d'Agnolo, Ridolfo del Ghirlandaio, and Cosimo Rosselli.

38. For descriptions and pictures of the paintings by Lorenzetti, Filippo Lippi, Rosso Fiorentino, Giulio Romano, Crivelli, Strozzi, and Tiepolo, see Hansen and Spicer, *Masterpieces of Italian Painting*, 22, 23, 46–49, 66–91, 94, 95, 148, 149, 152–155.

39. "Wonders in Art," *Baltimore Sun*, May 13, 1902 (quoting from the *New York Times*).

Chapter 5. A REMARKABLE ACQUISITION

1. Auchincloss, *Theodore Roosevelt*, 58.

2. For a discussion of Morgan's business activities in the steel and transportation industries at the turn of the twentieth century, see Strouse, *Morgan*, 396–408, 426, 458–476.

3. For a detailed discussion of the financial arrangements involved in the merger of the Savannah, Florida & Western Railway Co. with the ACLRR Co., see Hoffman, *A History of the Atlantic Coast Line Railroad*, 130–144.

4. NYT, Dec. 1, 1931.

5. Johnston, William and Henry Walters, 162, 278n123.

6. Memorandum to H. Walters transcribed by John J. Walsh, Archives Walters Art Museum.

7. Samuels, *Legend*, 13.

8. *Dictionary of American Biography*, ed. Dumas Malone (Charles Scribner's Sons, 1933). See also *American National Biography*, vol. 13 (Oxford University Press, 1999).

9. As to whether Laffan initially trusted Berenson is questionable. Laffan's wife, who also met Berenson in 1904, applied to Berenson a brand of anti-Semitism that was virulent at that time. In a letter to Roger Fry, she wrote that Berenson "was the first person of whom she understood what people felt when they talked about the feeling of mistrust inspired by Jews." Samuels, *Connoisseur*, 421.

10. Letter from Henry Walters to Bernard Berenson dated December 8, 1909, Archives, Villa I Tatti, Florence.

11. *Baltimore Sun*, July 13, 1902.

12. Letter from Henry Walters to Bernard Berenson, January 4, 1910, Archives, Villa I Tatti. See also Rubin, "Bernard Berenson, Villa I Tatti," 215.

13. For a study of the replication of these and other French paintings in the nineteenth and early twentieth century, see Kahng, *The Repeating Image*.

14. Walters Gallery, *Catalogue of Paintings* (1909), p. 110, no. 468.

15. Johnston, *William and Henry Walters*, 178, 179.

16. Wilson, "Architecture and Reinterpretation of the Past," 69–87.

17. For a discussion of the history and early photographs of the architecture and design of the Peabody Institute, see Hayward and Shivers, *The Architecture of Baltimore*, 144–146.

18. Massarenti Catalogue, 1897, no. 121. Massarenti attributed the painting to Pintoricchio. Over the years, it has been attributed to many different artists by different

scholars. The Walters Art Museum presently attributes the painting to Fra Carnavale. See Hansen and Spicer, *Masterpieces of Italian Painting*, 62–67.

19. The identity of the four virtues in this painting is debatable. Federico Zeri has identified them as Justice, Temperance, Abundance, and Fortitude. Zeri, *Italian Paintings*, 143. Joaneath Spicer has identified them as Justice, Moderation, Liberality, and Fortitude. Hansen and Spicer, *Masterpieces of Italian Painting*,67.

20. For an article that links Henry Walters's acquisition of the Massarenti collection to other milestones in the history of art collecting, see Mayo, "Collecting Ancient Art," 133–141.

21. For an article about "How Purchase was Made," written by the *Baltimore Sun*'s Rome correspondent, see "$1,000,000 for Art," *Baltimore Sun* (1902), Archives Walters Art Museum.

22. Massarenti Catalogue, p. 25, no. 132.

23. Vasari, Lives of the Artists, 313.

24. For an excellent discussion of the history of this painting and images of the engravings that were copied after it, see Brown and Nimmen, *Raphael and the Beautiful Banker*.

25. Ibid., 165–169, figs. 28, 36, 39.

26. Walker, *National Gallery of Art*, 180, 181.

27. Duveen, *The Rise of the House of Duveen*, 188, 189. Part of the confusion might have stemmed from the fact that another *Self-portrait* by Raphael was in the Uffizi Gallery in Florence.

28. Walters Gallery, Catalogue of Paintings (1909), no. 483; *Baltimore Sun*, January 30, 1909.

29. Letter from Henry Walters to William Laffan dated May 13, 1902, Archives Walters Art Museum.

30. For an excellent discussion of Morgan's acquisition of the Colonna altarpiece and the publicity it generated, see Wolk-Simon, "The Colonna Altarpiece," 56–59.

31. For Morgan's purchase in 1901 of Raphael's *Colonna Madonna* for $400,000, and his purchase in the Spring of 1902 of a tapestry that once belonged to Cardinal Mazarin for $340,000, a bas-relief by Donatello for $74,000, and a library containing magnificent illuminated manuscripts belonging to William Bennett for $700,000, see Strouse, *Morgan*, 414, 489, 490.

32. Letters from Henry Walters to William Laffan dated May 13 and May 29, 1902, Archives Walters Art Museum.

33. For a discussion of the import fee on art in the early twentieth century, see Santori, *The Melancholy of Masterpieces*, 34–37.

34. Strouse, "The Collector J. Pierpont Morgan," 2.

35. The letter from Gardner to Berenson, dated November 7, 1900, is published in Hadley, *Letters of Berenson and Gardner*, 233. Whether Mary and Bernard Berenson also participated in the smuggling of Renaissance art out of Italy is addressed in Hoving, "The Berenson Scandals," 134.

36. Hadley, *Letters of Berenson and Gardner*, 231, 327.

37. Letter from Henry Walters to Laffan dated May 29, 1902; letter from Henry Walters to Emil Rey dated May 13, 1902; both Archives Walters Art Museum.

38. "Mr. Walters New Treasures," *NYT*, May 20, 1902.

39. Cablegram from William Laffan to Henry Walters dated June 22, 1902, Archives Walters Art Museum.

40. See U.S. Import record dated July 14, 1902, and signed by Henry Walters, Archives Walters Art Museum.

41. See Memorandum dated April 2, 1904, Archives Walters Art Museum.

42. "The Duty on Art," *NYT*, September 10, 1902 (letter from A.W. Lyman).

Chapter 6. THE SACRIFICE OF CANDOR FOR ACCLAIM

1. Letters from Henry Walters to William Laffan dated May 13 and May 29, 1902, Archives Walters Art Museum.

2. Santori, *The Melancholy of Masterpieces*, 18, 19.

3. "Wanted: A School for Art Collectors," 417.

4. "Mr. Walters New Treasures," *Baltimore Sun*, 1902, Archives Walters Art Museum.

5. "Mr. Walters to Hide It," *Baltimore Sun*, 1902, Archives Walters Art Museum.

6. Walters's inventory of the paintings he purchased from Massarenti is in the Archives Walters Art Museum.

7. See Memorandum dated April 2, 1904, Walters Art Museum Archives ("the collection is now in New York where twelve men are engaged upon it in the work of restoration.")

8. Walters Gallery, *Catalogue of Paintings* (1909), nos. 629, 713, 587, 588, and 599.

9. Johnston, *William and Henry Walters*, 166.

10. For a description of the new museum and how it was constructed, see ibid., 163–169. See also letter from William Adams Delano to Dorothy Miner dated October 9, 1939, Archives Walters Art Museum.

11. Johnston, *William and Henry Walters*, 163–169.

12. For a description and initial impression of the Walters courtyard and its objects of art as seen by a reporter for the *New York Times*, see "Walters Art Temple Shown," *New York Times*, Jan. 30, 1909.

13. The handwritten plans for hanging the paintings acquired from Massarenti are in the Archives Walters Art Museum.

14. Walters Gallery, *Catalogue of Paintings* (1909), nos. 422 (Botticelli), 472 (del Sarto), 478 (Perugino), 483 (Raphael *Self-portrait*), 484 (Raphael *Madonna*), 486 (Correggio), 487 (Michelangelo), and 492 (Reni).

15. "Walters Gallery to Open Feb. 3," *Baltimore News*, Jan. 22, 1909, "Warren Wilmer Brown Journal," p. 64, Archives Walters Art Museum.

16. *New York Times*, January 30, 1909; *Baltimore Sun*, January 30, 1909.

17. "Art Lovers Throng Walters Gallery," *Baltimore News*, Feb. 3, 1909, "Warren Wilmer Brown Journal," p. 72, Archives Walters Art Museum.

18. Johnston, *William and Henry Walters*, 177.

19. Walters Gallery, *Catalogue of Paintings* (1909).

20. Pitt was an art collector and a longtime friend of the Walters family. In 1900, with the financial backing of Henry Walters, Pitt opened an art gallery in Baltimore. As indicated on the letterhead of his business, Pitt's gallery sold Paintings and Engravings, Chinese and European Porcelain, English and Colonial Silver and Antique Jewelry. In 1902, Pitt also served as the General Manager of the Municipal Art Society of Baltimore. He is credited with supervising the transfer of Walters's art collection from New York to Baltimore and advising Walters on how to arrange and display the paintings at the time of the grand opening of the Gallery in 1909. Walters retained Pitt as the museums' curator, and he held this position for twenty years until the time of his death in 1922. Information about Pitt can be found in the "Pitt" folder in the Archives of the Walters Art Museum.

21. Letter from Walters to Berenson dated January 4, 1910, Archives Villa I Tatti, Florence.

22. See four-page pamphlet describing the Walters Gallery in 1909, box 10, Archives Walters Art Museum.

23. Walters Gallery, *Catalogue of Paintings* (1909), nos. 466, 542, 559, and 651.

24. Puglisi, *Caravaggio*, 392, 393. At the turn of the last century, "defamation of Caravaggio all but supplanted acclaim."

25. Letter from Henry Walters to Bernard Berenson dated December 31, 1914, Archives Villa I Tatti, Florence.

26. The painting purportedly by Caravaggio of *The Magdalen* remains in the collection of the Walters Art Museum (WAM 37.651) but has been reattributed to Spadarino, a follower of Caravaggio. See Zeri, *Italian Paintings*, 444.

27. In 1909, American museums were beginning to develop principles and standards for educating visitors. See Gilman, "Museums of Fine Art," 4–17 (encouraging museums to provide visitors with handbooks describing works of art in order to encourage appreciation and investigation of art).

28. "Many Pictures of the Massarenti Collection Not Hung in the New Gallery," *Baltimore News*, Feb. 28, 1903, "Warren Wilmer Brown Journal," p. 85, Archives Walters Art Museum.

29. In an article about the best collections of art in America published in the *New York Times*, Walters's collection was not mentioned. William Bode, "Old Art in the United States," *New York Times*, December 31, 1911.

Chapter 7. THE WALTERS-BERENSON CONTRACT

1. Samuels, *Legend*, 73–77.

2. Letter from Bernard Berenson to John Graver Johnson dated October 5, 1909, Archives Philadelphia Museum of Art.

3. The paintings owned by Walters that were referred to by Berenson in *Northern Italian Painters of the Renaissance* were Cesare da Cesto, *Madonna*, p. 194; Defendente Ferrari, *Holy Family*, p. 204; Vicenzo Foppa, *Sts. Agnes and Catherine*, p. 219;

G. B. Moroni, *Portrait of a Lady*, p. 269; Sodoma, *Holy Family*, p. 287; and Marco Zoppo, *St. Francis*, p. 303.

4. Letter from William Laffan to Bernard Berenson dated July 10, 1909, Archives Villa I Tatti, Florence.

5. Letter from William Laffan to Bernard Berenson dated July 28, 1909, Archives Villa I Tatti, Florence.

6. Letter from William Laffan to Bernard Berenson dated August 28, 1909, Archives Villa I Tatti, Florence. Laffan acknowledged Berenson's offer to work on the project without compensation and stated that Walters preferred to defer any question pertaining to compensation.

7. Letter from Henry Walters to Bernard Berenson dated September 16, 1909, Archives Villa I Tatti, Florence.

8. For a good article on William Walters's publications, see Minor, "Publishing Ventures," 271–311.

9. Letter from Bernard Berenson to John Graver Johnson dated March 9, 1911, Archives Philadelphia Museum of Art.

10. Letter from Henry Walters to Bernard Berenson dated September 16, 1909, Archives Villa I Tatti, Florence.

11. Letter from Bernard Berenson to John Graver Johnson dated May 5, 1912, Archives Philadelphia Museum of Art.

12. Letter from Bernard Berenson to John Graver Johnson dated November 18, 1912, Archives Philadelphia Museum of Art.

13. While Berenson was purchasing paintings for Walters, he was also advising John G. Johnson about his collection and writing a catalogue about the Italian paintings in it. See Bernard Berenson, "Italian Paintings," in *Catalogue of a Collection of Painting and Some Art Objects*. The Italian painters in Johnson's collection whom Berenson recommended to Walters were Bartolomeo Di Giovanni, Antoniazzo Romano, Marco Basaiti, Bartolomeo Bramantino, Cima da Conegliano, Bernardo Daddi, Francesco Grannaci, Bartolomeo Montgna, Giovanni Battista Moroni, Ercole di Roberti, Niccolo Rondinelli, Cosimo Rosselli, Sodoma, Tintoretto, Barnaba da Modena, Giovanni Di Paolo, Fiorenzo di Lorenzo, Lo Spagno, and Giovanni Battista Vivarini.

14. Letter from Henry Walters to Ferris Pitt dated October 30, 1909, Archives Walters Art Museum

15. Letter from Henry Walters to Bernard Berenson dated November 13, 1909, Archives Villa I Tatti, Florence.

16. Letter from Henry Walters to Bernard Berenson dated January 4, 1910, Archives Villa I Tatti, Florence.

17. Letter from Bernard Berenson to Joseph Duveen dated April 5, 1913, "Duveen Brothers Records," Thomas J. Watson Library, Metropolitan Museum of Art, box 537, folder 5.

18. Letter from Henry Walters to Bernard Berenson dated March 18, 1910, Archives Villa I Tatti, Florence.

19. Letter from Henry Walters to Bernard Berenson dated March 18, 1910, Archives Villa I Tatti, Florence.

20. Letter from Henry Walters to Bernard Berenson dated May 23, 1910, Archives Villa I Tatti, Florence.

21. Letter from Henry Walters to Bernard Berenson dated May 24, 1910, Archives Villa I Tatti, Florence. With regard to the amount of Berenson's commission, the letter was somewhat contradictory. Although it called for "ten percent of its [the picture's] cost," elsewhere in his letter Walters stated that he would send Berenson "115 % of purchase price."

22. Letter from Walters to Berenson dated May 24, 1910.

23. After years of effort, in 1908, the Italian government enacted a "protection art law," which required the seller of ancient objects of art, including old-master paintings from the Renaissance, to apply to the government for approval prior to selling and exporting such object to a foreign purchaser. See "Italy Stoutly Holds Her Art Treasures," New York Times, March 29, 1908.

24. Letter from Walters to Berenson dated May 24, 1910.

25. The conversion is based on the worth in 2006 of $7,500 in 1910 using the Consumer Price Index. See Measuring Worth (www.measuringworth.com/calculators/uscompare/result.php).

26. Letter from Henry Walters to Bernard Berenson dated March 9, 1914, Archives Villa I Tatti, Florence.

27. Berenson's wife was delighted with the prospects of obtaining commissions from Walters on an annual basis. See Samuels, Legend, 106.

28. Walters's propensity to shy away from publicity is well captured in William Johnston's excellent biography of him and his father, who are fittingly referred to by Johnston as the "Reticent Collectors."

29. Baltimore News American, November 6, 1910, in "Isabel C. Smith Clippings," Archives Walters Art Museum.

Chapter 8. THE PAINTINGS BERENSON SOLD TO WALTERS

1. Letter from Henry Walters to Bernard Berenson dated August 25, 1910, Archives Villa I Tatti, Florence. Walters informed Berenson that he had sent him 880 pounds for "ye triptych." For a biographical sketch of Rondinelli and a detailed analysis of this painting, see Zeri, Italian Paintings (WAM 37.517 A.B.C.), 255, 256.

2. Bernard Berenson, Venetian Painting in America, 218, 219.

3. Neither Walters nor Berenson maintained any log or inventory that identifies all of the paintings Walters purchased from Berenson. As a result, the Walters Art Museum and outside scholars have been unable before now to identify with certainty these paintings. The Walters Art Museum's Accession Log prepared in the 1940s indicates that Berenon might have been the source of thirty-eight Italian paintings but expresses uncertainty about this by literally placing question marks after several of the references to Berenson. Likewise, Federico Zeri, in his two-volume study of the Italian Paintings in the Walters Art Gallery, lists thirty-seven paintings that Walters might

have acquired from Berenson but expresses uncertainty about seven of these by stating that they "possibly" or "perhaps" were acquired from Berenson. The problem is compounded by the fact that the references to Berenson in the Walters Accession Log and in Zeri's study are inconsistent.

The best source of information about the identity of the paintings Walters acquired from Berenson is the correspondence between them that expressly refers to the paintings Berenson offered and Walters accepted. This extant body of correspondence consists of sixty letters and telegrams located in the archives of the Villa I Tatti and the Walters Art Museum. This complete body of correspondence was not accessible and was probably unknown to the recorder of the Walters Gallery accessions in the 1940s or to Zeri when he published his study of the paintings in 1976. This body of correspondence was also unavailable to Meryle Secrest in 1979, when she wrote *Being Bernard Berenson*; consequently, the list of paintings that she identifies as being sold by Berenson to Walters is not complete (see *Being Bernard Berenson*, xxi, 403, 404). In preparing my list of thirty-six paintings that Walters acquired from Berenson, I relied heavily on the correspondence between Walters and Berenson. Their letters identify thirty-three of the thirty-six paintings on my list. Based on my review of other archival records, including photographs, I concluded that three additional paintings not referred to in the existing correspondence between Walters and Berenson should be on my list. They are Bronzino's *Portrait of a Baby Boy* (WAM 37.451), Giovanni Martini da Udine's *Dead Christ Supported by Angels* (WAM 37.1056), and Giovanni Batista Utile's *Virgin and Infant Saint John Adoring the Child* (WAM 37.506). I want to express my appreciation to Prof. Patricia Rubin for providing me with her research notes on this topic.

4. Letter from Henry Walters to Bernard Berenson dated October 26, 1911, Archives Walters Art Museum.

5. Letter from Henry Walters to Bernard Berenson dated May 30, 1911, Archives Walters Art Museum.

6. See Rubin, "Bernard Berenson, Villa I Tatti," 213–216. Professor Rubin reports that Berenson sold to Walters eight paintings that were from Berenson's own collection. According to the research conducted by her, they were by Marco Basaiti (WAM 37.444), Bernardo Daddi (WAM 37.553), Alvise Vivarini (WAM 37.537), Cosimo Rosselli (WAM 37.518), Pseudo Boccaccino (Agostino Da Lodi) (WAM 37.545), Giovanni da Udine (WAM 37.1056), Giovanni Battista Utili (WAM 37.506), and Bronzino (WAM 37.451). Zeri also noted that Walters acquired paintings from Berenson that were in Berenson's own collection, including paintings by Cosimo Rosselli (WAM 37.518), Giovanni di Paolo (WAM 37.554), Giovanni Battista Utili (WAM 37.506), Giovanni da Udine (37.1056), and Bronzino (WAM 37. 451). See Zeri, *Italian Paintings*, xiii, 93, 122, 179, 275, 328.

7. Letter from Bernard Berenson to Henry Walters dated October 8, 1911, Archives Walters Art Museum.

8. Berenson, *Italian Painters of the Renaissance*, pl. 185, 186.

9. Rubin, "Bernard Berenson, Villa I Tatti," 214, 215.

10. Letter from Bernard Berenson to John Graver Johnson dated February 9, 1911, Archives Philadelphia Museum of Art.

11. Letter from Bernard Berenson to Henry Walters dated October 8, 1911, Archives Walters Art Museum.

12. In *Principal Central Italian Painters*, Berenson referred to Benvenuto Di Giovanni, Fiorenzo Di Lorenzo, Bernardino Fungai, Pintoricchio, and Lo Spagno. In *Principal Venetian Painters*, Berenson referred to Antonello Da Messina, Marco Basiati, Vittore Carpaccio, Giovanni Battista Cima, Bartolomeo Montagna, Polidoro Lanzani, Rondinelli, Schiavone, and Tintoretto. In *Principal Florentine Painters*, Berenson referred to Alunno Di Domemico, Bronzino, Raffaello die Carli, Francesco Grannaci, and Cosimo Rosselli. In *Principal Northern Italian Painters*, Berenson referred to Bramantino, Butinone, Ercole de'Roberti, Giovanni Moroni, and Sodoma.

13. Letters from Henry Walters to Bernard Berenson dated February 7, 1911; June 9, 1912; and February 14, 1914; Archives Villa I Tatti, Florence.

14. Letters from Bernard Berenson to Henry Walters dated November 4, 1911; December 16, 1911; January 16, 1911; and November 9, 1912; Archives Walters Art Museum.

15. Walters did not maintain any organized or coherent records of the prices he paid for art. Indeed, he was known to have cut up invoices and other records that recorded the price of his art. In *Merchants of Art*, Germain Seligman writes that on one occasion he observed Walters using a large scissors to cut up invoices while informing him that "I don't want anybody in later years to talk of my collection in terms of money spent." Seligman, 134. The information set forth in the text about the prices Walters paid for art is based on either the prices set forth in the correspondence between Walters and Berenson or Walters's informal, handwritten lists of prices that have been discovered in the Walters archives. In 1913, the exchange rate was 1 pound = $4.86.

16. Hansen and Spicer, *Masterpieces of Italian Painting*. For an analysis of Bicci Di Lorenzo's *The Annunciation* (WAM 37.448), see 42–45; for an analysis of Bartolomeo di Giovanni's *Myth of Io* (WAM 37.421), see 52, 52; and for an analysis of Pintoricchio's *Saint Jerome in the Wilderness* (WAM 37.1089), see 68–71.

17. In 1962, the Walters Art Gallery engaged Federico Zeri to carefully evaluate the museum's entire collection of Italian paintings. Zeri's study, entitled *Italian Painting in the Walters Art Gallery*, was published in 1976. The study includes a history of the attributions given to each of the paintings by various scholars, including Berenson, and sets forth Zeri's own attribution. Zeri disagreed with most of the attributions made by Berenson of the paintings that Berenson sold to Walters. See also Secrest, *Being Bernard Berenson*, 402–404 (finding that two paintings sold by Berenson to Walters were "fakes" and fourteen carried attributions that have not withstood the test of time).

18. See conservation file on Carpaccio's painting of *Saint George and the Dragon*, Conservation Department, Walters Art Museum.

19. Zeri, *Italian Paintings* (WAM 37.482), 166, 167.

20. For the painting attributed by Berenson to Cima da Conegliano (WAM 37.470), see Zeri, *Italian Paintings*, 258, 259.

21. Registrar's De-accession File, 37.528, Walters Art Museum.

22. Zeri, *Italian Paintings* (WAM 37.526), 344, 345.

23. Ibid. (WAM 37.515), 400.

24. Ibid. (WAM 37.500), 216.

25. Ibid. (WAM 37.552), 8.

26. Walters Gallery, *Catalogue of Paintings* (1915) , nos. 449, 450, pp. 106, 107.

27. The two paintings by Bonsignori were discussed and praised by Berenson in *Venetian Paintings in America*, 170–173. In 1976, Zeri judged these paintings to be either forgeries or inferior copies with mistaken attributions. Zeri, *Italian Paintings*, 579. In 1989, the Walters Art Museum sought unsuccessfully to sell these paintings and ultimately contributed them to charity. See Registrar's De-accession files, Walters Art Museum.

28. Zeri, *Italian Paintings* (WAM 37.545), 419, 420.

29. Zeri, *Italian Paintings*, 255, 256.

30. Berenson's significant influence on the collection of Italian old-master paintings by those who contributed their collections to the National Gallery of Art in Washington, D.C., is summarized in Boskovits and Brown, *Italian Paintings of the Fifteenth Century*, xiv, xv.

31. For a good article about the acrimonious relationship between Berenson and Wilhelm von Bode, see Brown, "Bode and Berenson," 101–106. There is no historical evidence that Bode or any other contemporary competitor of Berenson challenged the quality of the attributions that Berenson provided to Walters.

32. Although no objective study has attempted to score Berenson's attributions, it has been estimated that Berenson was right about his attributions 75 to 85 percent of the time. Secrest, *Being Bernard Berenson*, 252.

33. Brown, *Berenson and Connoisseurship*, 30–41: "Berenson grasped that Connoisseurship can never be an exact science but must depend on the intuitive and analytical capabilities of an individual."

34. Ibid., 15, 16.

35. Berenson explained to Nicky Mariano that he had no misgivings about changing his attributions because "I have learned to see more clearly and that alone is important." Mariano, *Forty Years with Berenson*, 139.

36. Samuels, *Legend*, 223, 369, 370. Samuels quotes Berenson as stating that, "if I had leisure, I would reconsider every attribution I ever made."

37. Berenson, *Venetian Paintings in America*, 142.

38. For the changes in Berenson's evolving views about Bellini's contribution to the painting, see Berenson, *Italian Painters of the Renaissance* (Oxford, 1932), 69 ("in part by the artist") and Berenson, *Italian Painters of the Renaissance* (1952), 22 ("in great part autograph").

39. In Hansen and Spicer, *Masterpieces of Italian Painting*, published in 2005 by the Walters Art Museum, the painting is attributed to Giovanni Bellini and his workshop. X-rays have revealed that the saints in the painting were added by Bellini's assistants (see p. 80).

40. For the changing attributions to this painting, see painting no. 548 in the versions of the Walters Gallery *Catalogue of Paintings* published in 1909 (Giulio Romano), in 1915 (Bedolo), and in 1922 (Bedolo). See also Zeri's attribution in *Italian Paintings*, published in 1976 (Raffaello Dal Colle, pp. 355–357); the Walters Art Gallery *Guide to the Collections*, published in 1997 (Giulio Romano and workshop, pp. 52, 53); and *Masterpieces of Italian Painting*, published in 2005 (Giulio Romano, pp. 88–90).

41. This analysis is based on a comparison of the attributions given to paintings at the time they were acquired by Walters with the attributions given to these paintings in 1976 by Zeri in *Italian Paintings*. A change in attributions does not mean that the change downgraded the importance or quality of the painting. For example, Walters acquired from Paolo Paolini in Rome a *Full-Length Portrait of a Lady with a Little Girl* that was attributed to Zelotti. Walters Gallery, *Catalogue of Paintings* (1915), no. 541. Years later, the attribution of this painting was upgraded to Paolo Veronese.

Chapter 9. BERENSON'S FAUSTIAN BARGAIN WITH DUVEEN

1. Secrest, *Duveen* , 287.
2. Simpson, *Artful Partners*, 135.
3. Samuels, *Legend*, 136.
4. Meryle Secrest, biographer of both Berenson and Duveen, has written that the relationship between Berenson and Duveen became increasingly strained as the supply of paintings was dwindling. "Duveen still needed to sell and Berenson, more than ever was thinking about his legacy. Duveen was always pressing for the best possible attribution; Berenson, hating him for putting him once again into emotional torment, would capitulate. It could never be an easy relationship." Secrest, *Duveen*, 249.
5. For example, Paul Mellon regarded Joseph Duveen "with distaste and thought of him as an impossibly bumptious and opinionated ass who took advantage of any opportunity that presented itself to burnish his own image and to further his own interests." Mellon, *Reflections in a Silver Spoon*, 298.
6. For the reference to "king of the jungle," see Brown, *Berenson and Connoisseurship*, 26. For the reference to "evil," see letter from Bernard Berenson to John Graver Johnson dated March 9, 1911, Archives Philadelphia Museum of Art.
7. Samuels, *Legend*, 143.
8. Letter from Bernard Berenson to Henry Walters dated January 16, 1912, Archives Walters Art Museum.
9. Kiel, *The Bernard Berenson Treasury*, 139.
10. Letter from Henry Walters to Bernard Berenson dated August 25, 1910, Archives Villa I Tatti, Florence.
11. Letters from Henry Walters to Bernard Berenson dated May 30, 1911, and October 26, 1911, both Archives Villa I Tatti, Florence.
12. Letter from Bernard Berenson to Henry Walters dated May 13, 1912, Archives Walters Art Museum.

13. Samuels, *Legend*, 142. Walters thanked Berenson after the trip, stating, "I enjoyed my trip to Florence and the kind hospitality." Letter from Henry Walters to Bernard Berenson dated June 9, 1912, Archives Villa I Tatti, Florence.

14. Letter from Henry Walters to Bernard Berenson dated July 24, 1912, Archives Villa I Tatti, Florence.

15. Several photographs of paintings recommended by Berenson with Berenson's name on their backs are in the Archives Walters Art Museum.

16. Letters from Henry Walters to Bernard Berenson dated August 25, 1910; October 7, 1910; February 7, 1911; October 26, 1911; and December 22, 1913; all Archives Villa I Tatti, Florence.

17. See "Mr. Anderson's Account Book," 72, Archives Walters Art Museum.

18. For a discussion of the rising prices in Renaissance art after 1910 and the willingness of wealthy Americans to pay such prices, see Harris, *Cultural Excursions*, 258–267. For a discussion of the prices that Duveen clients were paying for art around this time, see Secrest, *Duveen*, 105–110.

19. The terms of the agreement dated September 18, 1912, between D.B. (Duveen) and Doris (Berenson) are set forth in Simpson, *Artful Partners*, appendix 1, 265–271. For a good description and analysis of the terms of this contract, see Samuels, *Legend*, 146–148.

20. Simpson, *Artful Partners*, 266.

21. Ibid., 265; Samuels, *Legend*, 146.

22. Letter from Bernard Berenson to Joseph Duveen dated June 2, 1912, "Duveen Brother Records," Thomas J. Watson Library, The Metropolitan Museum of Art, box 537, folder 5.

23. Letter from Bernard Berenson to Henry Walters dated October 12, 1912, Archives Walters Art Museum.

24. Letter from Bernard Berenson to John Graver Johnson dated September 25, 1912, Archives Philadelphia Museum of Art.

25. Samuels, *Legend*, 147.

26. Although I have found no hard evidence that Berenson intentionally misattributed any of the works of art that he sold to Walters, there is a division of opinion as to whether he did so with other collectors. According to David Alan Brown, Berenson resisted Duveen's requests that he misrepresent certain attributions to aid Duveen in making sales. Brown, *Berenson and Connoisseurship*, 26–29. Brown contends that "there is no evidence to suggest that he [Berenson] ever made an attribution he did not genuinely believe at the time it was made" (26). On the other hand, Colin Simpson, who wrote about Berenson's relationship with Duveen in *Artful Partners*, has opined that certain misattributions made by Berenson to help sell paintings were "deliberate." See Hoving, "The Berenson Scandals," 132–137.

27. See Samuels, *Connoisseur*, 311: "Of all the critics and art experts concerned with the traffic in Old Masters . . . no one was to equal Berenson's success and no one was to be so greatly envied and slandered." With regard to the unethical nature of the art market that Berenson entered, see Samuels, *Legend*, 3: Berenson "found his

involvement in the art trade a source of anguished dissatisfaction. As an idealistic aesthete he had quickly learned that the ethics of the world of art dealing were not those of Epicurus: to buy low and sell high was an imperative that could not be avoided, and conflicts of interest, dissimulation, and lavish puffery were an inevitable accompaniment." On p. 356: "Distasteful as the world of business and art dealing was to him, he found himself hopeless mired in it . . . He who as a younger man had inveighed against insincerity and commercialism found himself growing adept in the age-old art of the huckster." The attacks on Berenson's integrity began as early as 1902, when Richard Norton, a classicist at the American School in Rome and a competitor of Berenson, wrote to Isabella Stewart Gardner that "Berenson is dishonest. He is as you must know a dealer . . . Ask whom you will . . . collectors or people in Italy & I believe you will find no dissident voice to the statement that he is not honest,—that he will try to prejudice possible buyers against other dealers in order to keep commissions in his own hands." Norton's letter is quoted in Rubin, "Portrait of a Lady," 41. Berenson certainly was aware that his reputation was under attack. Mary Berenson noted in her diary that Berenson's enemies were trying to persuade Gardner that he "had cheated her" (Rubin, 42). After Henry Walters ceased doing any business with Berenson, Mary Berenson similarly attributed this defection to the belief that "they [the rival Seligman & Company] must have concocted all sorts of stories against all of us." Samuels, *Legend*, 354.

28. Clark, *Another Part of the Wood*, 139–141.

29. There is no dispute that Berenson became wealthy as a result of his dealing with Duveen. By one account, Berenson's share of the profits exceeded $100,000 each year and by 1937 amounted to $8,370,000, an enormous amount of money at that time. See Updike, "How to Milk a Millionaire."

30. Berenson, *Sketch for a Self-portrait*, 29. Using a biblical analogy to describe the choice he made to sell his expertise to Duveen, Berenson wrote that, at the age of thirty, he was pushed out of Eden and wandered through the wilderness for thirty years, during which the commercial misuse of his creative talent caused his dignity to be reduced to the ranks of fortune tellers and charlatans (see pp. 38, 43, 44, 47, 153, 154).

31. See Walters's letters to Berenson dated June 15, 1911 (commenting about Morgan's recent acquisition of enamels, which had been given to the Metropolitan, and his opinion about its quality and price), and September 25, 1917 (commenting about the high prices for works of art paid by Americans who had profited from the war), Archives, Villa I Tatti, Florence.

32. Samuels, *Legend*, 148 (gossip about Duveen having obtained an exclusive call upon Berenson's services).

33. Samuels, *Legend*, 106.

34. See "A Railroad Monarch," *Wilmington Morning Star*, September 12, 1905, "Bill Reaves Collection," New Haven County Public Library

35. Hoffman, *Atlantic Coast Line Railroad*, 178, 180: "These were marvelously prosperous times."

36. "To Erect Handsome Cottage," *Wilmington Evening Dispatch*, Feb. 17, 1911, "Bill Reaves Collection," New Haven County Public Library.

37. See Henry Walters Newspaper Clippings Collection, 1910, Archives Walters Art Museum.

38. See Hill, "The Classical Collection," 357, 358, and Simpson, "A Gallant Era," 103–111. For a chronological record of Walters's purchases of art, see Walters Art Museum Accession Records. For the Egyptian antiquities purchased from Kelekian in 1912, see WAM 32.1–32.9. For the French paintings purchased in 1913 and 1914 from Arnold Seligman, see WAM 27.355–27.359. In 1915, Walters purchased more than one hundred Chinese, Japanese, and Tibetan paintings. See WAM 35.1–35.121.

39. Pottier's "Record of Exports," dated December 10, 1914, lists on a month-by-month basis the art that was shipped to Walters during that year. During 1914, fourteen shipments contained hundreds of diverse objects of art, including sculpture, furniture, ivories, manuscripts, and paintings. A similar inventory exists for the year 1913. Archives Walters Art Museum.

40. Hill, "William T. Walters and Henry Walters," 183.

41. Taylor, "What Baltimore Will Do," 261–266, 261.

42. Walters maintained no coherent log that recorded the dates on which he acquired his paintings. Most of the dates when he bought paintings from Berenson can be ascertained from Walters's correspondence with Berenson. There is no similar source of information about dates on which Walters acquired paintings from other dealers. As a result, any determination of these dates depends on secondary sources of information. In estimating the years when Walters acquired paintings from sources other than Berenson, I have considered the following: (1) Mary Berenson's list of "New Acquisitions" recorded around 1914–15, at the time of her visit to the Walters Art Gallery, which is in the Archives of the Villa I Tatti; (2) the dates when paintings arrived at the Walters Art Gallery as indicated in Journal of James Anderson, the building superintendent, which is in the Archives of the Walters Art Museum; (3) the dates of acquisition estimated in the accession records of the Walters Art Museum; and (4) the dates referred to by Federico Zeri in his *Italian Paintings in the Walters Art Gallery.*

43. The precise date on which Walters acquired this painting is unknown. It was not listed in Walters's 1909 catalogue. The painting probably was not in Walters's collection in July 1912, when Walters turned down Berenson's offer to sell him a Bellini. The first reference to the painting appears in Mary Berenson's notes compiled in April 1914, at which time she and Bernard Berenson were inspecting the Walters collection. Mary Berenson listed the painting under the heading, "New Acquisitions." Accordingly, the painting was probably acquired by Walters between July 1912 and April 1914. Mary Berenson's notes recorded in Walters's 1909 catalogue are in the Archives of the Villa I Tatti. The painting was listed in Walters's 1915 catalogue at no. 446.

Chapter 10. THE JUDGMENT OF BERENSON

1. For a discussion of Berenson's business trip to the United States in the winter of 1913/14, see Samuels, *Legend*, 168–176.

2. Letter from Bernard Berenson to John Garner Johnson dated August 18, 1904, Archives Philadelphia Museum of Art.

3. According to William Johnston, the biographer of William and Henry Walters, no guest had stayed overnight in Walters's Baltimore house since 1894. The only person who resided in this home was Walters's servant.

4. Letter from Henry Walters to Bernard Berenson dated March 10, 1914, Archives Villa I Tatti, Florence.

5. For the dates when the painting was shipped to Berenson and returned to Walters, see Mr. Anderson's Account Book, Archives Walters Art Museum.

6. Letter from Belle da Costa Greene to B. Howell Griswold Jr. dated January 31, 1934, Archives Morgan Library.

7. Hadley, *Letters of Berenson and Gardner*, 514. Based on her tour of the Walters Gallery in 1904 and her subsequent review of the photographs of the Italian paintings that Henry Walters sent to Bernard Berenson, Mary Berenson had a poor impression of the Walters collection. On March 3, 1914, the day before she and Bernard Berenson returned to the Walters Gallery to inspect firsthand the Italian paintings, Mary Berenson wrote a letter to Geoffrey Scott, in which she referred to the overall collection as "the horrible, huge, mixed Walters' colln" and stated that, "It is bad business to bring order into even the small Italian section." For an account of the Berensons' visit to the Walters Gallery in 1914 and their impression of it, see Rubin, "Bernard Berenson, Villa I Tatti," 213, 214.

8. See Ardizzone, *An Illuminated Life*, 322–323.

9. Duplicate copies of the memorandum, entitled "Pictures to be removed from Mr. Walters Collection," are in the Archives of the Villa I Tatti and the Archives of the Walters Art Museum.

10. Walters's 1909 catalogue containing Bernard and Mary Berenson's notes and impressions recorded during their visit to the Walters Gallery in 1914 is in the Archives of the Villa I Tatti. I want to express my appreciation to Dr. Fiorella Superbi, the former curator of the Berenson Fototeca at the Villa I Tatti, for discovering this catalogue and bringing it to my attention.

11. Samuels, *Legend*, 174.

12. Letter from Walters to Berenson dated March 10, 1914, Archives Villa I Tatti, Florence.

13. *Baltimore News*, "Walters Gallery: Art Critic Denies it was Intentionally Slighted" ("To the Editor of the News") [1915 — exact date unknown], clippings file, Archives Walters Art Museum.

14. Bryant, *What Pictures to See in America*.

15. Letter from Henry Walters to Bernard Berenson dated July 13, 1914, Archives Villa I Tatti, Florence.

16. Samuels, *Legend*, 180.

17. Letter from Henry Walters to Bernard Berenson dated January 23, 1915, Archives Villa I Tatti, Florence.

18. Letter from Henry Walters to Bernard Berenson dated February 25, 1915, Archives Villa I Tatti, Florence.

19. Anderson's Account Book, Archives Walters Art Museum.

20. Letter from Henry Walters to Bernard Berenson dated February 25, 1915, Archives Villa I Tatti, Florence.

21. The reference to these corrections is found in the letter from Henry Walters to Bernard Berenson dated February 27, 1915, Archives Villa I Tatti, Florence. Walters corrected three attributions in the 1915 catalogue. As is evident from an examination of the 1915 catalogue, the corrections were made by pasting white slips of paper over items no. 644 (Raffaello Dei Carli); no. 687 (Nicola Di Maestro Antonion Da Ancona); and no. 752½ (Giovanni Di Paolo). A copy of the 1915 catalogue containing these pasted slips is in the Archives of the Walters Art Museum and in the Library of the Villa I Tatti.

22. The newspaper stories about the changes made by Walters in 1915 are collected in the Isabel C. Smith Clippings, Archives Walters Art Museum.

23. *Baltimore News*, "New Art Objects," Jan. 1, 1915, Isabel C. Smith Clippings, Archives Walters Art Museum.

24. *Baltimore News*, January 12, 1915, Isabel C. Smith Clippings, Archives Walters Art Museum.

25. Walters's identification of the Italian paintings that, in his view, were "the most important pictures in the Gallery," is set forth in *Baltimore News*, "Walters Gallery: Art Critic Denies It Was Intentionally Slighted."

26. Letter from Henry Walters to Bernard Berenson dated January 8, 1919, Archives Villa I Tatti, Florence.

27. Photographs of Salvator Rosa's *Soldier in Armor with a Banner* and Pietro Liberi's *Allegorical Figure* in the Cape Fear Club are in Leslie N. Boney Jr., *The Cape Fear Club* (Cape Fear Club, 1984). For an article about Henry Walters, his life in Wilmington, North Carolina, and the Cape Fear Club, see Steelman, "Art-loving Millionaire," *Wilmington Star-News*, December 28, 2003, 7D–F.

Chapter 11. THE UNFINISHED CATALOGUE

1. Letter from Bernard Berenson to Henry Duveen dated September 23, 1914, "Duveen Brothers Records," Box 537, folder 5.

2. Duveen Brother Records.

3. Ibid.

4. Samuels, *Legend*, 195, 196.

5. Ibid., 201.

6. Letter from Henry Walters to Bernard Berenson dated September 19, 1914, Archives Villa I Tatti, Florence.

7. Letter from Henry Walters to Bernard Berenson dated December 31, 1914, Archives Villa I Tatti, Florence.

8. Letter from Henry Walters to Bernard Berenson dated February 25, 1915, Archives Villa I Tatti, Florence.

9. Santori, *The Melancholy of Masterpieces*, 156, 157.

10. Letter from Bernard Berenson to Henry Duveen dated December 6, 1914, "Duveen Brother Records," Box 537, folder 5.

11. Letter from Henry Walters to Bernard Berenson dated January 23, 1915, Archives Villa I Tatti, Florence.

12. Letter from Henry Walters to Bernard Berenson dated August 18, 1915, Archives Villa I Tatti, Florence.

13. Letter from Henry Walters to Bernard Berenson dated February 29, 1916, Archives Villa I Tatti, Florence.

14. Berenson, *Venetian Paintings in America*.

15. See Mr. Anderson's Journal, December 27, 1916, Archives Walters Art Museum.

16. Berenson, *Venetian Painting in America*, 3, 13, 46, 47, 53, 139, 185, 164, 226, 245, 246.

17. The undated list of the six different schools and 156 paintings prepared by Mary Berenson is in a file relating to Berenson's unfinished catalogue in the Archives Villa I Tatti, Florence.

18. Berenson's handwritten notes for the Walters catalogue are in the Archives Villa I Tatti, Florence.

19. Letter from Henry Walters to Bernard Berenson dated September 25, 1917, Archives Villa I Tatti, Florence.

20. Letter from Henry Walters to Bernard Berenson dated September 25, 1917, Archives Villa I Tatti, Florence.

21. Letter from Henry Walters to Bernard Berenson dated January 8, 1916, Archives Villa I Tatti, Florence.

22. Letter from Henry Walters to Bernard Berenson dated January 8, 1919, Archives Villa I Tatti, Florence.

23. Letter from Henry Walters to Bernard Berenson dated January 8, 1919, Archives Villa I Tatti, Florence.

24. Letter from Henry Walters to James Anderson dated January 26, 1927, Archives Walters Art Museum

25. Hans Froelicker, "Italian Art at Walters Gallery," *Baltimore Sun*, January 20, 1919.

26. Samuels, *Legend*, 354.

27. Hadley, *Letters*, 650.

28. Samuels, *Legend*, 354.

Chapter 12. A MUSEUM IN REPOSE

1. Johnston, *William and Henry Walters*, 221.

2. The seven paintings were identified somewhat awkwardly at the end of the list of Italian paintings and numbered as 756 (A) through (G). The paintings, in the order in which they were acquired, were: 1915-no.756 (B) *Mythological Subject* [*Myth of Hippo*]; 1916-no. 756 (E) *Virgin and Child* by Bartolomeo Montagna; 1916-no. 756 (D) *Virgin and Child and Saints*; 1917-no. 756 (C) *Murder of the Innocents* by Bartolo di Fredi; 1920-no. 756 (F) *Virgin and Child* by Pietro Lorenzetti; 1920-no. 756 (A) *The Crucifixion* by Simone Martine; and 1920-no. 756 (G) *Madonna and Child* by Bernardino Martini. While adding these seven pictures, the 1922 catalogue retained all of the Italian pictures and attributions previously decided upon by Berenson. In this

sense, the 1922 catalogue was not a brand new catalogue but a modestly updated version of the catalogue published in 1915 under Berenson's direction.

3. Letter from Henry Walters to Laurana Vail Coleman dated January 13, 1923, Archives Walters Art Museum.

4. Letter from Henry Walters to James C. Anderson dated May 8, 1931, Archives Walters Art Gallery.

5. See for example Henry Walters letter to James C. Anderson dated March 10, 1923, Archives Walters Art Museum.

6. Letter from Henry Walters to J. C. Anderson dated March 6, 1915, Archives Walters Art Museum.

7. Letter from Henry Walters to H. G. Kelekian dated September 14, 1918, Archives Walters Art Museum.

8. Letter from Henry Walters to Pembrook Jones Jr. dated January 13, 1930, Archives Walters Art Museum.

9. Seligman, *Merchants of Art*, 132.

10. Seligman, *Merchants of Art*, 133.

11. See letter from Walter Gale, Maryland Representative of the *American Art Journal*, dated May 6, 1931, and the response of the Gallery dated May 9, 1931, Archives Walters Art Museum.

12. "Baltimore as an Art Center."

13. The absence of any documented visits to the Walters Art Gallery by any trustee or officer of the Metropolitan Museum of Art from 1922 to the time of Walters's death in 1931 probably reflects the lack of interest on the part of that museum in Walters's collection, especially his collection of Italian Renaissance paintings. It is reasonable to assume that Walters in 1922, in his capacity of vice president of the Metropolitan, informed the other leaders of the Metropolitan of his decision to bequeath his collection of art to the city of Baltimore to avoid any false expectations that the collection, in whole or in part, would be given to the Metropolitan. Although there was no factual basis for believing that Walters's collection was destined for New York, such speculation continued to the time of his death: "In that Walters was a director and a patron of the Metropolitan Museum of Art in New York it had been thought probable that at least part of the works of art assembled in the Walters gallery would go to that institution, but [Walters'] will provides only for a cash bequest to it" (*New York Times*, December 8, 1931).

14. Johnston, *William and Henry Walters*, 172, 198. Johnston notes that Walters came to Baltimore alone and that he seldom visited the collection in the company of his wife, Sadie.

Chapter 13. THE LINE BETWEEN FACT AND FICTION

1. *New York Times*, June 6, 1923, 23.

2. The paintings that were stored in the Long Museum at the time of Walters's death in 1931 were listed in the probate records prepared by John E. Marshall & Son, Archives Walters Art Museum.

3. For information about Wharton's relationship with Berenson, see Lee, *Edith Wharton*, 403–418; and Dwight, *Edith Wharton: An Extraordinary Life*, 265–272. For a discussion about the connections between Walters and Wharton and the likelihood that she modeled the figure of Horace Maclew after Walters in *The Mother's Recompense*, which she published in 1925, see Johnston, "Edith Wharton and Henry Walters," 14–19.

4. The identity of the actual art collector whom Wharton had in mind when writing *False Dawn* is debatable. Sizer, in an article about Jarves published in 1933, wrote that Wharton informed a third source that she modeled Raycie after Tomas J. Bryan, whose collection of around thirty purported Italian masters was brought to the United States in 1853. Sizer, "James Jackson Jarves: A Forgotten New Englander," 328–352, 341n28. Lee, in her very recent biography of *Edith Wharton*, asserts that Wharton based her portrait of Raycie on the life of Jarves (601). There is good reason to question whether Raycie was based on Jarves. Jarves was not from New York but from Boston, and Berenson spoke highly of Jarves and wanted to own some of the Italian paintings Jarves had collected. Samuels, *Connoisseur*, 426, 429.

5. See letters from James Anderson to Henry Walters dated January 25, 1929 and February 5, 1929, Archives Walters Art Museum.

6. Letter from Henry Walters to James Anderson dated January 22, 1931, Archives Walters Art Museum.

7. Hans Froelicher, "Italian Art at Walters Gallery," *Baltimore Sun*, January 20, 1929.

8. *Baltimore Sun*, December 31, 1929.

9. Johnston, 224, 294n8; Walters Art Gallery, Second Annual Report, 2.

10. Mark S. Watson, "Adventures in Art Collecting," *The Baltimore Sun*, January 25, 1931.

Chapter 14. FADED MEMORIES

1. "Henry Walters, Financier, Dead," *New York Times*, December 1, 1931, 27.

2. *Bulletin of the Metropolitan Museum of Art*, Vol. 27, January 1932, 2.

3. The two articles about Henry Walters's death appeared in the *Baltimore Sun* on December 1, 1931. Insofar as Walters's collection of Italian paintings was concerned, the two articles were inconsistent. The lengthier article praised the collection but misrepresented what remained in it. The obituary entitled "Henry Walters" stated that his art collection was particularly famous for its Persian and Oriental collections, and made no reference to Walters's collection of Italian paintings.

4. This report can be found in the files relating to Belle da Costa Greene in the Archives of the Morgan Library, 3.

5. *The Baltimore Sun*, February 3, 1934.

6. Letter from Dorothy Minor to Belle da Costa Greene dated March 30, 1934, Archives Morgan Library.

7. For the quotation by Pearlman, see *The Baltimore Sun*, February 2, 1934.

8. See "Walters Art Called Finest of Kind in U.S.," *The Baltimore Sun*, February 2, 1934.

9. Walters Art Gallery, *First Annual Report*, 2.

10. Walters conveyed to Berenson in their correspondence that he had read his books, and given Walters's interest in Italian paintings and his own interest in collecting books about Italian paintings, it is safe to assume that Walters at one time had all or practically all of the books that Berenson had written. Some of these books, such as *Venetian Paintings in America*, focused on Walters's collection. None of the books by Berenson that Walters once owned were found following Walters's death. There is some evidence that Walters gave them away. On April 3, 1917—a time which coincided with Walters's decision to sever his financial ties with Berenson—Walters donated to the Peabody Institute Berenson's *The Drawing of Florentine Painters in the Ufizzi Gallery*. See Anderson Log, 122, Archives Walters Art Museum. Walters wrote 56 letters to Berenson (which are in the Archives of the Villa I Tatti). The letters appear to respond to letters that Berenson sent to Walters. On this basis, it is reasonable to estimate that Berenson sent approximately 50 letters to Walters. Walters, however, retained only 8 of these letters which were dated: October 15, 1909, October 8, 1911, November 4, 1911, December 16, 1911, January 16, 1912, May 13, 1912, October 21, 1912, and November 9, 1912.

11. The letters from Marshall and Greene to Berenson and Berenson's response are in the files pertaining to Belle da Costa Greene in the Archives of the Morgan Library.

12. See letter from Edward S. King to Bernard Berenson dated October 21, 1952, Archives Walters Art Museum.

AFTERWORD

1. Zeri's early observations about the Walters collection of Italian paintings were reported in the *Baltimore Sun* on March 9, 1959 and June 28, 1963.

2. Bernard Berenson died on October 6, 1959. Mary Berenson died on March 23, 1945. Belle da Costa Greene died on May 10, 1950.

3. The earliest reference to the catalogue that Walters, with Berenson's guidance, published in 1915 appears in Samuels, *Legend*, 192. Berenson's notes relating to the 1915 catalogue and his unfinished draft of the grand, illustrated catalogue that he promised to write for Walters was discovered in 2008 in the archives of the Villa I Tatti.

4. Zeri, "The Italian Pictures: Discoveries and Problems," 24, 25. Zeri's lack of knowledge about the details of the relationship between Walters and Berenson is reflected in his misunderstanding that the relationship between Berenson and Walters lasted until 1922. This mistake was compounded by Zeri's estimates that certain paintings were acquired by Walters from Berenson "before 1922." See Zeri, *Italian Paintings in the Walters Art Gallery*, xiii.

5. Zeri, *Italian Paintings*, xiv.

Bibliography

BOOKS

Ardizzone, Heidi. *An Illuminated Life.* W. W. Norton, 2007.

Auchincloss, Louis. *Theodore Roosevelt.* Henry Holt, 2001.

Baedeker, K. *Handbook for Travellers,* Central Italy and Rome. Karl Baedeker, 1893.

———. *Italy: Handbook for Travellers.* Londai Dulan, 1876.

Barkan, Leonard. *Unearthing the Past: Archeology and Aesthetics in the Making of Renaissance Culture.* Yale University Press, 1999.

Behrman, S. N. *Duveen.* Random House, 1951.

Berenson, Bernard. *The Venetian Painters of the Renaissance.* G. P. Putnam's Sons, 1894.

———. *The Florentine Painters of the Renaissance.* G. P. Putnam's Sons, 1896.

———. *The Study and Criticism of Italian Art,* "Venetian Painting, chiefly before Titian," volume 1. Chiswick Press, 1901.

———. *The Study and Criticism of Italian Art,* "Rudiments of Connoisseurship," Second Series. George Bell and Sons, 1902.

———. *The Northern Italian Painters of the Renaissance.* G. P. Putnam's Sons, 1907.

———. *The Central Italian Painters of the Renaissance.* G. P. Putnam's Sons, 1908.

———. *Catalogue of a Collection of Paintings and Some Art Objects.* Vol. 1. John G. Johnson, Philadelphia, 1913.

———. *Venetian Painting in America.* Frederic Fairchild Sherman, 1916.

———. *The Painters of the Renaissance.* Oxford University Press, 1938.

———. *Sketch for a Self-portrait.* Pantheon, 1949.

———. *The Italian Painters of the Renaissance.* Phaidon Press, 1952.

———. *Caravaggio: His Incongruity and His Fame.* Chapman and Hall, 1953.

———. *Lorenzo Lotto.* Phaidon Publishing, 1956.

Block, Susan Taylor. *Airlie: The Gardens of Wilmington.* Airlie Foundation, 2001.

Boskovits, Miklós, and David Alan Brown. *Italian Paintings of the Fifteenth Century.* National Gallery of Art, 2003.

Brown, Beverly Louise. *The Genius of Rome, 1592–1623.* Royal Academy of Arts, 2001.

Brown, David Alan. *Berenson and the Connoisseurship of Italian Painting.* National Gallery of Art, 1979.

———. *Raphael in America.* National Gallery of Art, 1983.

Brown, David Alan, and Jane Van Nimmen. *Raphael and the Beautiful Banker: The Story of the Bindo Altoviti Portrait.* Yale University Press, 2005.

Bryant, Lorinda Munson. *What Pictures to See in America.* John Lane, 1915.

Burckhardt, Jacob. *The Cicerone: An Art Guide to Painting in Italy.* Translated by Mrs. A. H. Clough. John Murray, 1879.

Chapman, Hugo. *Michelangelo Drawings: Closer to the Master.* British Museum Press, 2005.

Clark, Kenneth. *Another Part of the Wood.* John Murray, 1974.

Cochrane, Eric. *Florence in the Forgotten Centuries, 1527–1800.* University of Chicago Press, 1973.

Condivi, A. *The Life of Michelangelo.* Translated by A. Sedgewick Wohl. Phaidon, London, 1976.

Constable, W. G. *Art Collecting in the United States of America.* Thomas Nelson and Sons, 1964.

Duveen, James H. "The Mazzarenti [sic] Collection." In *The Rise of the House of Duveen*, chapter 21. Knopf, 1957.

Dwight, Eleanor. *Edith Wharton: An Extraordinary Life.* Harry N. Abrams, 1994.

Fantoni, Marcello. *The Art Market in Italy (15th–17th Centuries).* Franco Cosimo Panini, 2003.

Fredericksen, Burton B., and Federico Zeri. *Census of Pre-Nineteenth-Century Paintings in North American Public Collections.* Harvard University Press, 1972.

Friedlander, Walter. *Caravaggio Studies.* Princeton University Press, 1955.

Gibson-Wood, Carol. *Studies in the Theory of Connoisseurship from Vasari to Morelli.* Garland Publishing, 1988.

Hadley, Rollin Van N. *The Letters of Bernard Berenson and Isabella Stewart Gardner.* Northwestern University Press, 1987.

Hansen, Morten Steen, and Joaneath A. Spicer. *Masterpieces of Italian Painting: The Walters Art Museum.* Walters Art Museum and D. Giles, 2005.

Harris, Neil. "Collective Possession: J. Pierpont Morgan and the American Imagination." In *Cultural Excursions*, 250–275. University of Chicago Press, 1990.

Hayward, Mary Ellen, and Frank R. Shivers Jr. *The Architecture of Baltimore.* Johns Hopkins University Press, 2004.

Hoffman, Glen. *A History of the Atlantic Coast Line Railroad.* CSX, 1998.

Holmes, Megan. "Copying Practices and Marketing Strategies in a Fifteenth-Century Florentine Painter's Workshop." In *Artistic Exchange and Cultural Translation in the Italian Renaissance City*, edited by Stephen J. Campbell and Stephen J. Milner, 38–74. Cambridge University Press, 2004.

Jarves, James Jackson. "A Lesson for Merchant Princes." In *Italian Rambles: Studies of Life and Manners in New and Old Italy.* G. P. Putnam's Sons, 1883.

Johnston, William R. *The Taste of Maryland: Art Collecting in Maryland, 1800–1934.* Walters Art Gallery, 1984.

———. *William and Henry Walters, the Reticent Collectors.* Johns Hopkins University Press, 1999.

Jones, Howard Mumford. "The Renaissance and American Origins." In *Ideas in America*, 140–151. Harvard University Press, 1945.

Jones, Pamela. *Federico Borromeo and the Ambrosiana.* Cambridge University Press, 1993.

Kahng, Eik. *The Repeating Image.* Yale University Press, 2007.

Kiel, Hanna. *The Bernard Berenson Treasury.* Simon and Schuster, 1962.

King, Ross. *The Judgment of Paris.* Walker and Co., 2006.

Lee, Hermione. *Edith Wharton.* Vintage Books, 2007.

Levey, Michael. *Later Italian Pictures in the Royal Collection.* Phaidon Publishers, 1964.

Loh, Mariah H. *Titian Remade: Repetition and the Transformation of Early Modern Art.* Getty Research Institute, 2007.

Marani, Piero C. *Leonardo Da Vinci: The Complete Paintings.* Harry N. Abrams, 1999.

Mariano, Nicky. *Forty Years with Berenson.* Alfred A. Knopf, 1966.

Mayo, Margaret Ellen. "Collecting Ancient Art: A Historical Perspective." In *Who Owns the Past,* edited by Kate Fitz Gibbon. Rutgers University Press, 2005.

Mellon, Paul. *Reflections in a Silver Spoon.* William Morrow, 1992.

Moir, Alfred. *Caravaggio and His Copyists.* New York University Press, 1976.

O'Malley, Michelle. *The Business of Art: Contracts and the Commissioning Process in Renaissance Italy.* Yale University Press, 2005.

Pater, Walter. *The Renaissance: Studies in Art and Poetry.* Oxford University Press, 1986.

Pepper, D. Stephen. *Guido Reni.* Phaidon Oxford, 1984.

Puglisi, Catherine. *Caravaggio.* Phaidon Press, 2000.

Rubin, Patricia. "Bernard Berenson, Villa I Tatti, and the Visualization of the Italian Renaissance." In *Gli Anglo-Americani a Firenze,* edited by Marcello Fantoni, 207–221. Bulzoni Editore, 2000.

Saltzman, Cynthia. *Old Masters, New World.* Viking, 2008.

Santori, Flaminia Gennari. "James Jackson Jarves and the Diffusion of Tuscan Painting in the United States." In *Gli anglo-americano a Firenze,* edited by Marcello Fantoni. Bulzoni Editore, 2000.

——. *The Melancholy of Masterpieces: Old Master Paintings in America, 1900–1914.* 5 Continents Editions, 2003.

Samuels, Ernest. *Bernard Berenson: The Making of a Connoisseur.* Belknap Press, 1979.

——. *Bernard Berenson: The Making of a Legend.* Belknap Press, 1987.

Secrest, Meryle. *Being Bernard Berenson.* Holt, Rinehart and Winston, 1979.

——. *Duveen: A Life in Art.* Alfred A. Knopf, 2004.

Seiler, R. M. *Walter Pater: The Critical Heritage.* Routledge and Kegan Paul, 1980.

Seligman, Germain. *Merchants of Art, 1880–1960: Eighty Years of Professional Collecting.* Appleton-Century-Crofts, 1961.

Simpson, Colin. *Artful Partners: Bernard Berenson and Joseph Duveen.* Macmillan Publishing, 1986.

Spear, Richard. *Domenichino.* Yale University Press, 1982.

Spear, Richard E. "Di Sua Mono." In *The Ancient Art of Emulation,* edited by Elain K. Gazda, 79–98. University of Michigan Press, 2002.

Strehkle, Carl Brandon. *Pontormo, Bronzino and the Medici.* Philadelphia Museum of Art, 2004.

——. *Italian Paintings, 1350–1450: In the John G. Johnson Collection and the Philadelphia Museum of Art.* Philadelphia Museum of Art, 2004.

Strouse, Jean. *Morgan: American Financier.* Harper Collins, 2000.

Symonds, John Addington. *The Life of Michelangelo Buonarroti.* University of Pennsylvania Press, 2002.

Tomkins, Calvin. *Merchants and Masterpieces: The Story of the Metropolitan Museum of Art.* E. P. Dutton, 1970.

Vasari, Giorgio. *The Lives of the Artists.* E. P. Dutton, 1927.

Walker, John. *Self-portrait with Donors: Confessions of an Art Collector.* Little Brown, 1969.

———. *National Gallery of Art.* Paul N. Abrams, 1975.

Walters Gallery. *The Walters Collection: Catalogue of Paintings.* Lord Baltimore Press, 1909.

———. *The Walters Collection: Catalogue of Paintings.* Lord Baltimore Press, 1915 [erroneously hand-dated 1922].

———. *The Walters Collection: Catalogue of Paintings.* Lord Baltimore Press, 1922 [erroneously hand-dated 1929].

———. *Guide to the Collections.* Walters Art Gallery, Scala Books, 1997.

Wharton, Edith. *Old New York.* D. Appleton and Co., 1924.

Wollheim, Richard. "Giovanni Morelli and the Origin of Scientific Connoisseurship." In *On Art and the Mind,* 176–201. Allen Lane, 1973.

Zafran, Eric M. *Fifty Old Master Paintings from the Walters Art Gallery.* Walters Art Gallery, 1988.

Zeri, Federico. *Italian Paintings in the Walters Art Gallery.* Walters Art Gallery, 1976.

ARTICLES

NEWSPAPER ARTICLES

"His Mother's Idea," *Wilmington Messenger,* 27 November 1894.

"A $200,000 Picture for the Walters Art Gallery," *Wilmington Messenger,* 7 July 1901.

"Baltimore to Have Massarenti Pictures," *New York Times,* 11 May 1902, p. 14.

"Wonders in Art," *Baltimore Sun,* 13 May 1902.

"The Massarenti Collection," *New York Times,* 11 May 1902, p. 8 (editorial).

"The Massarenti Collection," *Baltimore Sun,* 14 May 1902.

"A Chance for New York," *New York Times,* 18 May 1902.

"The Last Word Not Said," *New York Times,* 20 May 1902, p. 6.

"Massarenti Collection: Further Information Regarding the Great Collection Which Henry Walters Seeks," *New York Times,* 20 May 1902.

"Baltimore Gets the Massarenti Collection," *New York Times,* 8 June 1902, p. 24.

"Massarenti Collection Here from Italy," *New York Times,* 13 July 1902, p. 1.

"The Massarenti Collection," *Baltimore Sun,* 13 July 1902.

"Duty on Art Collection," *New York Times,* 14 July 1902, p. 3.

"Baltimore to Have Massarenti Pictures," *New York Times,* 11 August 1902, p. 14.

"The Duty on Art," *New York Times,* 10 September 1902 (letter from A.W. Lyman).

"Old Masters of Italy," *New York Times,* 21 March 1904.

"Walters Gallery Ready for Placing of Paintings," *Baltimore Sun*, 20 June 1907, p. 14.
"Italy to Preserve Art," *New York Times*, 29 December 1907, sec. 3, p. 2.
"Italy Stoutly Holds Her Art Treasures," *New York Times*, 29 March 1908, sec.3, p. 3.
"Walters Art Gallery to Open February 3," *Baltimore News*, 22 January 1909.
"Walters Art Temple Shown," *New York Times*, 30 January 1909.
"Art Lovers Throng Walters Gallery," *Baltimore News*, 3 February 1909.
"Many Pictures from the Massarenti Collection Not Hung in the New Gallery," *Baltimore News*, 28 February 1909.
"Guarding Art Treasures," *New York Times*, 18 July 1909, p. 8
"Madonna of the Candelabra," *Baltimore News*, 1 January 1910.
"Old Art in the United States," *New York Times*, 31 December 1911.
"New Art Objects," *Baltimore News*, 1 January 1915.
"Walters Gallery: Art Critic Denies It Was Intentionally Slighted," *Baltimore News* (letter to the editor quoting Henry Walters), 1915 [exact date unknown], Clippings File, Archives Walters Art Museum.
"Italian Art at Walters Gallery," *Baltimore Sun*, 20 January 1919.
"Promises Inquiry into Museum Pieces . . . Admits His Art Mistakes," *New York Times*, 6 June 1923.
"Italian Art at Walters Art Gallery," *Baltimore Sun*, 20 January 1929.
"A Monument," *Baltimore Sun*, 31 December 1929.
"Adventures in Art Collecting," *Baltimore Sun*, 25 January 1931.
"Henry Walters, Financier, Dead," *New York Times*, 1 December 1931.
"Henry Walters," *Baltimore Sun*, 1 December 1931.
"Walters Art Left to Baltimore City," *New York Times*, 8 December 1931.
"The Walters' Gift Gains in Stature," *Baltimore Sun*, 14 January 1934.
"Walters Art Called Finest of Its Kind," *Baltimore Sun*, 2 February 1934.
"Walters Art Collection Is Immense," *Baltimore Sun*, 3 February 1934.
"Notable Canvases in the Italian Group," *Baltimore Sun*, 4 February 1934.
"Walters Art Museum" [Zeri observations], *Baltimore Sun*, 9 March 1959, 28 June 1963.

JOURNAL ARTICLES

Anderson, Jaynie. Review of "La Raccolta Morelli nell' Accademia Carrara" by Federico Zeri. *Burlington Magazine* 129, no. 1012 (July 1987): 468–470.
———. "The Political Power of Connoisseurship in the Nineteenth-Century Europe: Wilhelm von Bode versus Giovanni Morelli." *Jahrbuch der Museen* 38 (1996): 107–119.
Askew, Pamela. "The Parable Paintings of Domenico Fetti." *Art Bulletin* 43, no. 1 (March 1961): 21–45.
"Baltimore as an Art Center," *Art and Archeology* 19, nos. 5–6 (May–June 1925).
Barolsky, Paul. "Walter Pater and Bernard Berenson." *New Criterion* (April 1984): 47–57.
Beck, James. "The Portrait of Julius II in London's National Gallery: The Goose That Turned into a Gander." *Artibus et Historiae* 17, no. 33 (1966): 69–95.

Berenson, Bernard. "Venetian Paintings in the United States I; Venetian Paintings in the United States II (The Vivarini and Crivelli); Venetian Paintings in the United States III (Antonello da Messina and Derivatives)." *Art in America* 3 (February, April, June, 1915): 43–55, 105–119, 141–173.

Bode, Wilhelm. "More Spurious Pictures Abroad Than in America." *New York Times Magazine,* 31 December 1911, p. 4.

Brown, David Alan. "Bode and Berenson: Berlin and Boston." *Jahrbuch der Berliner Museen* 38 (1966): 101–106.

———. Review of "Federico Zeri, Italian Paintings in the Walters Art Gallery." *Art Bulletin* 60, no. 2 (June 1978): 367–369.

Calo, Mary Ann. "Bernard Berenson and America." *Archives of American Art Journal* 36, no. 2 (1996): 8–18.

Carrier, David. "In Praise of Connoisseurship." *Journal of Aesthetics and Art Criticism* 61, no. 2 (Spring 2003): 159–169.

Christiansen, Keith. "Caravaggio's Second Versions." *Burlington Magazine* 134, no. 1073 (August 1992): 502–504.

Clark, Kenneth. "Bernard Berenson." *Burlington Magazine* 102, no. 690 (September 1960): 381–386.

Findlen, Paula. "Possessing the Past: The Material World of the Italian Renaissance." *American Historical Review* 103, no. 1 (February 1998): 112, 113.

Fleming, John. "Art Dealing and the Risorgimento." *Burlington Magazine* 115, no. 838 (January 1973): 4–17.

"Forward—The Founders of the Collection," *Journal of the Walters Art Gallery* 1 (1938): 9–12.

Fry, Roger. "Review of *The Study and Criticism of Italian Art* by Bernard Berenson." *Anthenaeum,* 16 November 1901, pp. 668–669.

Gilman, Benjamin Ives. "Aims and Principles of the Construction and Management of Museums of Fine Art." *Museums Journal,* July 1909, pp. 28–44.

Gilmore, Myron P. "The Berensons and Villa I Tatti." *Proceedings of the American Philosophical Society* 120, no. 1 (5 February 1976): 7–12.

Graeve, Mary Ann. "The Stone of Unction in Caravaggio's Painting for the Chiesa Nuova." *Art Bulletin* 40, no. 3 (September 1958): 223–238.

Hartt, Frederick. "Michelangelo in Heaven." *Artibus et Historiae* 13, no. 26 (1992): 191–209.

Headley, Janet A. "Public Art and the Private Collector: William T. Walters and the Peabody Institute Art Gallery." *Archives of American Art Journal* 32, no. 1 (1992): 2–10.

Heisinger, Ulrich. "The Paintings of Vincenzo Camuccini, 1771–1884." *Art Bulletin* 60, no. 2 (June 1978): 297–320 (appendix A).

Hill, Dorothy Kent. "William T. Walters and Henry Walters." *Art in America* 32, no. 4 (October 1944): 178–186.

———. "The Classical Collection and Its Growth." *Apollo Magazine,* November 1974, pp. 352–359.

Hill, G. F. "The Portraits of Michelangelo." *Burlington Magazine* 25, no. 138 (September 1914): 345, 346.

Hoving, Thomas. "The Berenson Scandals: An Interview with Colin Simpson." *Connoisseur* (October 1986): 132–137.

"How We Strip Europe of Her Treasures of Art," *New York Times Magazine*, 19 February 1911, p. 9.

"In Memoriam Henry Walters," *Bulletin of the Metropolitan Museum of Art* 27 (January 1932): 2.

Jarves, James. "Italian Experience in Collecting Old Masters." *Atlantic Monthly* 6 (November 1860): 578–586.

Johnston, William R. "Edith Wharton and Henry Walters." *Maryland Humanities* 80 (November 2001): 14–19.

Kennick, W. E. "Art and Inauthenticity." *Journal of Aesthetics and Art Criticism* 44, no. 1 (Autumn 1985): 3–12.

Loh, Mariah H. "New and Improved: Repetition as Originality in Italian Baroque Practice and Theory." *Art Bulletin* 86, no. 3 (2004): 477–504.

Lopez, Jonathan. "Gross False Pretenses." *Apollo*, 30 November 2007.

Matthews, Arnold. "The Walters Art Collection in Baltimore." *Magazine of Western History* 10, no. 1 (May 1889): 1–16.

Minor, Dorothy. "The Publishing Ventures of a Victorian Connoisseur." *Papers of the Bibliographical Society of America* 47 (3d quarter, 1962): 271–311.

"Mr. William T. Walters," *Harper's Weekly*, December 1894, p. 1132.

"Old Masters Themselves Were Adept in Copyist's Art, *New York Times Magazine*, 20 June 1909.

Paoletti, John T. "Michelangelo's Masks." *Art Bulletin* 74, no. 3 (September 1992): 423–440.

Pepper, Stephen D. "Guido Reni's Roman Account Book—II: The Commissions." *Burlington Magazine* 113, no. 820 (July 1971): 372–386.

———. "Guido Reni's Practice of Repeating Compositions." *Artibus et Historie* 20, no. 39 (1999): 27–54.

Pepper, Stephen D., Elizabeth Cropper, and Charles Dempsey. "An Exchange on the State of Research in Italian 17th Century Painting." *Art Bulletin* 71, no. 2 (June 1989): 305–309.

Quodbach, Esmée. "The Last of the American Versailles: The Widener Collection at Lynnewood Hall." *Simiolus: Netherlands Quarterly for the History of Art* 29, no. 1/2 (2002): 42–96.

Rubin, Patricia. Book Review of *Giovanni Morelli*. *Burlington Magazine* 137, no. 112 (November 1995): 767.

———. "Portrait of a Lady: Isabella Stewart Gardner, Bernard Berenson and the Market for Renaissance Art in America." *Apollo Magazine* 152 (2000): 37–44.

Santori, Gennari. "Turning Points in Old Master Collecting, 1830–1940." Center for the History of Collecting in America, May 19, 2007.

Schmitter, Monika. "Virtuous Riches: The Bricolage of Cittadini Identities in Early Sixteenth-Century Venice." *Renaissance Quarterly* 57 (2004): 93, 94.

Simpson, Marianna Shreve. "'A Gallant Era': Henry Walters, Islamic Art, and the Kelekian Connection." *Journal of the Walters Art Museum* 59 (2001): 101–111.

Sizer, Theodore. "James Jackson Jarves: A Forgotten New Englander." *New England Quarterly* 6, no. 2 (June 1933): 328–352.

Steelman, Ben. "Art-loving Millionaire Left His Mark on Port City." *Wilmington Star News*, 28 December 2003, pp. 7D–F.

Strouse, Jean. "The Collector J. Pierpont Morgan." In *Collectors, Collections, and Scholarly Culture*, paper 48. American Council of Learned Societies, 6 May 2006.

Sutton, Denys. "Connoisseur's Haven." *Apollo Magazine* 84, no. 58 (December 1966): 2–13.

Taylor, Francis Henry. "What Baltimore Will Do with the Walters Bequest." *American Magazine of Art* 27, no. 5 (May 1934): 261–266.

———. "The Walters Gallery Revisited." *Parnassus* 6, no. 7 (December 1934): 2–6.

Tietze-Conrat, E. "Titian's Workshop in His Late Years." *Art Bulletin* 28 (1946): 76–88.

Updike, John. "How to Milk a Millionaire." *New York Times*, 29 March 1987.

Venturi, Lionello. "Private Collections of Italian Paintings." *Art in America* 32, no. 4 (October 1944): 168–177.

"Walters Art Gallery." *American Art Annual* 28 (1931): 149.

"The Walters Collection of Art Treasures: Its History and Educational Importance." *Magazine of American History* 27, no. 4 (April 1882): 241–264.

"Wanted: A School for Art Collectors." *Nation* 75, no. 1952 (27 November 1902): 416–417.

Waterhouse, Ellis. Book Review. *Burlington Magazine* 103, no. 704 (November 1961): 476.

Wilson, Richard Guy. "Architecture and the Reinterpretation of the Past in the American Renaissance." *Winterthur Portfolio* 18, no. 1 (Spring 1983): 69–87.

Wolk-Simon, Linda. "The Colonna Altarpiece." *Metropolitan Museum of Art Bulletin* (Spring 2006).

"Wonders of Walters." *Time Magazine*, 12 February 1934.

Zeri, Federico. "The Italian Pictures: Discoveries and Problems." *Apollo Magazine* 84, no. 58 (December 1966): 22–31.

ARCHIVES

Villa I Tatti Archives

Letters and telegrams from Henry Walters to Bernard Berenson dated September 16, 1909; November 13, 1909; December 8, 1909; January 4, 1910; February 4, 1910; March 4, 1910; March 18, 1910; April 23, 1910; May 24, 1910; August 25, 1910; October 7, 1910; January 5, 1911; February 7, 1911; February 23, 1911; April 13, 1911; May 30, 1911; June 5, 1911; June 15, 1911; October 26, 1911; December 1, 1911; January 1, 1912; June 9, 1912; July 24, 1912; January 8, 1913; December 22, 1913; February 6, 1914; March 10, 1914; March 19, 1914; July 13, 1914; September 19, 1914; December 31, 1914; January 16, 1915; January 23, 1915; January 25, 1915; February 25, 1915; February 27, 1915; August 18, 1915; October 12, 1915; January 8, 1916; January 14, 1916; February

29, 1916; March 27, 1916; April 24, 1916; July 12, 1916; August 12, 1916; September 6,
 1916; undated, 1916; undated 1916; September 25, 1917; and January 8, 1919.
Letters from William Laffan to Bernard Berenson dated July 10, 1909; July 28, 1909;
 and August 28, 1909.
Memorandum entitled "Pictures to be removed from Mr. Walters collection."
Walters Catalogue of Paintings, 1909, with notes handwritten by Bernard Berenson
 and Mary Berenson regarding attributions, paintings to be removed from the col-
 lection, and Walters's new acquisitions.
Walters Catalogue of Paintings, 1909, annotated with notes by W. Kennedy indicating
 paintings disposed of on February 3, 1915, and February 9, 1922, and dated February
 12, 1934.
"Provisional list" of 156 paintings in the Walters Art Gallery, organized by schools of
 art, by Mary Berenson for inclusion in Berenson's catalogue of Walters's Italian
 paintings.
Bernard Berenson's 61-page draft of catalogue of Henry Walters's collection of Italian
 paintings (file of unfinished manuscripts).

WALTERS ART MUSEUM ARCHIVES

Agreement dated April 16, 1902, between Dr. J. H. Senner (for Don Marcello Mas-
 sarenti) and Henry Walters.
Catalogue of Massarenti Collection (1981).
Catalogue of Massarenti Collection (1897), and Supplement (1900), with marginal
 notes.
Correspondence between Henry Walters and James Anderson, 1912–1931.
Correspondence between Henry Walters and Farris Pitt and related notes (Pitt File).
Henry Watson Kent, "Henry Walters," January 27, 1940 [speech].
Henry Walters's Newspaper Clippings Collection.
Isabelle Smith [newspaper] Clippings.
James Anderson Account Book (153 pages) detailing objects of art arriving at Walters
 Art Gallery and dates on which Henry Walters visited the gallery.
Letters from Bernard Berenson to Henry Walters dated January 6, 1911; October 8,
 1911; November 4, 1911; December 16, 1911; January 6, 1912; May 13, 1912; October
 21, 1912; and November 9, 1912.
Letter from Edward King to Bernard Berenson, dated October 21, 1952.
Letters from Henry Walters to William Laffan, dated May 13 and 29, 1902.
Letter from Henry Walters to Emil Ray, dated May 13, 1902.
Letter from Henry Walters to Laurence Coleman, Secretary American Association of
 Museums, dated January 23, 1923.
Letter from Henry Walters to James Anderson, dated January 22, 1931.
Letter from Wm. Adams Delano to Dorothy Minor, dated October 9, 1933.
Lists of paintings in Massarenti collection organized alphabetically and by schools of
 Italian art for Henry Walters, undated.

Memorandum to H. Walters possibly from Senner regarding the terms of sale of the Massarenti Collection.

Memorandum dated April 2, 1904, regarding loss of records regarding items from Massarenti collection that were left in Italy.

Memorandum entitled "Pictures to be removed from Mr. Walters collection."

Memorandum of Regina Soria about Don Marcello Massarenti, June 2, 1958.

Notes (informal) handwritten by Henry Walters regarding the cost of some of the paintings he acquired.

Photographs of the Massarenti Collection, at 1900.

Photographs of Italian paintings from Massarenti Collection disposed of by Henry Walters in 1915 and 1922.

Photographs with handwritten notes of Bernard Berenson regarding attributions of Italian paintings.

Probate Records of Henry Walters prepared by John E. Marshall & Son, July 8, 1932 (with inventory of Italian paintings).

Record of Exports, prepared by Ch. Pottier, 1913, 1914.

Sketchbook/journal notes written by Henry Walters about his tour of Italy, May 9 to May 23, 1879.

Walters Art Museum Deaccession files.

The Walters Collection (Press of the Friedenwald Co., 1903).

Walters Art Gallery First Annual Report, dated December 31, 1933; Second Annual Report, dated March 14, 1935; and Third Annual Report, dated March 14, 1936.

Warren Wilmer Brown Journal (newspaper clippings).

PHILADELPHIA MUSEUM OF ART ARCHIVES

Letters from Bernard Berenson to John Graver Johnson, 1904–1914.

MORGAN LIBRARY ARCHIVES

Belle da Costa Greene files relating to the Walters Art Gallery, 1934–1938.

THOMAS J. WATSON LIBRARY, METROPOLITAN MUSEUM OF ART

Duveen Brothers Records, containing correspondence between Bernard Berenson and Henry and Joseph Duveen.

ENOCH PRATT FREE LIBRARY, BALTIMORE, MARYLAND

Maryland Collection, Vertical Files, William and Henry Walters.

NEW HAVEN COUNTY PUBLIC LIBRARY, WILMINGTON, NORTH CAROLINA

Bill Reaves Collection.

Index